WAYNE THIEBAUD

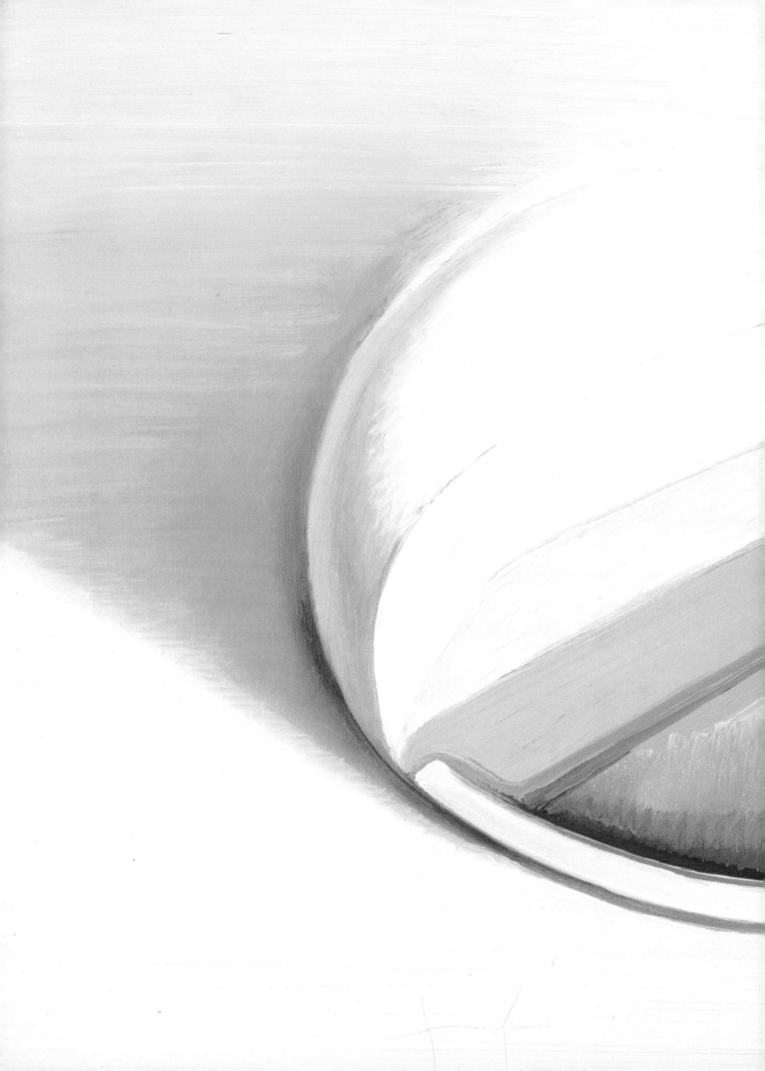

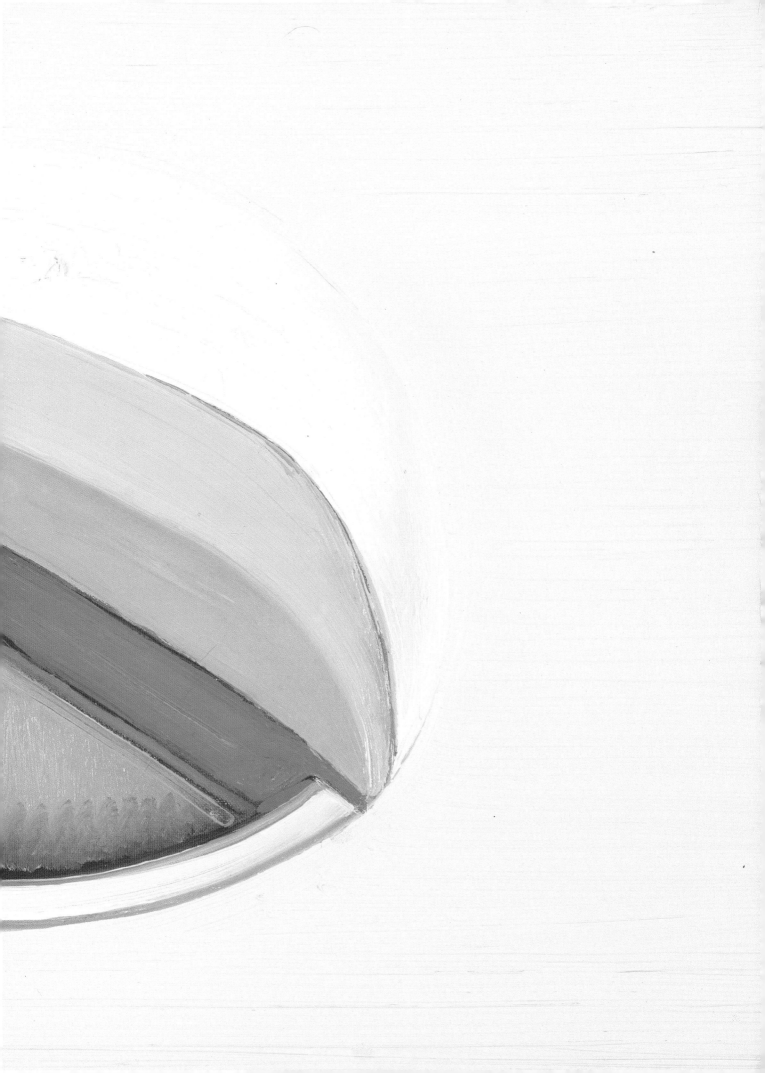

WAYNE
THIEBAUD

by KAREN TSUJIMOTO

Published for the
SAN FRANCISCO MUSEUM OF MODERN ART
by the
UNIVERSITY OF WASHINGTON PRESS
Seattle & London

San Francisco Museum of Modern Art
401 Van Ness Avenue
San Francisco, California 94102-4582
Library of Congress #85–40351
Library of Congress Cataloging in Publication Data
Tsujimoto, Karen.
 Wayne Thiebaud.

 Bibliography : p.196
 Includes index.
 I. Thiebaud, Wayne—Exhibitions. I. San Francisco
Museum of Modern Art. II. Title.
ND237. T5515A4 1985 759. 13 85 – 40351
ISBN 0 – 295 – 96251 – 8
ISBN 0 – 295 – 96269 – 0 (pbk.)

Produced by Perpetua Press, Los Angeles
Printed and bound in Japan

CONTENTS

The *Wayne Thiebaud* exhibition has been made possible
by the Wells Fargo Foundation.

FOREWORD

THE YEAR 1985 MARKS THE FIFTIETH ANNIVERSARY OF
the San Francisco Museum of Modern Art. That Wayne Thiebaud is a central part of our anniversary celebration is only fitting, as he exemplifies so much of what the Museum stands for and strives to achieve. Thiebaud's insights into the process of art, its role in everyone's lives, his commitment to teaching, and the constant pursuit of his own learning are all goals that the Museum set for itself fifty years ago.

Equally important for us, however, is the opportunity to recognize and celebrate the enriching and continuing contribution Thiebaud has made through his art itself. Everyone who comes in contact with the work of the artist is enormously affected by it—it is recognizable and straightforward, and the images are rich and exuberant. Thiebaud brings to our attention the most commonplace, inducing us to discover beauty and delight in that which we so often overlook. This exhibition and catalog provide a special opportunity to view his work in depth and to begin to comprehend the basic yet intricate and complex issues of art that he confronts every day. But finally, what is paramount, of course, is that Wayne Thiebaud is an artist of great distinction whose influence ranges from coast to coast and beyond, and it is our privilege that we recognize his achievements.

For making this possible, I gratefully acknowledge on behalf of the Museum and its trustees, the Wells Fargo Foundation. Their generous support has helped make this special fiftieth anniversary project a reality.

The Museum placed its full enthusiasm and resources behind this exhibition and publication. I am grateful to Karen Tsujimoto, curator of the exhibition and author of this book, for what she has accomplished. The exhibition and accompanying publication have been organized to reflect both the range and the vitality of Thiebaud's work. The exhibition itself is a special opportunity to view firsthand images spanning almost a twenty-five-year period. The catalog is an important contribution that contains valuable insights into both the artist's life and his art. As Ms. Tsujimoto has done in

the past, she has achieved a level of accomplishment by which the Museum can be judged for years to come.

As the Museum enters its second half century, I am grateful to the many who have served the Museum so diligently and so generously in the past and at the present time. The future appears just as promising, full of plans and accomplishments, and the artists, trustees, staff, members, and those from the general public who have worked so hard and who have enjoyed the Museum so much over the years deserve the best this Museum can offer. With that charge clearly in mind, the Museum is honored in this signal year of celebration to exhibit the art of Wayne Thiebaud for them and all the world to see.

HENRY T. HOPKINS
Director

ACKNOWLEDGMENTS

ONE OF THE FINAL PLEASURES OF ORGANIZING AN EXHIBItion and book of this scope is to take the time to reflect upon the many individuals who have helped bring such a project to fruition. The time and energy expended are negligible compared to the reward of working with so many people of such goodwill and generosity. To all of these individuals I would like to express my sincere appreciation.

First and foremost I would like to thank Wayne Thiebaud and his wife Betty Jean for their cooperation throughout the organization of this project. On numerous occasions they extended their hospitality to me, supplied valuable research material, and patiently answered seemingly endless and detailed questions. My needs were substantial, and they responded amiably and generously.

I would also like to express my appreciation to Allan Stone of the Allan Stone Gallery, New York. As the artist's primary gallery dealer for the last twenty-three years, he has provided crucial support. For his insight and counsel I am truly grateful. Joan Wolff and Allison Stone Stabile of the Allan Stone Gallery have also been valued contributors to this undertaking. Their unstinting and enthusiastic cooperation in making available their files, answering my numerous questions, and overseeing many of my needs made my own task that much easier. John Berggruen of the John Berggruen Gallery, San Francisco, must also be thanked for his ongoing interest and support of this project and for providing valuable resource information.

To the lenders—whose commitment to Thiebaud is unwavering—I would like to extend my true gratitude. Their generosity and willingness to part with cherished works for such a long period of time is inestimable. Without their full cooperation this exhibition would not be possible.

Certainly one of the great joys of working on a project such as this has been the opportunity to make new friends and meet new colleagues who have freely and generously given of their time and knowledge. Gene Cooper, a leading authority on the work of the artist, not only made available useful information from his extensive resources but offered helpful

suggestions during the organization of the exhibition. L. Price Amerson, Jr., Director of the Richard L. Nelson Gallery and The Fine Arts Collection, University of California, Davis, also gave amply of his time and furnished important research information. I would also like to thank warmly Gregory Kondos, Patrick Dullanty, Jack Ogden, and Joe Draegert for taking time to reminisce with me about their friendship with the artist and share their insights into his work.

It is hoped this book will be a meaningful addition to the material already available on the artist. For making this possible, I would like to thank Donald R. Ellegood, Director, University of Washington Press, Seattle, Letitia Burns O'Connor, editor, Dana Levy, designer, and Diana Rico, copy editor. It has been a pleasure to work with individuals of such attentiveness, enthusiasm, and talent.

A project of this scope requires the goodwill and hard work of still many more people, not the least of which are my colleagues at the Museum. My deepest and greatest expression of gratitude must be given to them. It has been a privilege and joy to work with such devoted and capable individuals. Their commitment and excellent work is matched only by their warmth and good humor. I am especially indebted to my associates in the Curatorial Department who worked so closely with me and with such unflagging enthusiasm and diligence. Anne Munroe, Exhibitions and Publications Coordinator, expertly negotiated several aspects of this publication, assisted with the editing of the manuscript, and gently nudged along the production of the book. Donna Graves, Curatorial Assistant, researched and compiled the extensive exhibition history and chronology, coordinated loans, and managed a myriad of other exhibition needs. Her research into the exhibition history was substantially facilitated by the dedicated work of Kathleen Butler, Curatorial Intern. Lydia Tanji, Curatorial Secretary, organized with cheerfulness and conscientiousness numerous details concerning the exhibition and the preparation of the manuscript and photographs. James Scarborough, former Curatorial Secretary, also assisted me in the early stages of organization, and Michael Schwager, Curatorial Assistant, oversaw many day-to-day functions of the department, allowing me the flexibility to concentrate more fully on my writing. My heartfelt thanks go to these colleagues for their steadfast and spirited work.

I would also like to thank Michael McCone, Associate Director for Administration, for his sustained encouragement throughout the planning of this project, and Katherine Church Holland, former Research/ Collections and Registration Director, for her cogent comments regarding the manuscript. I am especially indebted to these two close associates for their professional expertise and personal friendship, which buoyed me through this effort. Additionally, I would like to thank Henry T. Hopkins, Director, for his support of this project from its inception, and several other staff members who have facilitated numerous other aspects of this exhibition and publication. Eugenie Candau, Librarian, compiled the bibliography; Greacian Goeke and Jo Rowlings of the Public Relations Department expertly orchestrated the demanding details of publicity; Robert Whyte,

Director of Education, and Miriam Grunfeld, Assistant Director of Education, planned the educational components; Toby Kahn, Bookshop Manager, offered sage advice concerning the book; and Diana duPont, Research Assistant, provided useful research material despite her own demanding schedule. Tina Garfinkel, Associate Registrar/Exhibitions, handled with meticulous efficiency the complex details of loans and transportation, and Julius Wasserstein, Gallery Superintendent, and his staff have, as always, expedited the installation of the exhibition with swiftness and skill.

Last, but by no means least, I would like to thank my family. To my husband, Bill Lee, goes my fondest gratitude. He has been my most acute critic and ardent supporter. To my parents, I dedicate this book.

KAREN TSUJIMOTO
Curator

This catalog was published in conjunction with the exhibition *Wayne Thiebaud*, organized by the San Francisco Museum of Modern Art. The San Francisco Museum of Modern Art is supported in part by grants from the California Arts Council, the Institute of Museum Services, the San Francisco Foundation, and the San Francisco Hotel Tax Fund.

SCHEDULE OF THE EXHIBITION:

SAN FRANCISCO MUSEUM OF MODERN ART
12 September–10 November 1985

NEWPORT HARBOR ART MUSEUM, Newport Beach, California
19 December 1985–16 February 1986

MILWAUKEE ART MUSEUM
11 April–1 June 1986

COLUMBUS MUSEUM OF ART, Ohio
19 July–31 August 1986

THE NELSON-ATKINS MUSEUM OF ART, Kansas City, Missouri
27 September–9 November 1986

LENDERS TO THE EXHIBITION

Allan Stone Gallery, New York
Anonymous Private Collections
John Berggruen, San Francisco
Mr. and Mrs. Edwin A. Bergman, Chicago
John Bransten, San Francisco
H. Christopher J. Brumder, New York
Charles and Esther Campbell, San Francisco
Crocker Art Museum, Sacramento
Mr. and Mrs. Julian I. Edison, Saint Louis
Dorry Gates, Kansas City, Missouri
Mr. and Mrs. Graham Gund
Mr. and Mrs. Richard Hedreen, Bellevue, Washington
Hirshhorn Museum and Sculpture Garden, Smithsonian
 Institution, Washington, D.C.
Malcolm Holzman, New York
Mr. and Mrs. William C. Janss, Sun Valley, Idaho
Byron Meyer, San Francisco
The Nelson-Atkins Museum of Art, Kansas City, Missouri
Mr. and Mrs. Robert Powell, Sacramento
Mr. and Mrs. Ken Siebel
Howard and Gwen Laurie Smits
Mrs. Louis Sosland
The Southland Corporation, Dallas
Mr. and Mrs. Alan L. Stein, San Francisco
Mr. and Mrs. C. Humbert Tinsman, Shawnee Mission, Kansas
Mr. and Mrs. Thomas W. Weisel, San Francisco

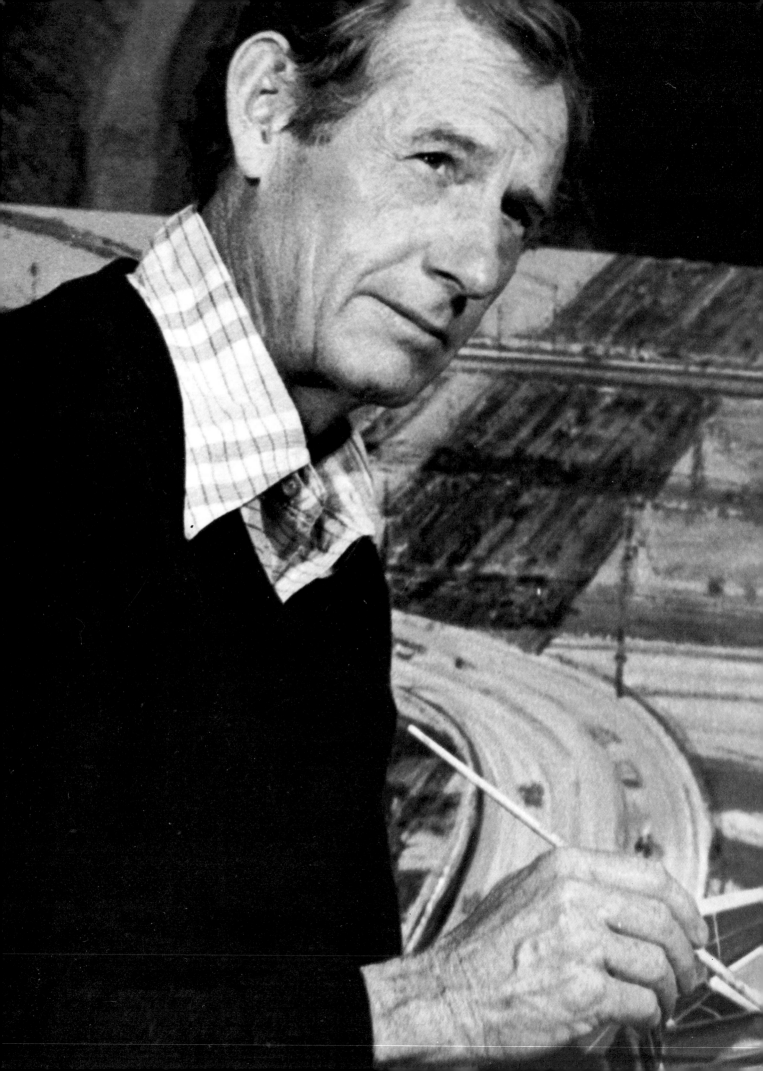

WAYNE THIEBAUD

"**I** SEE MYSELF AS A TRADITIONAL PAINTER. I'M VERY much interested in the concept of realism and the notion of inquiry into what the tradition of realism is all about."[1] In these few words, Wayne Thiebaud once summarized the creative investigation that has preoccupied him for more than twenty-five years. Yet the apparent simplicity of his intent is deceiving. As art historians, critics, and Thiebaud himself will generally acknowledge, the concept of realism is a bedeviling one. Fundamental problems arise from the different, often diametrically opposed ways in which the term is used. The relationship between a representational work of art and reality itself—how colored markings and shapes can be made to signify and suggest things beyond themselves—is equally complex. These are the issues that have continued to challenge and stimulate Wayne Thiebaud over the years; they form the essence of his work.

Ironically, when Thiebaud first gained national and international acclaim in the early sixties, it was not as a realist working in the tradition of such admired artists as Diego Velázquez, Jean Siméon Chardin, and Thomas Eakins. Writers, critics, and curators more quickly linked this painter of pies, ice-cream cones, and gumball machines to Pop Art, allying him with such contemporaries as Andy Warhol, Roy Lichtenstein, and James Rosenquist. With his modest, self-effacing personality, Thiebaud was disinclined to oppose this identification vigorously, particularly because he appreciated the public attention to his work. As he once remarked, "I think a painter is always overjoyed when anybody pays any attention to him at all, puts [him] in any category, calls [him] anything—as long as they call [him] something."[2] Thiebaud's comments are significant because initial critical acclaim came relatively late in his life. He did not decide to become a painter until he was almost thirty; several years later, at the age of forty-one, he finally reached his mature style and gained widespread recognition for it.

Wayne Thiebaud, San Francisco studio, 1982.

WAYNE THIEBAUD
FORMATIVE YEARS

MORTON WAYNE THIEBAUD WAS BORN ON 15 November 1920, in Mesa, Arizona, to Morton J. and Alice Eugenia Le Baron Thiebaud. Less than a year following the birth of their son, the Thiebauds moved to Long Beach, California, then a popular beach resort (fig. 1). The elder of two children, Thiebaud enjoyed a pleasant and ordinary childhood despite the generally difficult economic circumstances of the Great Depression. Morton Thiebaud was an inventor and engineer who supported his family as a foreman, working in the machine shop of a local creamery and at a Ford Motor Company distributor. While at the creamery, he patented an electrical milk truck with a double-sided open door that allowed the driver to make his deliveries more efficiently than before. He also designed and built the largest electric truck in the world. It ran between San Francisco and Los Angeles.

After the onset of the Depression, in 1931, the senior Thiebaud resigned from his job at the creamery and moved his family to southern Utah, where he took up ranching. They remained there until 1933, relocating within the area several times. When the ranch was lost, the family moved back to Long Beach, where the father became a safety supervisor for the city; he eventually sold real estate in the San Fernando Valley. But in spite of disruptions caused by the Depression, Thiebaud enjoyed a warm and supportive family life. On rainy days, Thiebaud's mother would give the children art projects, and their Uncle Jess, an amateur cartoonist, would often amuse them with his skills. For the most part, however, art was not an integral part of the Thiebauds' lives.

Participation in the Church of Jesus Christ of Latter-Day Saints, however, was an important cultural factor in their family life. Thiebaud's maternal grandmother was one of the original Mormon pioneers who settled in Utah in the mid-1800s, and his father, a convert, was a devoted member of the church who, along with his wife, initiated his

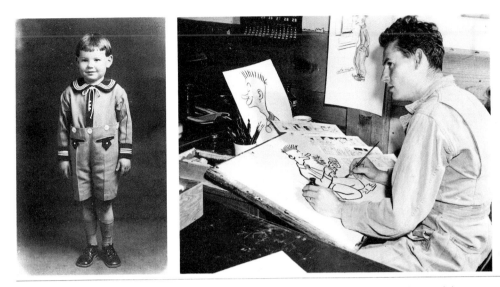

Fig. 1 Wayne Thiebaud, Long Beach, California, 1924.

Fig. 2 Corporal Wayne Thiebaud, Mather Army Air Field, near Sacramento, 1944.

children into Mormon ideology at an early age. Learning from his parents' example, the younger Thiebaud participated actively in church events and applied himself diligently to its teachings. From the age of ten, he regularly attended church classes in public speaking, drama, and chorus and participated in programs that celebrated historical Mormon events. He also became an active member of the church's Boy Scout troop, working his way up the ranks to the top echelon of the organization's hierarchy.

The energy and commitment Thiebaud gave to church-related activities was equaled by the time devoted to extracurricular events at Long Beach Polytechnic High School, which Thiebaud attended from 1936 to 1938. Thiebaud's scholastic curriculum was enlivened by his participation on the basketball team and the stage crew that supervised the school's theatrical productions. An interest in singing and playing the guitar and harmonica also emerged at this time. Thiebaud soon became accomplished enough to form a musical trio, which played at school and church socials and even performed on local radio programs.

In retrospect, it was his training and experience with the stage crew that had the most pronounced effect on Thiebaud's later work. Through an inspiring teacher, H.A. Foster, Thiebaud was introduced to the principles of theatrical production, including design theory and technical applications. Visiting behind the scenes at the Pasadena Playhouse in Southern California, creating large, multicolored backdrops, and learning to create special lighting effects and to control the overhead spotlight—the most coveted assignment among the stage crew members—were valuable lessons later applied to the stage designs Thiebaud created in the early fifties. Even more significant was the impact these visual experiences had on Thiebaud's development as a painter. As art historian Gene Cooper has noted, Thiebaud's imagery retains certain aspects of theatrical staging: the dramatic effects of light on an object, the isolation of a figure on a ground, and the deeply cast shadows on the stage.[3]

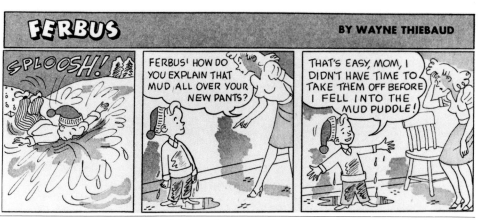

Fig. 3 "Ferbus," cartoon strip created by Wayne Thiebaud for Rexall Drug Company magazine, ca. 1946–49. Mr. and Mrs. Gregory Kondos, Shingle Springs, California.

Although Thiebaud was active in the theater arts and took some drawing and art appreciation courses in high school, the thought of becoming an artist was far from his mind. "My parents were very supportive, but they didn't know anything about painting, and neither did I," Thiebaud recalls. "In terms of what I do now, my childhood seems like a completely separate experience."[4] An interest in cartooning and illustration soon became a passion, however, and eventually led to Thiebaud's decision to study art.

At the age of sixteen, after breaking his back while participating in sports, Thiebaud began drawing. His primary interest was cartooning, an interest that he retains to this day. Though young and inexperienced, his talents were substantial enough that he was hired by Walt Disney Studios in Los Angeles, assigned to work in the animation department as an "in-betweener." The principal animator would draw a beginning and ending pose of Goofy, Pinocchio, or Jiminy Cricket, and Thiebaud would complete the frames in between. Although the opportunity to learn was substantial, Thiebaud's employment with Disney was brief; he was fired for his pro-union view and for going on strike. "I was sixteen years old and making fourteen dollars a week, working about sixty hours a week and going to school, an impossible situation," Thiebaud remembers. "It wasn't so bad for me because I was a kid, but there were people with families, and they were desperate."[5]

The political encounter at Walt Disney Studios may have left a bitter aftertaste, but the work experience ignited Thiebaud's growing interest in drawing and illustration. Shortly thereafter, while still in high school, he decided to take commercial art courses at the Frank Wiggins Trade School in Los Angeles. The school was a modest one and within Thiebaud's means: tuition was free, with admission contingent upon an acceptable portfolio. There were only two teachers, an advertising art director and a fashion and shoe illustrator. In spite of the small program and staff, it was a positive and fruitful experience for Thiebaud, as he was able to learn directly from practicing professionals.

In the few years following his graduation from high school in 1938, Thiebaud cast about. He worked as a free-lance cartoonist for

various clients and as a stage technician, usher, and occasional illustrator of movie posters at the Rivoli Movie Theater in Long Beach. He also gave college a brief try, although his primary objective in enrolling in Long Beach Junior College (now Long Beach City College) in 1940 was to pursue sports and the pleasures of fraternity life. But Thiebaud left after one year because he lost interest in school altogether.

Following this abbreviated college experience, Thiebaud found employment in 1941 as a shipfitter, working on Terminal Island, close to Long Beach. A year later, he joined the United States Army Air Force with the intention of becoming a pilot. His plans were quickly diverted when Thiebaud realized that his interests and talents in illustration could be put to good use in the military. Within the year he was transferred to Mather Army Air Field (now Mather Air Force Base) near Sacramento, where he was assigned to the Special Services Department as an army artist and cartoonist (fig. 2). The responsibilities he undertook were varied, from designing posters and executing murals to creating a cartoon strip, "Aleck," for the base's newspaper, *Wing Tips*. Later, when he was transferred to Culver City in Southern California in 1945, Thiebaud worked in the first Air Force Motion Picture Unit commanded by Ronald Reagan, which had temporarily taken over the Hal Roach Studios. There he was assigned to a secret project producing full-scale map models of Japan to assist pilots for bombing runs. After V-J Day, he worked on documentary and training films until his discharge in 1945.

Following his release from the service, Thiebaud defined more clearly his desire to become a commercial artist and cartoonist. As if in reaction to the relative calm and confinement of his army life, he hopscotched across the country, intensely exploring the many possibilities of his new career. He worked briefly as an advertising artist for a small Los Angeles firm and then traveled to New York intent on selling cartoons. Every Wednesday, he would make the rounds of the magazines with cartoons done on speculation and then return to his room at the Y.M.C.A. to draw up roughs for the following week. Trying to establish himself as a cartoonist was difficult, however, so he also sought jobs in commercial art. His experience included work in the art department of Fairchild Publications, among whose fashion-oriented publications were *Women's Wear Daily* and *Men's Wear*. Within the year, Thiebaud returned to California, worked briefly in Sacramento as a free-lance commercial artist, and finally resettled in Los Angeles.

Thiebaud worked for Universal-International Studios, based just north of Los Angeles in the San Fernando Valley. He illustrated movie posters and designed sets for publicity photographs in which actors and actresses, among them Marlene Dietrich, John Wayne, Ava Gardner, and Merle Oberon, were posed amid movie props. As before, the position did not last long; a labor strike forced his departure. Thus, in the beginning of 1946, Thiebaud once again started a new job, this time with the Rexall Drug Company in Los Angeles. He remained at Rexall for almost three years, working as a layout art director and cartoonist for the com-

pany magazine and creating a comic strip entitled "Ferbus" (fig. 3).

Beginning in 1947, during his tenure at Rexall, Thiebaud's interest shifted from commercial art to the fine arts. "The more I got interested in layout and design," Thiebaud has explained, "the more I was led to those examples in fine art from which they derived. The most interesting designs were influenced by Mondrian or Degas or Matisse. That revelation really transfixed me."[6] Hearing artists speak at seminars and art directors' meetings further piqued his interest. But more than any person or event, Thiebaud's friendship with the artist Robert Mallary ultimately shaped his decision to become a painter (fig. 4).

A sculptor, self-taught intellectual, and typographer at Rexall, Mallary had an extraordinary impact on Thiebaud. From the age of fourteen, when he had run off to Mexico to work with David Alfaro Siqueiros and José Clemente Orozco, Mallary remained a political and social activist. Although he never attended college, his knowledge—whether of art history, Karl Marx, Jean-Paul Sartre, Erwin Panofsky, or William Shakespeare—was impressive. Once chiding Thiebaud because he did not know the essential differences in point of view between Sigmund Freud and Carl Jung, Mallary encouraged his protégé to broaden his reach of life. Mallary was an avid believer in art and celebrated being an artist. Stimulated and encouraged by Mallary, Thiebaud began to read voraciously about art. He also started to paint seriously for the first time, looking consistently to Mallary for direction: "He was a mentor who tore apart what I did," Thiebaud has stated. "I welcomed it because I needed his criticism so desperately."[7]

Thiebaud's earliest works were of a Cubist-Expressionist nature, inspired by the paintings of John Marin and Lyonel Feininger, whom he had learned about through his reading, and by the work of the Italian émigré Rico Lebrun, one of the most prominent art figures in Southern California in the late forties and early fifties. The work of these artists, which shared a Cubist faceting of space and dynamic compositions of tonal washes and expressive lines, made an early impression on Thiebaud, as reflected in his untitled print of 1951 (fig. 5).

In 1948, Thiebaud participated in his first significant museum exhibition, the *Artists of Los Angeles and Vicinity* annual sponsored by the Los Angeles County Museum. A year later, Thiebaud participated in another group show, *Artists under Thirty-three*, organized by the Los Angeles Art Association. It was an exhibition of young talent selected by Lorser Feitelson, who, like Lebrun, was a leading and highly influential painter in Southern California. These experiences were exhilarating for Thiebaud and further reinforced his absorption with painting. Although by this time he was a husband and father, he could not resist the lure of taking a chance, of changing professions to become an artist. Thus at the age of twenty-nine Thiebaud returned to school to study painting.

In the fall of 1949 Thiebaud enrolled at San Jose State College (now San Jose State University) in Northern California. The follow-

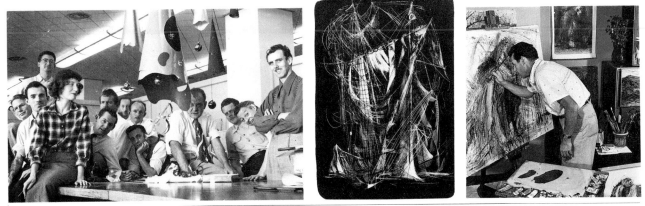

ing year he transferred to California State College (now California State University) in Sacramento, where he completed his undergraduate degree in 1951. Like many older students returning to school at the time, Thiebaud entered college on the G.I. Bill. He also received credit by showing proficiency in his work or by passing special examinations. Paradoxically, because of Thiebaud's substantial experience as a commercial artist, he waived so many of the mandatory studio classes that he essentially received no formal training in drawing and painting. The majority of the classes he took focused on art history, theory, and education. In 1951, immediately following his graduation, Thiebaud began teaching at Sacramento Junior College (now Sacramento City College) while working on his master's degree in art, which he received in 1953.

Although Sacramento has been the capital of California since 1854, it was a relatively small city with a pervasive rural atmosphere when Thiebaud moved there in the fifties. Agriculture and government were, and continue to be, its economic base. The art community was limited at best. The painter Patrick Dullanty recalls that only a handful of artists were working there in a serious fashion at the time.[8] To compensate for the lack of cultural vitality, Thiebaud quickly began to create his own. He did this through his teaching and by participating in broader civic activities: designing sets for local theater productions and creating public murals and sculptures.

Seizing the opportunity to participate fully in the art department of Sacramento Junior College, Thiebaud threw himself wholeheartedly into his new responsibilities, teaching classes in drawing, painting, color design, and art history. Later he helped to create numerous new courses ranging from commercial art and television production to special classes in the history of pre-Columbian and oriental art. In addition, he actively advised extracurricular school activities: the art club, yearbook, art ball, and several of the college stage productions.

Thiebaud also established a small film production company, Patrician Films, in the basement of his home from 1954 to 1959. He specialized in art education films geared toward junior high school audiences. Addressing complex subjects such as Expressionism, Impression-

Fig. 4 Rexall Drug Company advertising department, Los Angeles, ca. 1946–49. Wayne Thiebaud and Robert Mallary, fifth and seventh from left, respectively.

Fig. 5 Wayne Thiebaud, Untitled, 1951, lithograph, 3/20, 16⅞ × 13″ (42.9 × 33.0 cm.). Mr. and Mrs. Gregory Kondos, Shingle Springs, California.

Fig. 6 Wayne Thiebaud, Sacramento studio, ca. 1956.

ism, and nonobjective art, he condensed them into animated educational shorts—in his own words, "Cubism in six minutes."[9]

Simultaneously Thiebaud was actively involved with the design and production of local theater extravaganzas. Beginning with the production of *Embarcadero*, ca. 1951–53, a caricature of life on the San Francisco wharf for which he designed a colorful, pointillistic light show for a backdrop, Thiebaud established quite a reputation in the Sacramento area for his imaginative and elaborate stage designs. Shortly thereafter, he created the stage designs for a 1953 production of Jean Giraudoux's *The Madwoman of Chaillot*, presented at Sacramento's Eaglet Theatre (fig. 8). The sets were largely inspired by Eugene Berman, an artist and well-known stage designer then active in Southern California. In 1946, when Thiebaud was working in New York as a commercial artist, he had seen an exhibition of Berman's stage designs (fig. 7). He had responded immediately to the highly theatrical quality of Berman's work—the dark, shadowy, often decaying environments, the melodramatic use of suspended and draped fabric, and the exaggerated use of highlights—and avidly incorporated these elements into his own stage designs for *The Madwoman of Chaillot*.

From 1950 to 1959, Thiebaud also designed the annual art exhibitions for the California State Fair and Exposition, held during late summer in Sacramento. Amid the buildings displaying prizewinning tomatoes, pickled relishes, and 4-H heifers, Thiebaud orchestrated exhibits of crafts and fine arts under the direction of Grant Duggins and with the assistance of fellow Sacramento painters including Patrick Dullanty, Gregory Kondos, Jack Ogden, and Mel Ramos. The displays were often didactic: one installation featured art forms found in the everyday world, with separate displays on "Design for Fun" or "Design for Worship" that included such design examples as tennis rackets, bows and arrows, crucifixes, and candleholders.

Local commissions for public sculptures, murals, and stage designs were frequently bestowed upon Thiebaud during this time as well. During his years with the California State Fair and Exposition, he was commissioned to design several public artworks, now destroyed: a kinetic fountain created with Gerald McLaughlin, *Water Play*, 1952; an outdoor mural, 1955; and a 1956 welded sculpture, *Angel of Art*. He was also commissioned between 1953 and 1956 to design the sets for the Sacramento City Unified School District Annual Music Festival, and in 1958 he received a major commission from the Sacramento Municipal Utility District to create a large glass mosaic outdoor mural, *Water City*, for one of its buildings. The commission, like Thiebaud's paintings at the time, was characterized by a fifties postwar moderne look of painterly, Cubist-derived abstract patterns.

Despite the extraordinary demands on his time, Thiebaud's interest in painting remained vital (fig. 6). His erratic schedule, however, prevented him from concentrating on his painting for extended periods of time. It was, at best, an unsatisfactory situation, and Thiebaud consid-

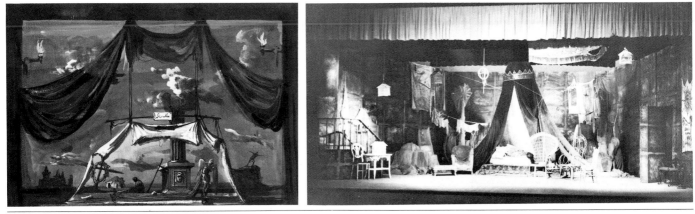

Fig. 7 Eugene Berman, *Giselle,* 1940, one of six designs for scenery, gouache on paper, 14⅜ × 22″ (36.3 × 55.9 cm.). The Museum of Modern Art, New York; Gift of Paul Magriel 60.42.3.

Fig. 8 Set design by Wayne Thiebaud for production of Jean Giraudoux's play *The Madwoman of Chaillot,* Eaglet Theatre, Sacramento, 1953. Courtesy Sacramento Theatre Company Archives.

ers much of his output prior to 1959 to be student explorations. But he exhibited wherever he could.

Thiebaud had begun seriously exhibiting his work in Northern California in 1949, the year he enrolled at San Jose State College. That year he participated in the twenty-fourth Kingsley Annual sponsored by the E.B. Crocker Art Gallery (now the Crocker Art Museum), a small museum serving the larger Sacramento Valley.[10] Initiated in 1927, the Kingsley annuals are group shows that present current work produced by local artists. Thiebaud's entry in 1949, an oil painting titled *City Patterns,* was awarded second prize in its category. Two years later, the E.B. Crocker Art Gallery presented the first solo museum exhibition of Thiebaud's work, displaying sixty works. Other one-person exhibitions were quick to follow. In 1951 the California State Library in Sacramento exhibited a selection of his graphics, and that same year he had his first solo exhibition in a commercial gallery, at the Contemporary Gallery in Sausalito, just north of San Francisco across the Golden Gate Bridge.

Despite these auspicious beginnings, the exhibition opportunities in Sacramento were limited, and Thiebaud continued to show wherever he could, sometimes in restaurants, furniture stores, and drive-in movie snack bars. Gregory Kondos, a fellow painter and close friend of the artist, humorously recalls that Thiebaud once negotiated an exhibition of his work at the snack bar of the Starlite Drive-In Theater in Sacramento in exchange for four free passes. During intermission, the two artists loitered around the snack bar hoping to overhear from the customers even the smallest comments about the works on display.[11] They took turns transporting their paintings and drawings to art shows in small neighboring towns such as Auburn or Lodi and often drove to San Francisco to enter works in the annuals sponsored by the San Francisco Museum of Art and the California Palace of the Legion of Honor.

The limitations of Sacramento's art scene seemed even more pronounced after Thiebaud visited New York in 1956–57 and encountered the numerous and vital artist-operated galleries that lined Manhattan's East Tenth Street. Inspired by what he saw, Thiebaud, along

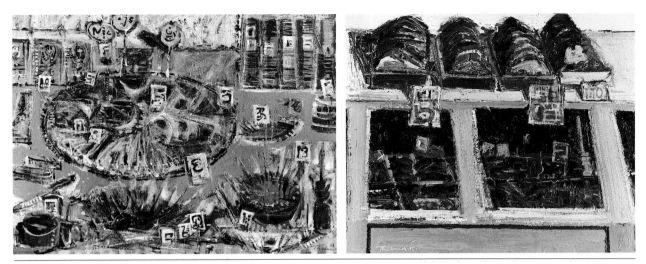

with several fellow artists, founded a small local gallery in 1958 that, as reported in the local paper, was "Sacramento's first New York–style cooperative gallery."[12] Located in a shopping center in downtown Sacramento,
the Artists Cooperative Gallery (now the Artists Contemporary Gallery)
had a membership of nineteen, with Thiebaud as the gallery's first director. The primary agenda of the gallery was to present exhibitions of its
members' work. Thiebaud exhibited there almost annually until the late
sixties.

The work Thiebaud displayed in these early exhibitions reflected his eclectic exploration of painting traditions ranging from
Byzantine art to Cubism. His first solo exhibition at the E.B. Crocker Art
Gallery in 1951 was, in fact, titled *Influences on a Young Painter* and was
systematically installed to indicate the influences of artists as diverse as
John Marin, Pablo Picasso, and C.S. Price. In one of Thiebaud's earliest
reviews, for his 1953 Los Angeles exhibition at Zivile Gallery, the critic
Jules Langsner was quick to note the artist's eclectic tendency. Thiebaud,
he wrote, is a "facile and varied talent...at work in the manner of a half-
a-dozen or so contemporaries." But at the same time, Langsner saw the
exceptional promise of a work titled *The Feast,* which, he noted, "evokes a
kind of hushed awe at the ferocity of human appetites."[13] Although it was
early in his career, Thiebaud's fascination with images of food was already
emerging, and the critical response to these paintings anticipates what was
to come in the sixties.

Many of these pictures created in the early fifties, such as
Hors d'Oeuvres, 1955 (fig. 9), denote Thiebaud's then-dominant interest in
Byzantine art and Middle Eastern culture. Thiebaud had just read Arthur
Upham Pope's essays on Persian art and was inspired by them to paint images based on Middle Eastern ritual and pageantry. Several of the paintings were based on historical photographs of heraldic Indian marches,
funerals, and feasts. Increasingly, however, Thiebaud was discovering
equivalents in his own culture: the shiny, glittering wares of America's
dime stores and shop window displays that celebrated postwar abundance.

Beginning in 1953, Thiebaud turned his attention to images of trophies, slot machines, and food and store displays—decorative and festive artifacts of contemporary society that Thiebaud saw as the last vestige of the Byzantine tradition. Stylistically these paintings are characterized by spiky, ornamental brushwork. Thiebaud also favored using metallic paints and gold or silver leaf to heighten the sense of glittering opulence.

While paintings such as *Hors d'Oeuvres* should be appreciated only as student explorations, they are important because they foreshadow issues that surface later, in Thiebaud's mature work. Thiebaud here investigates the quality of light by utilizing reflective paints and by selecting subjects that reflect light in multiple directions, such as jewelry trees and glass display cases. He also remains fascinated with the concept of ceremony. His food paintings are often observations of how our society ritualizes its gastronomic experiences: ice-cream sundaes emblazoned with a flourish of whipped cream and crowned with a bright maraschino cherry (pl. 1) and club sandwiches perfectly layered and cut into triangles (pl. 2). "I'm interested in foods generally which have been fooled with ritualistically, displays contrived and arranged in certain ways to tempt us or to seduce us or to religiously transcend us," Thiebaud explains. "There's something I find fascinating about making a circle of butter, hollowing a cantaloupe. Fish, laid out on a plain white surface, are very moving, a kind of tragedy, actually."[14] These are what Thiebaud has referred to as the "tattletale signs" of our culture, and he is absorbed with documenting them.

During the fifties, Thiebaud maintained a hectic but satisfying schedule of teaching, painting, and exhibiting. But increasingly he felt the need to focus on his personal work, particularly as the impact of Abstract Expressionism began to be felt across the country. Thus in the academic year of 1956–57, Thiebaud took a leave of absence from teaching and moved to New York. He intended to learn firsthand about Abstract Expressionism and to meet those artists he had come to admire through reading and studying reproductions in magazines, among them Franz Kline and Willem de Kooning.[15] To support himself, he went to work as an art director for two advertising agencies in Manhattan.

Abstract Expressionism was at its height when Thiebaud arrived in the fall of 1956. Although Arshile Gorky had committed suicide eight years earlier and Jackson Pollock had perished in a car accident just months prior to Thiebaud's arrival, many of the major Abstract Expressionists—de Kooning, Kline, and Barnett Newman among them—and a growing contingent of younger artists were still painting large-scale abstractions and frequenting the Cedar Bar. Along East Tenth Street, cooperative galleries exhibited a potpourri of works covering the entire range of New York School painting. The Eighth Street Club, or the Club as it was simply known, was still the lively focal point for these artists. Though the Club was governed by a voting committee, it was essentially a loosely knit group of artists who banded together to create their own audience and support group in reaction to a generally hostile public. The

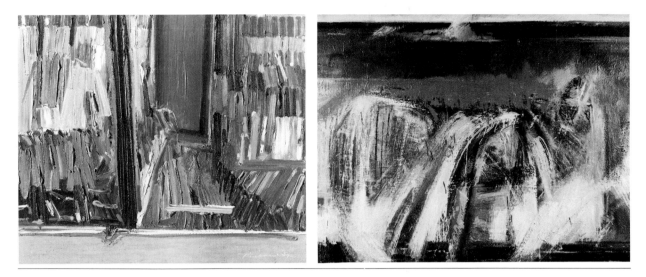

Fig. 11 Wayne Thiebaud, *Ribbon Shop*, 1957, oil on linen, 28 × 34″ (71.1 × 86.4 cm.). Private Collection.

Fig. 12 Wayne Thiebaud, *The Sea Rolls In*, 1958, oil on canvas, 36½ × 47″ (92.7 × 119.4 cm.). Crocker Art Museum, Sacramento.

Club became the core of a subculture whose purpose was as much social as intellectual, where the need of these painters to exchange ideas could be satisfied. Like many artists who flocked to New York during the fifties, Thiebaud frequented the Cedar Bar and attended discussions and parties at the Club. He met established artists such as de Kooning, Kline, and Newman, and younger painters including Philip Pearlstein, Milton Resnick, Lester Johnson, and Wolf Kahn.

The Abstract Expressionists—particularly gesture painters like de Kooning, to whom Thiebaud was most drawn—emphasized painting as an unpremeditated, risk-taking voyage into abstraction. These artists rejected the canons of Cubist structure and eliminated representational elements. They emphatically believed that if they followed the dictates of their passion during the process of painting abstractly, a more aesthetically and morally valid art would result.

While Thiebaud was privy to these philosophical and analytical discussions, he also observed that the New York painters frequently indulged in "cracker barrel" speculation. He remembers that once several painters ruminated for hours about the meaning and significance of wall-to-wall carpeting and why the local galleries were beginning to install it.[16] More important for Thiebaud were their discussions about other artists and their work. At the Cedar Bar, Kline and de Kooning talked of Rembrandt and discussed formalist issues. The New York painters also openly praised the work of unlikely colleagues, among them the realist Edward Hopper, the sculptor George Spaventa, Elias Goldberg, an American Impressionist active in the fifties, and Earl Kerkam, a relatively unknown neo-Cubist.[17] The discussions were enlightening and invigorating experiences for Thiebaud, who has always acknowledged the contribution of any and all painters, whether celebrated or obscure, contemporary or historical. "What they were interested in was heartening," Thiebaud has commented, "because it seemed to me that they were much more authentic in the way they viewed painting and its purposes than what the art world had seemed to infer."[18]

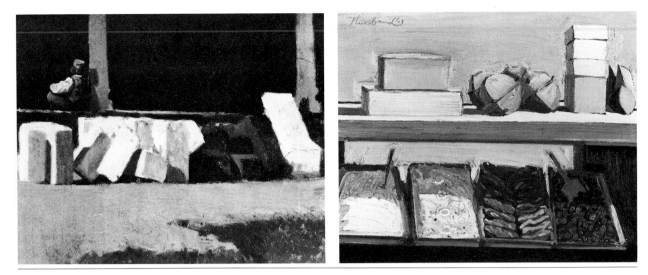

During his stay in New York and shortly after his return to Sacramento, Thiebaud executed numerous canvases based on various window displays, among them *Meat Counter*, 1955–57 (fig. 10), and *Ribbon Shop*, 1957 (fig. 11). Not surprisingly, the image of *Ribbon Shop* is more abstract and submerged in painterly strokes that strongly suggest the influence of the Abstract Expressionists. This influence is even more apparent in experimental canvases such as *The Sea Rolls In*, 1958 (fig. 12), which recalls the expansive and energized paint handling of de Kooning and Kline. But, as the title suggests, Thiebaud could never fully relinquish his grasp of realistic imagery. "I felt sort of embarrassed by the fact that I had subject matter in there," Thiebaud explains, "so I tried to cover it up with arty strokes and expressive lines, and so forth."[19]

Thiebaud discovered through this experience that representational painting was ultimately a richer and fuller means of expression for him, and he gradually returned to painting more explicitly recognizable subject matter. This recognition also coincided with his emerging interest in the work of representational painters and movements, among them the nineteenth-century Italian school I Macchiaioli, the nineteenth-century Spaniard Joaquin Sorolla y Bastida, and the contemporary Bay Area figurative painters working only a few hours away in San Francisco. Although substantial gaps of time and distance separate the work of these artists, they share one dominant characteristic to which Thiebaud was drawn: an opulent handling of paint applied to totally representational subject matter.

The Italian Macchiaioli movement flourished in Florence between 1855 and 1862. Its members included, among others, Giuseppe Abbati, Vincenzo Cabianca, Giovanni Fattori, and Telemaco Signorini. The works for which the school is best known today are small, broadly conceived plein air studies, such as Abbati's *Cloister*, n.d. (fig. 13). These intimate canvases were inspired by the artists' immediate observations of the natural world and their interest in experimenting with the effects of strong sunlight upon form and color. The root word *macchia*—translated

Fig. 13 Giuseppe Abbati, *Cloister,* n.d., oil on cardboard, 9¹⁵⁄₁₆ × 7⅝" (25.2 × 19.3 cm.). Galleria d'Arte Moderna, Florence.

Fig. 14 Wayne Thiebaud, *Delicatessen Counter,* 1961, oil on canvas, 28 × 35" (71.1 × 88.9 cm.). The Oakland Museum; Gift of Concours d'Antiques.

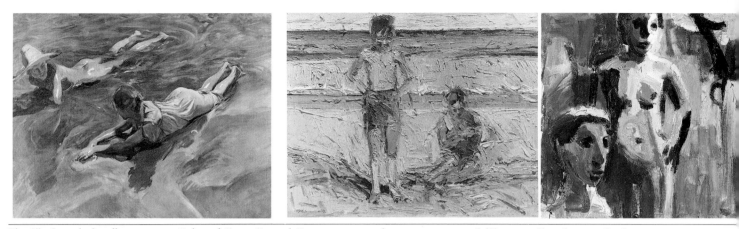

Fig. 15 Joaquin Sorolla y Bastida, *Sea Idyl*, 1908, oil on canvas, 59½ × 78½" (151.0 × 199.3 cm.). The Hispanic Society of America, New York.

Fig. 16 Wayne Thiebaud, *Beach Boys*, 1959/1960, oil on linen, 24 × 30" (61.0 × 76.2 cm.). Private Collection.

Fig. 17 David Park, *Women in Landscape*, 1958, oil on canvas, 50 × 56" (127.0 × 142.2 cm.). The Oakland Museum; Anonymous Donor Program of the American Federation of Arts.

as "sketch" or "patch"—suggests the coarse, patchlike applications of pigment that characterize these artists' work. The painting method employed by the Italians was radically economical: simple, thick strokes of paint define shapes and create vivid tonal contrasts. Early critics recognized this technique but evaluated it harshly. *I Macchiaioli* was a derisive term coined by conservative Florentine critics hostile to the work of this progressive group of young artists.

Thiebaud learned of I Macchiaioli by studying reproductions in books checked out from the California State Library in Sacramento. He was especially intrigued by what he refers to as the artists' "tracking method" of painting: how they built and heightened their compositions through thick strokes of pigment.[20] This bas relief–like brushwork appears in Thiebaud's early food paintings such as *Delicatessen Counter*, 1961 (fig. 14), and has become an identifying characteristic of the artist's work. An equally important influence was the emphasis of I Macchiaioli on light and shadow, which they arranged into distinct masses in order to achieve compositional vigor in their work. This architectonic use of light is also apparent in *Delicatessen Counter* and reveals Thiebaud's continuing interest in evoking the different qualities of light.

Because of their concern with light, I Macchiaioli painters are frequently described as proto-Impressionists. They followed a line of inquiry that anticipated the work of the French Impressionists, although the Italian artists are less well known. The work of the Spanish painter Joaquin Sorolla y Bastida (1863–1923), likewise closely linked with the French Impressionists, also exerted an early influence on Thiebaud. Born in Valencia, Sorolla's most characteristic images are local beach scenes of naked children frolicking in the water, rugged fishermen beaching their boats, and skirted women strolling along the gleaming shorelines. Like the Impressionists, Sorolla was intrigued by the possibilities of depicting the momentary effects of light and atmosphere. His characteristic works, such as *Sea Idyl*, 1908 (fig. 15), capture the brilliant warmth and radiance of the Iberian sun as it poured over his figures. Sorolla's canvases have also been celebrated for their painterly virtuosity. Critics of his generation often cited him as the heir apparent to Diego Velázquez and Francisco Goya.

There is no blending or overpainting in his images; each tone is placed directly on the canvas with quick yet fluid and assured strokes.

Thiebaud's knowledge of Sorolla came secondhand, again through his study of books from the local libraries in Sacramento. He was fascinated by the quality of light in Sorolla's images and his *premier coup* approach—the "first strike" of the paintbrush that spontaneously describes several things at once. Thiebaud completed a number of canvases, including *Beach Boys*, 1959/1960 (fig. 16),[21] that are strongly influenced by the Spanish artist. With short, rapid strokes, he lavishly worked the paint to describe simultaneously form and atmosphere: two figures suffused in glimmering, fractured luminosity. The painting breathes fresh ocean air and brilliant sunlight and directly reflects the sense of light and painterly immediacy that Thiebaud admired in the work of Sorolla and I Macchiaioli.

At the same time that Thiebaud was being influenced by these Europeans, he also became interested in the work of a number of contemporary painters living and working in the San Francisco Bay Area. Collectively identified as the Bay Area figurative painters, these artists, like Thiebaud, had previously worked in an Abstract Expressionist mode. In the early and mid-fifties, however, their work took a surprising turn toward figuration. Among those identified with this loosely formed coterie are Elmer Bischoff, Richard Diebenkorn, David Park, and Paul Wonner.[22]

These painters believed, as Bischoff once noted, that there was "more stimulous [sic] and provocation" to be found in the objective world than in purely abstract art.[23] Diebenkorn identified the reasons for this change in his own work in 1957: "I came to mistrust my desire to explode the picture and super-charge it in some way. At one time the common device of using the super-emotional to get 'in gear' with a painting used to serve me...but I mistrust that now."[24] He went on to observe: "Something was missing in the process—I sensed an emptiness—as though I were a performer. I felt the need for an art that was more contemplative and possibly even in the nature of problem solving."[25] Not surprisingly, Diebenkorn's comments reflect much of what Thiebaud was feeling at the time.

The work of the Bay Area figurative painters fuses the raw brushwork of Abstract Expressionism with representational imagery—whether a still life, a landscape, or a figure. A tree, an arm, or a coffee cup are boldly modeled with sharply contrasting pigments. Figures, as seen in David Park's *Women in Landscape*, 1958 (fig. 17), are generalized rather than made specific, and the brushwork exudes a sense of expediency. The often scabrous textures of the images reflect changes and decisions—the painting out, the correcting, the searching for the spontaneous but correct placement of forms. Although Thiebaud did not personally get to know these painters well until the sixties, he was aware of their work through local exhibitions.[26] Among the shows he saw was the land-

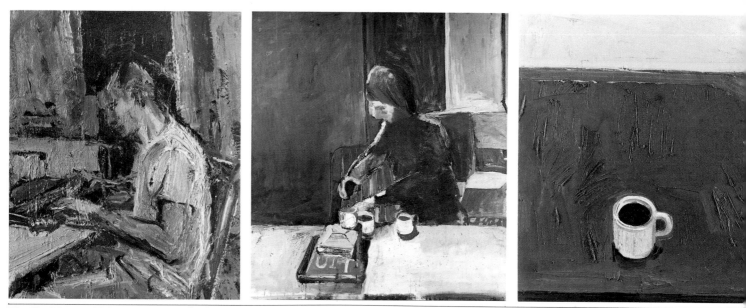

Fig. 18 Wayne Thiebaud, *Zither Player*, 1959, oil on canvas, 28 × 24″ (71.1 × 61.0 cm.). Private Collection.

Fig. 19 Richard Diebenkorn, *Girl and Three Coffee Cups*, 1957, oil on canvas, 59 × 54″ (149.9 × 137.2 cm.). Yale University Art Gallery, New Haven, Connecticut; Gift of Richard Brown Baker, B.A., 1935.

Fig. 20 Wayne Thiebaud, *Coffee*, 1961, oil on canvas, 24⅛ × 20⅛″ (61.3 × 51.1 cm.). Mr. and Mrs. Gregory Kondos, Shingle Springs, California.

mark *Contemporary Bay Area Figurative Painting*. Presented at The Oakland Art Museum (now The Oakland Museum) in 1957, the exhibition was the first to acknowledge the collective accomplishments of these painters.[27]

Paintings such as *Zither Player*, 1959 (fig. 18), indicate the influence these artists had on Thiebaud at the time. The figure, rendered in bold, rigorous strokes of paint, is stripped of individual distinction. The obvious manipulation of paint to describe form is again critical and recalls the similar painting technique that Thiebaud admired in the work of I Macchiaioli.[28] It has always remained important for Thiebaud that the artist's hand be visible in a work of art. This is reflected in his continued admiration for those figures—among them Velázquez, Eakins, and de Kooning—for whom the manipulation of paint was key. As Thiebaud once explained, "There is a long tradition of painting that I happen to admire, in which the paint is obviously manipulated by hand. That kind of coding and descriptive characteristics [are] very fundamental to my inquiry."[29]

Of the Bay Area figurative painters, Diebenkorn had the most pronounced influence on Thiebaud and continues to do so to this day. In the fall of 1960, when the California Palace of the Legion of Honor in San Francisco presented a solo exhibition of his paintings, Diebenkorn had already astonished the art world by turning from his highly acclaimed Abstract Expressionist paintings to embrace figuration.[30] The exhibition emphasized the artist's recent work in this vein and included, among other canvases, *Girl and Three Coffee Cups*, 1957 (fig. 19). Thiebaud recalls that the exhibition was a riveting experience, and he visited it many times to make sketches of the paintings on view.[31] What intrigued him about Diebenkorn's work was the calculated effort to control and organize the compositions. In *Girl and Three Coffee Cups*, for example, Thiebaud was struck by the underlying abstract structure and

the studied movement and countermovement of the composition: how the oval of the girl's head barely grazes the edge of the back wall, how the dense huddle of coffee cups is relieved by the open expanses of the tabletop and walls. Thiebaud no doubt also responded to Diebenkorn's choice of mundane household imagery, which later appears in his own paintings, such as *Coffee*, 1961 (fig. 20).

The period from 1957 to 1960 was a critical time of assimilation and evaluation for Thiebaud. His personal style of painting and many of the concepts that would occupy him in his mature period—inquiries into composition, light, and paint handling—were formulated at this time. Moreover, Thiebaud determined that objects themselves should be the focus of his attention and that his subjects should be rendered clearly and directly.

NOTES

1. Wayne Thiebaud, "As Far as I'm Concerned, There Is Only One Study and That Is the Way in Which Things Relate to One Another," *Untitled 7–8* (Carmel, Calif.: Friends of Photography, 1974), p. 24.

2. Dan Tooker, "Wayne Thiebaud," *Art International*, November 1974, p. 24.

3. For a more detailed account of Thiebaud's theater experience and the impact it has had on his work, see Gene Cooper's essay "Thiebaud, Theatre, and Extremism," in *Wayne Thiebaud: Survey 1947–1976* (Phoenix: Phoenix Art Museum, 1976).

4. Thiebaud, correspondence with the author, 20 December 1984.

5. John Arthur, *Realists at Work* (New York: Watson-Guptill, 1983), p. 116.

6. Mark Strand, ed., *Art of the Real: Nine American Figurative Painters* (New York: Clarkson N. Potter, 1983), p. 181.

7. Thiebaud, correspondence with the author, 20 December 1984.

8. Patrick Dullanty, interview with the author, Sacramento, 12 July 1984.

9. Cooper, "Thiebaud, Theatre, and Extremism," p. 20.

10. Prior to his decision to become a painter, Thiebaud had exhibited once in Northern California, while he was still in the service, in the *Twentieth Annual Local Exhibit* at the Crocker Art Gallery in 1945. As "Sgt. Wayne Thiebaud," he submitted two works: *Grandpere*, n.d., an oil, and *Put to Pasture*, n.d., a watercolor. Inconsistent numbering of the annuals in the early years accounts for the discrepancy in exhibition dates.

11. Gregory Kondos, interview with the author, Shingle Springs, Calif., 15 July 1984.

12. John C. Oglesby, "Cooperative Gallery Has Stimulating First Show," *Sacramento Bee*, 3 May 1958, p. L-23.

13. Jules Langsner, "Art News from Los Angeles: Thiebaud and Texas," *Art News*, December 1953, p. 66.

14. Thomas Albright, "Wayne Thiebaud: Scrambling Around with Ordinary Problems," *Art News*, February 1978, p. 86.

15. Between 1951 and 1959, while teaching at Sacramento Junior College, Thiebaud organized an almost annual travel program to New York for students and faculty to visit museums, galleries, and artists' studios. Because of this program, Thiebaud was able to keep abreast of developments occurring on the East Coast.

16. Arthur, *Realists at Work*, p. 116.

17. Thiebaud, interview with the author, Sacramento, 21 May 1984.

18. Thiebaud, correspondence with the author, 20 December 1984.

19. Tooker, "Wayne Thiebaud," p. 22.

20. Thiebaud, interview with the author, Sacramento, 21 May 1984.

21. The notation "1959/1960" indicates that the painting has been inscribed with more than one date by the artist. Thiebaud often reworks pieces, sometimes over an extended

period of time, as in *Fish on Platter,* 1964–80 (pl. 12), and *Wedding Cake,* 1973–82 (pl. 30).

22. Park began painting figuratively in 1950, Bischoff and Diebenkorn in 1952 and late 1955, respectively.

23. Dore Ashton, "Art: Elmer Bischoff's Paintings at the Staempfli," *New York Times,* 8 January 1960, p. 22L.

24. Paul Mills, *Contemporary Bay Area Figurative Painting* (Oakland: The Oakland Art Museum, 1957), p. 12.

25. Gerald Nordland, *Richard Diebenkorn: Paintings and Drawings, 1943–1976* (Buffalo, N.Y.: Albright-Knox Art Gallery, 1976), p. 26.

26. Thiebaud recalls that he never met Park, who died in 1960, and that he did not meet Diebenkorn until approximately 1964 or 1965, when making prints in Oakland at Kathan Brown's Crown Point Press (Thiebaud, interview with the author, Sacramento, 12 February 1984). Though they did not meet until the mid-sixties, Diebenkorn remembers jurying an exhibition at The Oakland Art Museum (now The Oakland Museum) in the late fifties in which Thiebaud was awarded first prize for one of his impressionistic beach scenes (Diebenkorn, correspondence with the author, 30 July 1984). Thiebaud recalls meeting Bischoff in the late fifties when he took classes at the San Francisco Art Institute (Thiebaud, interview with the author, Sacramento, 12 February 1984). Paul Wonner and Thiebaud met in approximately 1957 or 1958, when Wonner was working in the library of the University of California, Davis, but they did not become better acquainted until ten or fifteen years later (Wonner, correspondence with the author, 4 August 1984).

27. The exhibition, which took place in September 1957, was organized by curator Paul Mills. In addition to the work of Bischoff, Diebenkorn, Park, and Wonner, it featured paintings by Joseph Brooks, William A. Brown, Robert Downs, Bruce McGaw, Robert Qualters, Walter Snelgrove, Henry Villierme, and Jim Weeks.

28. The critic Thomas Albright has suggested that I Macchiaioli were an influence on the Bay Area figurative painters. However, the author's correspondence with Bischoff (18 July 1984), Diebenkorn (30 July 1984), and Wonner (4 August 1984) does not confirm this.

29. Arthur, *Realists at Work,* p. 120.

30. *Paintings by Richard Diebenkorn,* 22 October–27 November 1960. No catalog was published.

31. Thiebaud, interview with the author, Sacramento, 12 February 1984.

WAYNE THIEBAUD
MATURE WORK

THE DEVELOPMENT OF THIEBAUD'S MATURE STYLE coincided with his appointment in 1960 as an assistant professor of art at the University of California in Davis. The university encouraged and expected individual work. This fact, coupled with a lighter teaching schedule than at Sacramento Junior College, allowed him to concentrate for the first time on a series of paintings. From 1960 to 1962, Thiebaud produced hundreds of sketches, drawings, and oil paintings that focused on such unremarkable subjects as pies, cakes, club sandwiches, and candy machines. He worked exclusively from memory, never directly from objects, throughout this period. He also reworked many of his earlier paintings, simplifying structure, masking out busy backgrounds, and isolating fewer objects against simple backdrops of color. This prolific period marks the beginning of the artist's mature oeuvre.

Thiebaud's experience in commercial art enhanced his ability to work from memory. As an illustrator and cartoonist, he had developed the ability to compose a layout at a moment's notice—a skill still evident in his untitled drawing of 1974 (fig. 21). As an advertising art director, he had also learned to communicate through a lexicon of everyday objects. "Working from memory, I tried to arrange [the objects] in the same way that an art director arranges things," Thiebaud has said. "I wasn't that different from an art director except that I had more time, and I tried to be more careful, tried to be more refined and interesting in terms of relationships."[1]

The imagery Thiebaud created during this period spanned a wide range of contemporary food displays. He painted hamburgers, plates of bacon and eggs, roast beef dinners (fig. 22), hot dogs (pl. 11), barbequed chickens, salt and pepper shakers, cakes, pies (pl. 3), and candy machines (pl. 4). Regardless of the subject matter, Thiebaud's declared interest was a thorough investigation of formal issues. Although

his choice of subjects verged on the outlandish, he was spurred on by an almost stubborn belief in the tradition of modernism: that one should be able to make art out of anything. If Duchamp could claim a urinal as modern sculpture, why question Thiebaud's paintings of gumball machines and cream pies?

Thiebaud recalls sitting and laughing after painting his first row of pies, thinking that surely this was the end of him as an artist. By this time he had developed a small following in Sacramento, and, as he expected, they abandoned him with this change in his work. Yet for the first time Thiebaud felt at ease with his painting. "I worked freely on things that in the past I had worried about intensely," he recounts. "It was such a joy to find a release."[2]

By early 1961, Thiebaud had completed more than 100 paintings, drawings, and sketches. It was now time, he felt, to test his work on a broader audience. His new paintings premiered in a one-man exhibition in Sacramento at the Artists Cooperative Gallery in the spring of 1961. The response was a disappointment. The change in his work was too radical for a public accustomed to his earlier landscape and figurative paintings, and few sales were made. Despite the faltering interest of his local patrons, Thiebaud procured an exhibition in San Francisco later that same year at Art Unlimited, a small gallery located off Grant Avenue.[3] Thiebaud had previously exhibited in the large annuals sponsored by the San Francisco museums, but this was the first solo show of his mature work in the city.[4] It should have been an auspicious event, but again the response was disheartening. No sales were made, and only a one-paragraph review appeared in the local paper, describing Thiebaud as looking like "the hungriest artist in California."[5]

At the same time that he was pursuing exhibitions in Northern California, Thiebaud also determined to seek a gallery show in New York. In the summer of 1961, he packed his car with paintings and drove cross-country with Mel Ramos, a fellow Sacramento artist. The work of the Abstract Expressionists still dominated the attention of Manhattan galleries and museums. Paintings of hot dogs and ice-cream cones seemed absurdly out of place, and the general response by New York dealers was overwhelmingly negative. The exception was Allan Stone of the Allan Stone Gallery.

Thiebaud had been encouraged by Mallary, who was represented by the gallery, to show his work to Stone. In 1960 Stone had opened his new gallery in a townhouse on East 82nd Street and focused on the work of contemporary American artists, many of them young and unknown.[6] Upon seeing Thiebaud's paintings, his initial response was ambivalent. "When I first saw his work...it absolutely buffaloed me. I didn't know what to make of it," he has recalled.[7] Coincidentally, Stone had just been to Andy Warhol's studio but decided against exhibiting the work of the young artist: "There was something about [his] work that was a little flat for me....I liked the kind of surface and the lushness [of Thiebaud's

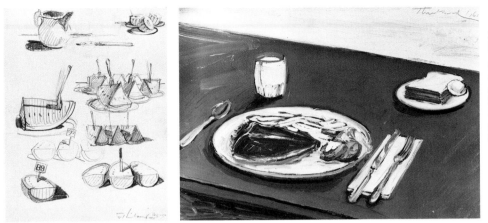

Fig. 21 Wayne Thiebaud, Untitled, 1974, pencil on paper, 11³⁄₁₆ × 8⁹⁄₁₆″ (28.5 × 21.8 cm.). The Corcoran Gallery of Art, Washington, D.C.; Gift of The Honorable William H.G. Fitzgerald, Mr. Desmond Fitzgerald, and Mr. B. Francis Saul II.

Fig. 22 Wayne Thiebaud, *Trucker's Supper*, 1961, oil on canvas, 20¼ × 30⅛″ (51.4 × 76.5 cm.). Private Collection.

work].... You sense a love of paint and surface,...there's a real joy of painting, a joy of life in his work."[8] Ultimately, Thiebaud's paintings made a positive and lasting impression on Stone. A few months after their meeting, Thiebaud was offered his first one-man show in New York, scheduled for April 1962 (fig. 23).

The response to the exhibition was phenomenal. The Museum of Modern Art in New York and several prestigious private collectors purchased work from the exhibition. Equally significant was the extensive national attention paid to Thiebaud and his work. Articles appeared in *The New York Times*, the *New York Post*, and several important national magazines, including *Time, Life, The Nation, Art News*, and *Art International*. Critics recognized Thiebaud as a promising new talent more readily than the commercial art world had, but their writing centered on the social implications they perceived in his work. Reviewing the exhibition in *The New York Times*, Brian O'Doherty saw Thiebaud as the "wordless poet of the banal" whose work, like that of Edward Hopper's, he felt commented on "the comfortable desolation of much American life."[9] Thomas Hess claimed in *Art News* that Thiebaud's "deadpan observations of supermarket delights" were "major social criticism made visual." Hess went on: "Looking at these pounds of slabby New Taste Sensation, one hears the artist screaming at us from behind the paintings, urging us to become hermits: to leave the new Gomorrah where layer cakes troop down air-conditioned shelving like chloresterol [*sic*] angels, to flee to the desert and eat locusts and pray for faith. [Thiebaud] preaches revulsion by isolating the American food habit."[10]

While Thiebaud did not fundamentally agree with the critics, his work was propelled before the public on the crest of an artistic wave then overtaking New York. This wave eventually became known as Pop Art. Thiebaud's entrée into the New York art scene coincided with exhibitions of other artists' work that emphasized mass-produced, consumer imagery—among them Jim Dine, Roy Lichtenstein, Andy Warhol, Claes Oldenburg, and James Rosenquist. By early 1962, Lichtenstein, Dine, and Rosenquist, like Thiebaud, had also had important one-person shows in Manhattan. These artists' new and radical work, which used

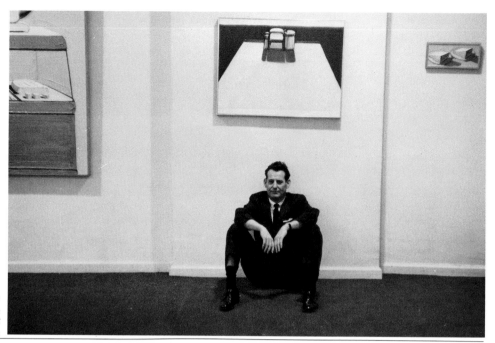

soup can, comic strip, and billboard imagery, quickly became the cele-
brated style of the early sixties. Their work not only caught the attention
of museums and collectors but also proved instantly appealing to youthful,
consumer-oriented Americans. Mass-media publications ranging from *La-
dies Home Journal* to *Time* magazine avidly publicized the movement. In
May 1962, *Time* named Thiebaud one of the leading innovators in the
"slice-of-cake school," along with Lichtenstein, Rosenquist, and Warhol.
"Unknown to one another," the magazine reported, "a group of painters
have come to the common conclusion that the most banal and even vulgar
trappings of modern civilization can, when transposed literally to canvas,
become Art."[11] A month later, a four-page color article appeared in *Life*
magazine touting the work of these artists and prominently featuring a
Thiebaud painting.[12]

　　　　Exhibitions reporting on this new style were mounted
quickly throughout the country, although there was initially confusion on
what to call the movement. These artists were variously referred to as
Kitschniks, American Dreamers, Commonists, New Realists, and neo-Da-
daists. Eventually the English term *Pop Art* was adopted. Regardless of
what this new aesthetic was called, Thiebaud figured prominently in the
exhibitions, reviews, and discussions taking place.

　　　　Given the subject of Thiebaud's paintings—mass-produced
foodstuffs—it is not surprising that he was so quickly linked with the New
York Pop artists. But in comparing the concerns of these artists with those
of Thiebaud, there are substantial distinctions to be made. Pop Art is
essentially about signs and sign systems, their translatability, and their
commonality. Pop artists did not simply portray common objects but oper-
ated one step removed from reality. Life as represented by comic strips or

advertisements bears little resemblance to the real world, but Pop artists adopted this detached point of view. The images they dealt with already existed as signs, whether they were photographs of movie stars, brand name canned goods, or comic strip heroes. They are, in Lawrence Alloway's words, "precoded material" that, when put in a new context by the artist, can function simultaneously as a sign of popular culture and as art.[13]

An important distinction between Thiebaud's work and Pop Art is seen in the handling of paint. The Pop artists minimized personal nuances and evidence of the artist's hand. Photographed, silk-screened, and stenciled images and flat applications of paint were generally employed to convey a passive and detached point of view. This impersonal approach was intended to reinforce the sense of anonymity and standardization encouraged by our mass-media culture. Thiebaud, by contrast, loves the manipulation of paint. It is a passion that stems from his early interest in painterly artists ranging from Sorolla to de Kooning.

Furthermore, while Pop artists were preoccupied with signs and sign systems, Thiebaud was, and remains, absorbed with objects per se, the visual perception of them, and the translation of this perception onto canvas. The iconoclasm of artists such as Warhol or Lichtenstein is foreign to Thiebaud, who has always and openly admired those artists who have helped mold the tradition of realist painting. Among them he cites Velázquez, Vermeer, Chardin, Eakins, and Hopper.

Thiebaud's approach to painting in many respects parallels that of the nineteenth-century French realists more closely than that of the sixties Pop artists. It is ironic that when he initially achieved acclaim his work was perceived as Pop Art rather than as grounded in the tradition of modernist French realism established by Gustave Courbet, Édouard Manet, Edgar Degas, and others. In 1861 Courbet declared that "painting is an essentially *concrete* art and can only consist of the presentation of *real and existing things*. It is a completely physical language, the words of which consist of all visible objects; an object which is *abstract*, not visible, non-existent, is not within the realm of painting."[14] Courbet characteristically rejected all metaphysical or histrionic overtones because, as he reasoned, he could never paint an angel since he had never seen one.

Thiebaud, like Courbet, works within these limitations, basing his art exclusively on observations and memories of real and existing things. He paints, not out of a sense of interpretive necessity or metaphysical prejudice, but rather to investigate the object as a nonextrapolative force. There is little room for subjectivity in his work. Early in his development he rejected the tenets of Abstract Expressionism to concentrate instead on the phenomenon of visual perception and how visual information is translated into a representational work of art. Another compelling concern of Thiebaud's is the issue of abstraction as a basic force of realism. "The interesting problem with realism [is] that it seem[s] alternately the most magical alchemy on the one hand, and on the other the most abstract construct intellectually," Thiebaud has observed.[15] "You

can enliven a construct of paint by doing any number of manipulations and additions to what one sees. This makes it possible for representational painting to be both abstract and real simultaneously."[16] It is this perception, modification, and communication of visual information that forms the essence of Thiebaud's realism.

The goal of the French painters was to translate and document the customs, ideas, and appearance of their own epoch. In their choice of subject matter, the artists particularly emphasized the ordinary and prosaic. Degas—an artist highly regarded by Thiebaud—reiterated in both word and action his passion for concrete, direct observation and the notation of humble experiences and things. He chose his subjects— whether a milliner's shop, a ballet dancer, or a washerwoman—precisely because they were little appreciated and of his time. With his peers, Degas chronicled what Baudelaire termed the "heroism of modern life."

Thiebaud is also a chronicler of his times: "I try to find things to paint which I feel have been overlooked, maybe a lollipop tree has not seemed like a thing worth painting because of its banal references, …more likely it has previously been automatically rejected because it is not common enough. We do not wish it to be *the* object which essentializes our time….It seems to me that we are self-conscious about our still lifes without good reason. It is easier to celebrate the copper pots and clay pipes of Chardin or to pretend that our revolutions are the same as the ones expressed in the apples of Cézanne. We are hesitant to make our own life special,…set our still lifes aside,…applaud or criticize what is especially us. We don't want our still lifes to tattle on us. But some years from now our foodstuffs, our pots, our dress, and our ideas will be quite different. So if we sentimentalize or adopt a posture more polite than our own we are not having a real look at ourselves for what we are."[17]

Among Thiebaud's early critics, Max Kozloff was the most insightful in discerning the artist's link to traditional realist painting. Reviewing Thiebaud's first New York show for *The Nation*, Kozloff described him as a painter working with all the virtuosity of Édouard Manet or Giorgio Morandi. More important, Kozloff saw him as vivifying a traditional but languishing subject matter: the still life. "Thiebaud's is not exactly a heroic vision of still life," he wrote. "Yet even his modest lollipop is a personage of sorts….Thiebaud leaps back in time, yet stays modern by giving us food for the common man."[18]

It was only one exhibition among many, but Thiebaud's 1962 New York debut at the Allan Stone Gallery caused quite a stir. Given the success of the show, his subsequent paintings surprised those who had neatly labeled him a Pop artist. Although he continued to paint still lifes, Thiebaud began to focus more on figure painting beginning in 1963. For the next three years he turned his attention almost exclusively to this subject. In 1966 he shifted his emphasis to landscapes and introduced a radical change in medium: the thick impastoes of his early oils gave way to thinly stained acrylics or combinations of oil, pastel, and charcoal. Then, in the seventies, he created the San Francisco cityscapes, which again confounded his critics and admirers alike.

Thiebaud tends to minimize what others see as being dramatic shifts in his painting. Often he will work and exhibit simultaneously in all three areas, although he may emphasize one subject over another. "I don't make a lot of distinctions between things like landscape or figure painting," he says, "because to me the problems are inherently the same— lighting, color, structure, and so on—certainly traditional and ordinary problems."[19] But because he keeps changing motifs, many critics have seen Thiebaud as a moving, erratic target. "My work does seem to change," Thiebaud acknowledges, "but it's a cyclic change in a number of ways. It's a tightrope walk between the development of a convention that seems to answer a problematic demand and the need to avoid a formula that devitalizes the work by repetition and prejudice. Or how can a painter refresh himself by staying open to genuine questions?"[20]

NOTES

1. Strand, *Art of the Real*, p. 188.

2. John Coplans, *Wayne Thiebaud* (Pasadena, Calif.: Pasadena Art Museum, 1968), p. 30.

3. Art Unlimited was directed by Wanda Hansen, one of the early and ardent gallery dealers who supported the work of Northern California artists. Hansen, along with Diana Fuller, eventually established the Hansen-Fuller Gallery in San Francisco.

4. Thiebaud had an early one-person exhibition at Gump's Gallery in San Francisco in 1954.

5. Alfred Frankenstein, "Impressive Shows at Legion of Honor," *San Francisco Chronicle*, 29 December 1961, p. 23.

6. Stone moved his gallery to its present East 86th Street location in 1962, where Thiebaud had his first show.

7. Price Amerson, *Interview with Allan Stone on Wayne Thiebaud*, New York, February 1981. Unpublished transcript, p. 1A. Courtesy Richard L. Nelson Gallery and The Fine Arts Collection, University of California, Davis.

8. Ibid., p. 4A.

9. Brian O'Dherty (*sic*), "Art: America Seen through Stomach," *New York Times*, 28 April 1962, p. 22.

10. T[homas] B. H[ess], "Wayne Thiebaud," in "Reviews and Previews," *Art News*, May 1962, p. 17.

11. "The Slice-of-Cake School," *Time*, 11 May 1962, p. 52.

12. "Something New Is Cooking," *Life*, 15 June 1962, p. 115.

13. Lawrence Alloway, *American Pop Art* (New York: Collier Books, 1974), p. 7.

14. Linda Nochlin, *Realism* (New York: Penguin Books, 1971), p. 23.

15. Strand, *Art of the Real*, p. 189.

16. Ibid., p. 192.

17. Thiebaud, "Is a Lollipop Tree Worth Painting?," *San Francisco Sunday Chronicle*, 15 July 1962, *This World*, p. 28.

18. Max Kozloff, "Art," *The Nation*, 5 May 1962, p. 406.

19. Albright, "Scrambling Around," p. 85.

20. Strand, *Art of the Real*, p. 192.

WAYNE THIEBAUD
STILL LIFES

THIEBAUD'S STILL LIFES FORM THE LARGEST PORTION of the artist's oeuvre. Certainly the best-known images within this genre are the paintings of mass-produced foodstuffs. But since the early sixties he has also focused his attention on a range of nonedible subjects dazzling in its diversity—from pinball machines to flowers, from cosmetics to tools, from toys to ties. Collectively these paintings are a veritable encyclopedia of modern accoutrements and taste. Despite the wide range of subject matter, however, there is a unifying structure: through his still lifes Thiebaud investigates very traditional painting problems of composition, light, color, and scale.

The subject of Thiebaud's first mature still lifes—*Club Sandwich*, 1961 (pl. 2), *Pies, Pies, Pies*, 1961 (pl. 3), and *Confections*, 1962 (pl. 1)—was food. His reasons for choosing these subjects drawn from window displays and cafe counters were threefold. In part his paintings reflect a cultural chauvinism: Thiebaud was not just claiming any still life object to paint, his subjects are unequivocally American. Like Chardin, with whom he has been compared, Thiebaud has revived the still life that celebrates the ordinary of his time. "Chardin has taught us that a pear is as alive as a woman, a kitchen crock as beautiful as an emerald," Marcel Proust once observed of this nineteenth-century painter.[1] In his own way, Thiebaud likewise has brought the commonplace to our attention. The artist remembers when he worked in restaurants as a young boy in Southern California "seeing rows of pies, or a tin of pie with a piece cut out of it and one piece sitting beside it. Those little *vedúta* in fragmented circumstances were always poetic to me."[2] This choice of food as his subject matter also afforded Thiebaud a degree of artistic autonomy that he found liberating. When he began painting these subjects in the early sixties, he was unaware of other artists working in this vein and so experienced an element of freedom that he had lacked during his Abstract

Detail, *California Cakes*, 1979 (Pl. 37)

Expressionist experiments. Finally, the food paintings were a vehicle for Thiebaud to reapproach basic formal concerns. He eliminated the busy expressionistic surfaces from his paintings to focus on three rudimentary shapes: the rectangle, the triangle, and the circle or ellipse. He selected subjects that mimicked these shapes: a club sandwich, for example, was seen simply as a series of triangles on a round platter. Working within these self-imposed limitations, Thiebaud explored a variety of compositional problems.

In paintings such as *Pies, Pies, Pies,* Thiebaud used a serial composition to study the dialectic between systematic repetition and individual variation. These platoons of pastries suggest rather obvious notions about conformity and standardization. Critics were quick to notice this quality and readily placed Thiebaud in the company of artists such as Andy Warhol. The serial composition was, in fact, predetermined by the mass-produced, consumer-oriented window displays from which the image was drawn, as were Warhol's. But whereas Warhol documented standardization, Thiebaud explored the ideas of repetition and variation—the duality between the conceptual notion of conformity in the rows of pies and what is actually perceived. Conceptually, the serial format suggests uniformity and predictability. In reality, each slice of pie can be perceived as slightly different: one slice is more squat than another, the meringue of one pie is fluffier than its twin. This juxtaposition of similarities and dissimilarities and the ability to discriminate between the two fascinated Thiebaud.

Thiebaud's inquiries into other formal problems have been far ranging and suggest the shared interests of artists as disparate as Giorgio Morandi and the Minimalists. In paintings such as *Three Cold Creams,* 1966 (pl. 14), for example, Thiebaud investigates how to create a sense of physical pressure through the manipulation of compositional elements, an issue later addressed in his cityscapes. The problem of how to gain pressure in a visual language is, of course, the same question with which Morandi so exquisitely grappled. In Morandi's intimate *Still Life,* 1953–54 (fig. 24), the small vases and tins appear squeezed and compressed together by an invisible vicelike force without quite enough room to exist. In *Three Cold Creams,* Thiebaud creates a similar tension by crowding the two jars on the right so closely that they appear almost fused to each other. In contrast, the single jar on the left is placed uncomfortably close to the edge of the canvas, heightening the sense of spatial imbalance.

Another ongoing interest of Thiebaud's has been to experiment with the spatial orientation of his images: how a painting can be made to suggest deep space, flatness, or any degree in between. Many of his still lifes—*Cream Soups,* 1963 (pl. 8), and *Various Cakes,* 1981 (pl. 36), for example—are based on a receding plane, the images moving back in deep space like a landscape. Other paintings are based on a vertical orientation and focus on objects hanging on a wall; among these are *Five Hammers,* 1972 (pl. 26), and *Yellow Dress,* 1974 (pl. 32). In still another

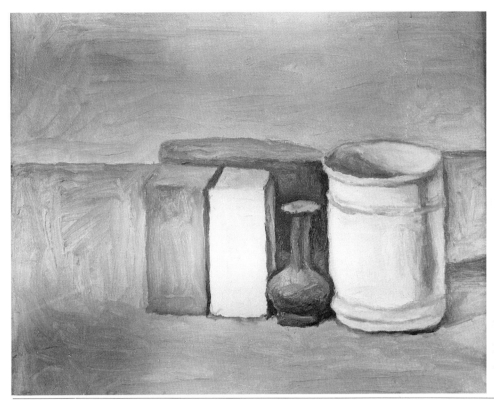

Fig. 24 Giorgio Morandi, *Still Life*, 1953–54, oil on canvas, 12 × 15⅞″ (30.5 × 40.2 cm.). The Saint Louis Art Museum; Gift of Professor and Mrs. Theo Haimann.

series of paintings begun in the early seventies, Thiebaud shifted his perspective to an aerial view, as seen in *Pastel Scatter*, 1972 (pl. 29), and in a 1971 untitled image of a screwdriver, light bulb, and roll of tape (pl. 27). Collectively, these individual investigations laid the groundwork for the more complex spatial compositions of Thiebaud's later cityscapes, in which multiple perspectives are combined in a single painting.

In contrast to the rigorously structured composition of paintings such as *Three Cold Creams*, the objects in *Pastel Scatter* and the untitled image of a screwdriver, light bulb, and roll of tape appear randomly, almost carelessly, scattered across the picture plane. Although these latter paintings are filled with objects, they are not strictly still life studies in perspective. The paintings are equally about the negative space between shapes and the edges of the image that contain them.

This emphasis on edges and negative space can also be found in the work of artists such as Sam Francis and Morris Louis, but Thiebaud's images reflect more directly the formal concerns of the Minimalists who emerged in the sixties as the impact of Pop Art began to wane. The Minimalists grappled with the problem of structuring their work, whether painting or sculpture, without recourse to internal hierarchies of form. Carl Andre's *Spill (Scatter Pieces)*, 1966, a work in which small plastic tiles were scattered on a gallery floor, is typical of the compositions emphasizing overall distribution and a greater awareness and utilization of negative space that these artists favored. The environment itself became a critical component of the Minimalists' work: in

asserting the holistic character of their paintings and sculpture, the edges of the canvas, the floor, and the walls became integral parts of their compositions. The subjects of Thiebaud's still lifes, such as the untitled image of a screwdriver, light bulb, and roll of tape, are far removed from the austere geometric forms that characterize the work of the Minimalists, but they address the same formal and compositional issues. The elevated perspective flattens space and enhances a nonhierarchical reading of forms. The painting is not to be seen or analyzed in terms of small or large parts; the total field is the unit of meaning. Thiebaud disguises his conceptual approach to art in representational form.

Often, as in the case of his early images of pies and cakes, Thiebaud explores the same subject in endless compositional variations. He experiments with changing the number of pie slices, their size, or their placement within the canvas, moving them close to the edges, bringing them to the middle, or encasing them in glass (fig. 25). He continues this practice in even more recent work, as seen in *California Cakes*, 1979 (pl. 37), and *Various Cakes*, 1981 (pl. 36). Thiebaud has always been curious about how an image is transformed in different media as well—how images change when rendered in color versus black and white or with a textured rather than a flat surface. Thus, he frequently executes the same subject in several media: ink, pencil, charcoal, pastel, and different printmaking techniques (fig. 26).[3] He also reinvestigates older, familiar images, as in his recent dark paintings of candy apples and lipsticks (pls. 39, 40). Although his subjects are mass-produced consumer goods, Thiebaud is married to the traditional idea of working compositions out slowly and coming to know his subjects with some depth and care. Thiebaud's experimental nature recalls Paul Valéry's comment on Degas, who possessed a similarly inquisitive mind. "Art for [Degas]," Valéry observed, "was simply a series of problems in a more subtle kind of mathematics than the real one....He would say a picture is the result of a *series of operations*."[4]

When Thiebaud's paintings were first seen in the early sixties, critics and the public alike were quick to respond to their delectable and confectionary look. One critic observed, "By some alchemy... Thiebaud does not seem to be working with oil paint at all, but with a substance composed of flour, albumen, butter, and sugar."[5] Manipulating the paint to look like the substance of the image is a Thiebaud trademark that he calls "object transference."[6] He remains fascinated with the magic of paint, how an artist can use oil pigment to describe so many objects in such different ways. He has long admired, for example, Chardin's ability to describe in paint the softness of rabbit hair, the sheen of copper pots, or the dull texture of clay pipes. Throughout his oeuvre, Thiebaud has likewise explored ways to convey different textures with paint. His most celebrated experiments are his tableaux of foodstuffs in which paint mimics a squiggle of mustard on a hot dog (pl. 11) or the creaminess of cake frosting (pls. 23, 37). In his landscapes, Thiebaud has also been interested in molding a rock out of pigment to capture the textures that

Fig. 25 Wayne Thiebaud, *Two Pies*, 1961, oil on canvas, 14⅜ × 16″ (36.5 × 40.6 cm.). Sacramento City College Permanent Art Collection.

Fig. 26 Wayne Thiebaud, *Pies*, 1961, india ink on paper, 19 × 24⅞″ (48.3 × 63.2 cm.). Rose Art Museum, Brandeis University, Waltham, Massachusetts; Gift of the Friends of the Rose Art Museum Acquisition Society.

exist in nature. And in his cityscapes, such as *Freeways*, 1978 (pl. 71), he evokes the tarry blackness of city streets and the sooty pollution of our urban centers.

Thiebaud discovered, however, that simulating pumpkin pie was not simply a matter of mixing together ochre and orange. When he mixed the logical colors and applied them to the canvas, the colors were flat and lacked the vitality of "pumpkinness." Part of the problem, Thiebaud learned, was that the artist has to compete with the real world. "When you think of painting as painting it is rather absurd," he has observed. "The real world is before us—glorious sunlight and activity and fresh air, and high speed motor cars and television, all the animation—a world apart from a little square of canvas that you smear paint on."[7] Thiebaud determined through experimentation that by adding patches of different colors—blue, yellow, green, red—around the edges of his pie slices, he could heighten the sense of their substance. Through this exercise Thiebaud discovered a new goal of pictorial representation: to achieve a sense of painterly vitality rather than an illusion of exact size or color. Thus he began to enrich his images by alternating hot and cool colors, intensifying contrasts of shadow and light, or exaggerating the tactile surfaces of the objects he painted.

The creation of light in a painting is a means by which Thiebaud further achieves a lively sense of reality. Light is a subject that has intrigued him since the fifties, when he worked with metallic paints and silver and gold leaf to reproduce the scintillating effects of reflective glass store displays. He continues to be absorbed with this problem even in his most recent dark still lifes. "The problem of the painter," Thiebaud has claimed, "is to have the painting create its own light—that's the theory of painting."[8]

"Each age brings with it its own light," Matisse once stated.[9] The light that Thiebaud evokes in these early still lifes is the harsh supermarket glare of fluorescent tubes. Thiebaud's interest in this quality of light was prompted by a trip to Mexico in late 1959.[10] The contrast between Mexico's slower paced and more dimly lit life and America's intense artificial light reflecting off chrome and glass displays made a striking impression on Thiebaud. As a consequence, he became absorbed with depicting the effects of artificial light. But while the quality of light in Thiebaud's paintings is emphatically defined, the source is not. Thiebaud is more interested in the transforming effects of artificial light on objects: shadows seem more colorful, colors change before one's eyes, and objects pulsate under the intensity of fluorescent glare. As Degas once noted in his journals, "The fun is not always showing the source of light, but rather the effect of light."[11]

Other modern painters intrigued by this problem have used different means to achieve a sense of luminosity in their canvases. Edward Hopper's passion for depicting the light of different times of day and different locales is well known. He emphasized the mood created by varying effects of light—whether the sun-warmed shores of Cape Cod or the incandescent light of city offices at night—and achieved these aims through relatively conventional tonal contrasts. Milton Avery and Mark Rothko, on the other hand, evoked a sense of light through chromatic harmonies, layering thin washes of closely valued hues one over another. Like Rothko and Avery, Thiebaud is not interested in the simple imitation of light, its color, or values. Rather, he devises a system of color relationships that defines light in terms specific to the painting. In Thiebaud's untitled painting of toy balls, 1967 (pl. 19), for example, the effect of luminosity is achieved by placing pure hues directly on the canvas. This technique recalls the powerful and instantaneous effects of light Matisse and the Fauves achieved by juxtaposing saturated colors next to each other. In most cases, however, Thiebaud obtains the effect of light by painting his objects against stark white backgrounds. These uninterrupted expanses of intense, reflective white surfaces create a cold glow that conveys the artificially lit glass and stainless steel world from which many of Thiebaud's subjects are drawn.

Thiebaud is also preoccupied with investigating the "color" of white. It is commonly known that white is composed of all colors, and painters throughout history have explored this visual paradox. Thiebaud has pointed out: "From a painter's standpoint, white both absorbs light and reflects light, it's composed of all colors, like Chardin's tablecloths."[12] The Impressionists Claude Monet, Alfred Sisley, and Camille Pissarro investigated the color of whiteness by painting a series of winter landscapes. Their observations revealed that white is never a pure hue but always a product of reflected color. They also discovered, importantly, that the shadows in a bright, white environment are not opaque and black, but are penetrated by light and color. They observed that shadows were composed of complementary colors, with blue dominant.

By painting his still lifes against stark white backgrounds,

Thiebaud likewise destroys the concept of local color—the true color of an object as distinguished from its apparent color when influenced by unusual lighting, atmospheric conditions, or reflected color. His subjects and their shadows take on a variety of color nuances as indeterminate light is reflected from one surface to another. This is especially apparent when Thiebaud paints predominantly white subjects against white backgrounds. In *Neapolitan Pie*, 1963/1964-65 (pl. 10), and *Heart Cakes*, 1975 (pl. 34), the whiteness of meringue or frosting takes on a multitude of subtle hues: lavenders, oranges, pinks, grays, and pale greens.

Thiebaud's preoccupation with light is closely related to his interest in the phenomenon of halation: what happens to the edges of objects when the objects are brightly illuminated. Technically, halation is a consequence of the imperfect binocular vision of the human eye in which two images merge but never exactly. Scientific tests have also confirmed that the human eye is rarely, if ever, stationary; small involuntary movements are inevitable even when an attempt is made to fix an object in the field of vision.[13] This constant movement, combined with our imperfect binocular vision, results in the fact that the boundaries of objects are never sharp and distinct. Thiebaud discovered that particularly by staring at an object in bright light he could perceive subtle yet definite vibrations around the edges of objects. It appears that edges have edges. The longer one stares at an object, the more it seems to pulsate. In his still lifes, Thiebaud imbues the edges of his objects with this same pulsating energy by circumscribing them with intense complementary hues: full-throttle reds and lime greens or burning oranges and electric blues.[14] At the same time, Thiebaud uses these rainbowed edges to merge the objects softly with their white background. He has explained that it is a way "to give a little bit of vibration, so the eye will accept the form as not being so pasted on."[15]

A corollary to Thiebaud's interest in light is his fascination with shadows. But shadows in Thiebaud's paintings are not of the conventional type: they are treated as areas of luminous color, as variations on light. The Impressionists had earlier perceived that shadows are penetrated by light and color, especially blue. Auguste Renoir once advised a young artist that "shadows are not black; no shadow is black. It always has a color. Nature knows only colors."[16] The Fauves were also aware of this phenomenon. In 1905, André Derain wrote to Maurice de Vlaminck of his discovery "that every shadow is a whole world of clarity and luminosity."[17] For the Fauves, this discovery led to a new, purified form of color painting in which light and shadow were rendered by contrasts of hue, not of tone. The general impact of this approach was that the works appear brighter and more colorful.

Thiebaud has assiduously incorporated these principles in his own work. His shadows are generally blue—though the blues may vary in hue and saturation—and they are most often outlined with intense yellows, greens, reds, or oranges. In rendering luminous shadows, as in depicting solid objects, Thiebaud employs the techniques of color contrasts and effects of halation to energize the canvas. Through the cal-

culated use of color, Thiebaud establishes a configuration that does not simply imitate nature but intensifies it according to the painter's perception. The paintings become alive with light and energy rather than simply illustrating objects.

In his more recent still lifes, Thiebaud has continued to explore how we perceive light and shadow. But these investigations focus on the possibilities of using black as a generating source of light and color. These small still lifes, among them *Dark Lipstick*, 1983 (pl. 40), *Dark Candy Apples*, 1983 (pl. 39), and *Black Shoes*, 1983 (pl. 38), recall the work of the seventeenth-century Dutch master Rembrandt van Rijn. As in Rembrandt's paintings, Thiebaud's subjects emerge from and are illuminated against a background of dark, rich shadow. But the shadows, like Rembrandt's, are not simply opaque and black. Thiebaud's black, like his white, is an Impressionist black, a colored shadow composed of numerous hues—blues, greens, umbers, browns. In these small paintings, darkness becomes a transparent container of color and light.

Light appears in two guises in the dark works: the objects appear to be lit from an indeterminate source—as in his white still lifes—and they also appear to be light sources themselves, radiating energy. To achieve this effect Thiebaud exploits one important phenomenon of perception: the observed brightness of an object is relative to the brightness of its background. Thus the candy apples appear luminous not only by virtue of their absolute brightness but also because of their relative brilliance when compared to the field on which they are placed. Psychological observations have also shown that luminosity results when brightness is not identified with a directly perceived light source. To achieve this objective of luminosity, the shadows of Thiebaud's objects are kept to a minimum, as in *Black Shoes*, and, as a result, light seems to originate from within the object. Paradoxically, although these paintings are dark, they appear almost dazzling in their radiance.

The creation of luminous energy in his still lifes has been a major preoccupation for Thiebaud. Another pervasive concern has been to create a sense of energy through the viscous stroking of paint. This is especially apparent around the edges of his objects and in the backgrounds, as in *Candy Counter*, 1969 (pl. 22). Thiebaud has explained that stroking around the object with a loaded paintbrush is calculated to echo the presence of that object.[18] Like the strong, dark strokes that outline Van Gogh's trees, houses, and faces, Thiebaud's brushwork establishes the existence of his objects with an emphatic conviction. Backgrounds are also painted so that the picture plane is as visually available as possible, but in a taut state, as though the background were literally pulled skintight to the frame's edge. According to Thiebaud, this stills the surface of the painting and suggests a clear, frozen moment, setting up a contrast to the gently intruding and vibrating edges of the objects. The result is "somewhat like the feeling in an air-conditioned, well-lighted, quiet place where the slightest tremor can be sensed."[19]

In addressing the issues of light, space, and color, Thiebaud confronts the continuing dilemma of the realist painter: how to translate reality into paint on canvas. But these still lifes are also about potential transformations: how objects can transcend their normal associations. In his essay "The World as Object," the philosopher Roland Barthes writes of the transformation of objects that occurs in classical Dutch still life painting. The paintings are filled with objects wherever you look—on the tables, the walls, the floor there are pots, pitchers, baskets, vegetables, meats, candles. The object is never alone, "never privileged," as Barthes notes.[20] "Everywhere the object offers man its *utilized* aspect, not its principal form....Behold then a real transformation of the object, which no longer has an essence but takes refuge entirely within its attributes. A more complete subservience of things is unimaginable."[21]

Unlike the Dutch painters whom Barthes describes, Thiebaud concertedly avoids the "subservience" of his images. Instead, he delves into the essences of his subjects, discovering them, in part, by divorcing them from their normal contexts. His subjects are generally placed against plain, unadorned backdrops, allowing the viewer to focus more intimately on the objects themselves. Because of this simplification and isolation, small details—the shine on a shoe, the curve of a flower stem—become major visual events. When the objects are isolated in this fashion, they can also assume ironically different identities of scale or essence. Big things may appear small and small things huge. Thiebaud's pastel of a wedding cake (pl. 30), for example, has all the weight and presence of a Mayan temple and seems almost to burst from the edges of the paper. By contrast, in *Star Boat*, 1966 (pl. 18), the boat reads as a toy, isolated without any reference to suggest its true size.

In other paintings, simple, ordinary objects assume radically new attributes. Thiebaud observes: "Common objects become strangely uncommon when removed from their context and ordinary ways of being seen."[22] In *Three Lipsticks*, 1965 (pl. 13), the small objects read as steely bulletlike shells that contrast vividly with the association of beauty that these cosmetics normally connote. And in *Strawberry Cone*, 1969 (pl. 17), Thiebaud imbues his subject with ironic grandeur and drama by isolating it; the single ice-cream cone looms with a theatrical presence that belies its ordinariness. In these paintings, Thiebaud satisfies an age-old principle of the still life tradition: that the artist discover some virtue, not in inanimate objects as such, but in the isolation of the object. Through this technique of isolation, Thiebaud invests his images with a significance normally denied them. "The objects are for me like small landscape buildings, or characters in a play with costumes," Thiebaud once stated. "They have all these images for me....When the painter creates a microcosm, a little world that he is able to manipulate and to bring parts of it into existence, [he] gets much downright pleasure from the experience."[23]

The role of memory in Thiebaud's painting is another

important concern of the artist. Many of his still lifes are created from memory, not from life, as one might presume. What interests Thiebaud in working from memory is how an artist can interrupt or reinterpret conventional ways of seeing. He explains: "A problem that I think is a continuing one is attempting to distinguish between objective, perceptual information and the attempt to distill or codify or symbolically refer to it, as opposed to memory, fantasy, and a lot of other kinds of references. Our minds are filled with conventions, which means convenient ways of doing something, or a cliche, which is probably the same thing....When you look at an object in comparison with these conventions, you're faced with a real dilemma, one which I propose is unending, because you can never see everything that's there."[24] Even works painted with the objects before him, as in *Yellow Dress*, 1974 (pl. 32), or his untitled images of a hat and a gun (pls. 20, 24), Thiebaud considers memory images. In working from life the duration interval is simply shortened.

Many of Thiebaud's still lifes, such as *Penny Machines*, 1961 (pl. 4), are based on childhood memories. In the summer as a youth he sold newspapers and sometimes worked for restaurants along the Long Beach boardwalk. On breaks from his job of selling newspapers, he would often go to Woolworth's to buy candy and enjoy the opulent glass counter displays. This fascination with counter and window displays continued well into Thiebaud's adulthood. Patrick Dullanty, a painter and close friend of the artist, recalls that during the fifties Thiebaud would often invite him on walks in downtown Sacramento for a leisurely perusal of the window displays.[25]

Because Thiebaud's subjects are painted from memory, specific details are generally subordinated to salient qualities of the subject as recalled. Psychological experiments confirm that memory tends to recall the object's simplest structure while preserving and exaggerating distinguishing characteristics. Things are remembered as larger, faster, brighter, uglier, or more painful than they actually were.[26] By extension, Thiebaud's still lifes often appear as almost-caricatures of actual subjects. The meringue of a slice of pie looks as pure and white as fresh drifts of snow; the folds of a satin party dress resemble shiny corrugated metal (pls. 10, 32). Other painters without the benefit of psychological training have recognized the important role memory plays in art. Hopper's paintings are, in the artist's own words, the result of "a long process of gestation in the mind and a rising emotion."[27] Degas also observed: "It is very well to copy what one sees. It's much better to draw what one has retained in one's memory. It is a transformation in which imagination collaborates with memory. One reproduces only that which is striking, that is to say, the necessary. Thus one's recollections and inventions are liberated from the tyranny that nature exerts."[28]

Memory is added to knowledge about painting conventions and art history as a resource stored in the artist's mind. In his major study on the psychology of pictorial representation, *Art and Illusion*, E.H. Gombrich asserts that the representational artist paints what his or her

memory offers as the proper form of the subject. These memory reservoirs contain the schemata supplied by the artist's teachers and by other models of the past.[29] Both learned and stored knowledge play a crucial role in Thiebaud's work. He explains: "When you paint a glass of water you can do one of two things. You can get the painting of the glass of water to match your visual experience or you can interpret—bring forward [information] from years ago, from other painters—[and] add your own inventive sense in concert with your perception."[30] One can learn through the discoveries of others, for example, that shadows are not black but filled with color. Thiebaud's still lifes are the result of both his inquiries into the nature of the physical world and his reactions to it. He enlivens the perceived construct of his paintings with conceptual information drawn from other sources, among them memory and knowledge. Thiebaud's dual resources produce work both real and abstract. His still lifes are about an *idea* of reality.

Despite Thiebaud's emphasis on formal issues, inevitably the question will be asked: What is the meaning of these paintings of ordinary objects? In answer, Thiebaud has consistently upheld the viewpoint that his subjects are chosen primarily for the formal problems they pose: How does one paint light? How can adjustments in composition affect perceptions of scale? The objects in Thiebaud's still lifes possess no symbolic or metaphysical meaning for him: "I have, in my own ranging around, a somewhat deep suspicion about being too much aware of symbolic reference or conscious-message sorts of programs and formulas, and I tend to be quite formal in terms of formal problems of painting, but not so formal in terms of subject matter."[31]

This detached and objective point of view was frequent in the avant-garde circles of the sixties, when Thiebaud's art came to maturity. It is particularly exemplified by the works of the French *nouveau roman* writers of this same period. Francis Ponge, for example, disclaimed any taste for ideas, which repelled him because of their pretension to absolute truth. In his writings, Ponge completely abandons ideas and chooses things instead. In his most well known collection of prose poems, the 1942 *Le Parti pris de choses* ("Taking the Side of Things"), Ponge writes of an orange, a candle, a pebble, a cut of meat, rain. Of an oyster he observes: "The oyster, about as big as a fair-sized pebble, is rougher, less evenly colored, brightly whitish. It is a world stubbornly closed. Yet it can be opened: one must hold it in a cloth, use a dull jagged knife, and try more than once. Avid fingers get cut, nails get chipped: a rough job. The repeated pryings mark its cover with white rings, like halos."[32] As is evident in this example, Ponge's writing style is antiheroic: it is based on the language of everyday things.

This detached and objective point of view is also characterized by the writings of the French novelist Alain Robbe-Grillet, who, in the late fifties, formalized the theoretical base of *le nouveau roman*—the "new novel." Robbe-Grillet asserted that all emotional and intellectual comments writers might make about human experience had been ex-

Fig. 27 René Magritte, *The Active Voice*, 1951, oil on canvas, 39½ × 31½″ (100.3 × 80.0 cm.). The Saint Louis Art Museum; Gift of Mr. and Mrs. Joseph Pulitzer, Jr.

hausted. The task that remained was to describe the surface of the world, impervious to any system of meaning. Robbe-Grillet, like Ponge, was a spokesman for *choseism,* or "thingism." "The world is neither significant nor absurd," he noted. "It *is* quite simply.…Around us, defying the noisy pack of our animistic or protective adjectives, things *are there.* Their surfaces are distinct and smooth, *intact,* neither suspiciously brilliant nor transparent. All our literature has not yet succeeded in eroding their smallest corner, in flattening their slightest curve."[33]

Thiebaud's still lifes are visual embodiments of Robbe-Grillet's theories. His is neither a heroic nor a mystical vision of life. Isolated from their larger contexts, Thiebaud's objects are simply meant to be as they really appear. As Robbe-Grillet has gone on to assert, "Let it be first of all by their *presence* that objects and gestures establish themselves, and let this presence continue to prevail over whatever explanatory theory that may try to enclose them in a system of references, whether emotional, sociological, Freudian, or metaphysical."[34]

This task is not easily achieved, however. Meaning is a subversive and uncontrollable factor in art that will often appear of its own accord, independent of the subject matter of the canvas or the intent of the artist. A case in point is found in Georgia O'Keeffe's iconic flower paintings: despite her constant disclaimers, writers continue to read sexual meaning into her magnified blossoms. Another example can be found in René Magritte's painting *The Active Voice,* 1951 (fig. 27), an isolated image of a rock. Because of its very neutrality, this still life is, paradoxically,

all the more a vehicle of feeling and a crystallizer of tension. With seemingly little control by the artist's hand, fact is transmuted into mystery.

There is something equally compelling in many of Thiebaud's paintings of isolated subjects. The image of a single flower resting in a shoe box (pl. 45) or of a flower pinned to the wall (pl. 44) is imbued with a disarming drama that belies the mundaneness of the objects. The flowers in *Flower Fan*, 1983 (pl. 41), are almost too perfectly arranged, as though offered as an homage on a gravestone. Thiebaud's painting of a gun (pl. 24), because it is such an emotionally charged subject, prompts a multitude of subjective associations. These images are provocative because they offer signs without the events, giving rise to internal questions within the viewer. The enigma of these paintings is further enhanced when one realizes that the flowers are artificial and the gun is a toy. The disparity between cause and effect invests Thiebaud's paintings with a subtle, yet potent, impact. Robbe-Grillet reinforced this idea when he wrote that the function of art is never to illustrate a truth "but to bring into the world certain interrogations...not yet known as such to themselves."[35]

A final important element in Thiebaud's still lifes is a sense of reflective nostalgia. Many of his subjects, such as pinball and candy machines (pls. 5, 7), are based on childhood memories of the Long Beach boardwalk. Other paintings, such as *Yellow Dress*, 1974 (pl. 32), and his untitled image of a gray fedora, 1972 (pl. 20), are based on objects found in the secondhand stores Thiebaud frequents and reflect his passion for used and overlooked subjects. "Commonplace objects are constantly changing," he has observed, "and when I paint the ones I remember, I am like Chardin tattling on what we were. The pies, for example, we now see are not going to be around forever. We are merely used to the idea that things do not change."[36]

In his paintings of toy displays (pl. 6), delicatessen displays (pl. 9), and candy counters (pl. 22), Thiebaud chronicles our contemporary folk customs: how our foods are presented and decorated, what toys entertain our children. These paintings reveal in bald facts who and what we are: "When we line our shelves with blocks and panda dolls or with trucks, guns, jeeps, and 'G.I. Joe' monkey outfits," Thiebaud notes, "we are showing our preoccupations in life."[37] But Thiebaud passes no negative judgment when painting these commonplace subjects; rather, he paints them out of a sense of true affection. By focusing on their banalities he pushes them in the direction opposite to the familiar. In his still lifes, mediocrity is raised to a level of significance. It is a familiar vision without any of the dullness that familiarity brings.

NOTES

1. *Marcel Proust on Art and Literature 1896–1919* (New York: Dell, 1958), p. 334.

2. Arthur, *Realists at Work*, p. 120.

3. Since the sixties, Thiebaud has actively made prints that focus on the same subjects found in his paintings: pastries, lipsticks, toy counters. He has worked with intaglio, lithography, linocuts, and screenprinting. In 1983 he traveled to Japan, under the auspices of

Crown Point Press, Oakland, to collaborate with traditional woodblock artists, creating a print titled *Dark Cake*, 1983.

4. Theodore Reff, *Degas: The Artist's Mind* (New York: The Metropolitan Museum of Art and Harper & Row, 1976), pp. 273–274.

5. Kozloff, "Art," p. 407.

6. A. LeGrace G. Benson and David H.R. Shearer, "Documents: An Interview with Wayne Thiebaud," *Leonardo,* January 1969, p. 70.

7. Ibid.

8. Albright, "Scrambling Around," p. 85.

9. Quoted in Jack D. Flam, *Matisse on Art* (New York: E.P. Dutton, 1973), p. 100.

10. Thiebaud traveled to Mexico on his honeymoon after marrying Betty Jean Carr.

11. Linda Nochlin, *Impressionism and Post-Impressionism 1874–1904* (Englewood Cliffs, N.J.: Prentice-Hall, 1966), p. 62.

12. Benson and Shearer, "Documents," p. 66.

13. C.A. Padgham and J.E. Saunders, *The Perception of Light and Color* (New York: Academic Press, 1975), p. 25.

14. According to Thiebaud, the rainbow edge around his objects was initially an accident. He normally begins his paintings by sketching his objects on the canvas in a very light color, such as yellow. He then goes back into the drawing with orange, cadmium, green, and blue. Each drawing in a darker color is a correction of the previous one. When Thiebaud began to fill in the images with color, some of the outlines remained, and he found this a satisfying effect. He subsequently equated the colored edges with the optical effects of halation and thereafter intentionally made the boundaries of his objects more vivid.

15. Susan Stowens, "Wayne Thiebaud: Beyond Pop Art," *American Artist,* September 1980, p. 102.

16. John Rewald, *The History of Impressionism* (New York: The Museum of Modern Art, 1973), p. 210.

17. John Elderfield, *The Wild Beasts: Fauvism and Its Affinities* (New York: The Museum of Modern Art, 1976), p. 49.

18. Coplans, *Wayne Thiebaud,* p. 36.

19. Thiebaud, "A Painter's Personal View of Eroticism," *Polemic* (Cleveland: Case Western Reserve University, 1966), p. 36.

20. Roland Barthes, *A Barthes Reader* (New York: Hill and Wang, 1982), p. 64.

21. Ibid., p. 65.

22. Gene Cooper, *Wayne Thiebaud: Survey of Painting 1950–72* (Long Beach: California State University, 1972), n.p.

23. Benson and Shearer, "Documents," p. 68.

24. Albright, "Scrambling Around," p. 86.

25. Dullanty, interview with the author, Sacramento, 12 July 1984.

26. Rudolf Arnheim, *Visual Thinking* (Berkeley and Los Angeles: University of California Press, 1969), p. 81.

27. Brian O'Doherty, *American Masters: The Voice and the Myth* (New York: Random House, 1973), p. 22.

28. Ibid.

29. E.H. Gombrich, *Art and Illusion* (Princeton, N.J.: Princeton University Press, 1969). Gombrich deals specifically with this issue in the chapter entitled "Truth and the Stereotype," pp. 63–90.

30. Arthur, *Realists at Work,* p. 124.

31. Tooker, "Wayne Thiebaud," p. 22.

32. Francis Ponge, "The Oyster," *The Voice of Things* (New York: McGraw-Hill, 1972), p. 37.

33. Alain Robbe-Grillet, *For a New Novel: Essays on Fiction* (New York: Grove, 1965), p. 19.

34. Ibid., p. 21.

35. Ibid., p. 14.

36. Benson and Shearer, "Documents," p. 70.

37. Ibid., p. 72.

PLATE 1

CONFECTIONS, 1962

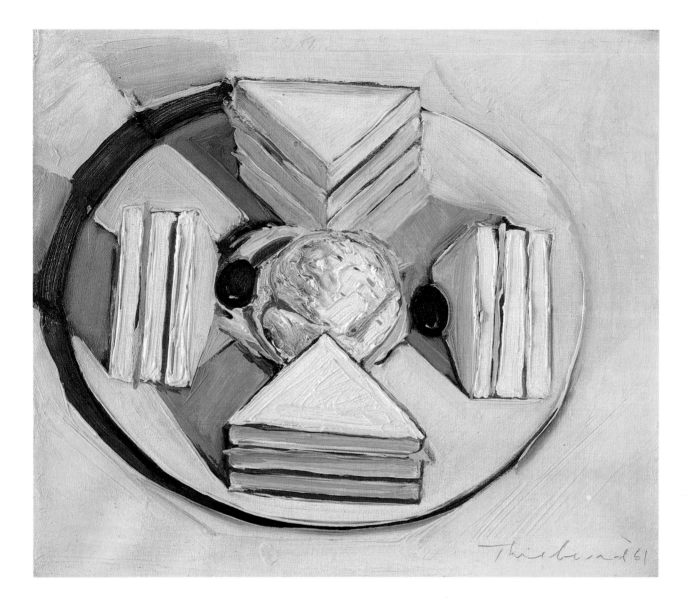

PLATE 2

CLUB SANDWICH, 1961

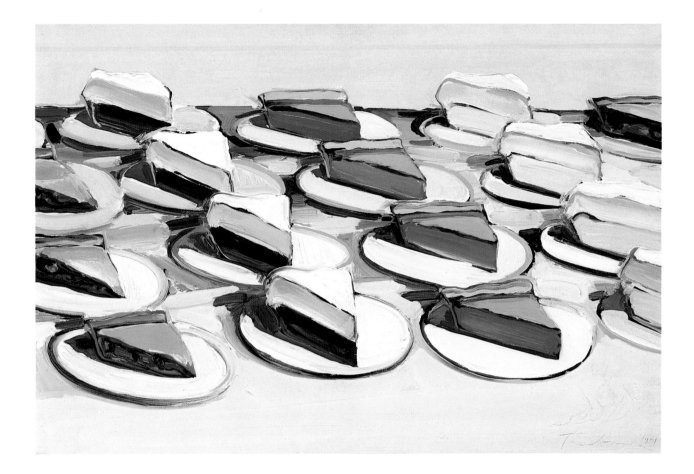

PLATE 3

PIES, PIES, PIES, 1961

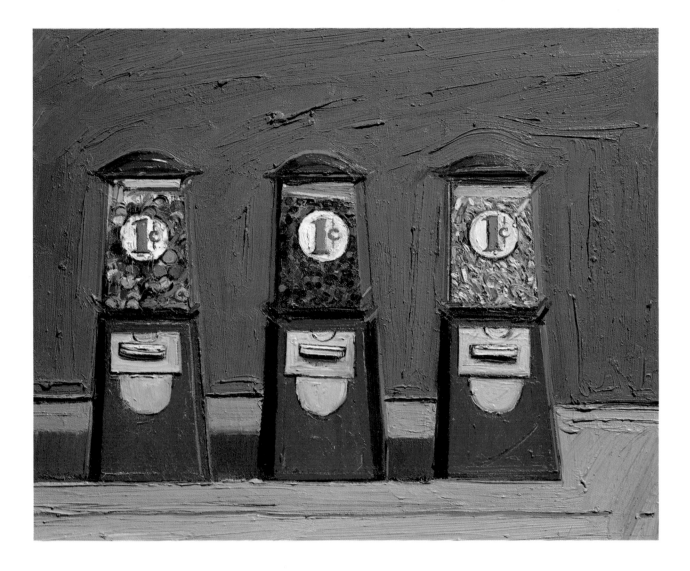

PLATE 4

PENNY MACHINES, 1961

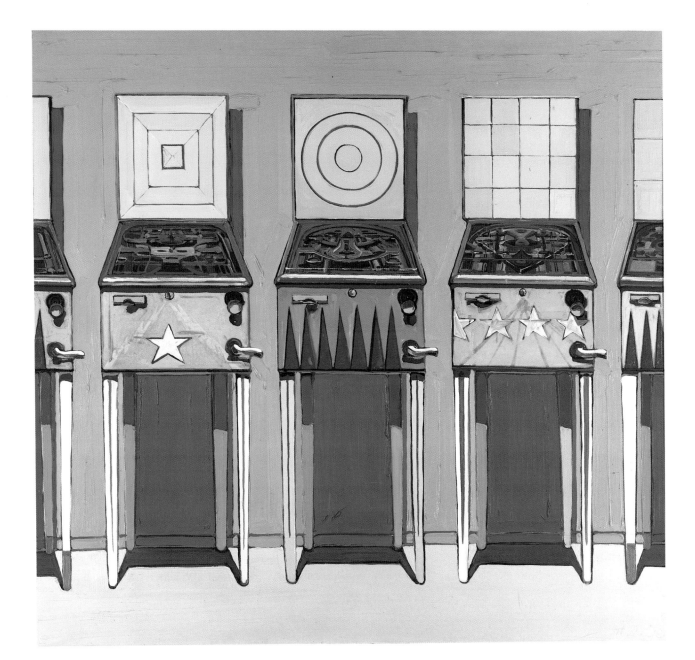

PLATE 5

FOUR PINBALL MACHINES, 1962

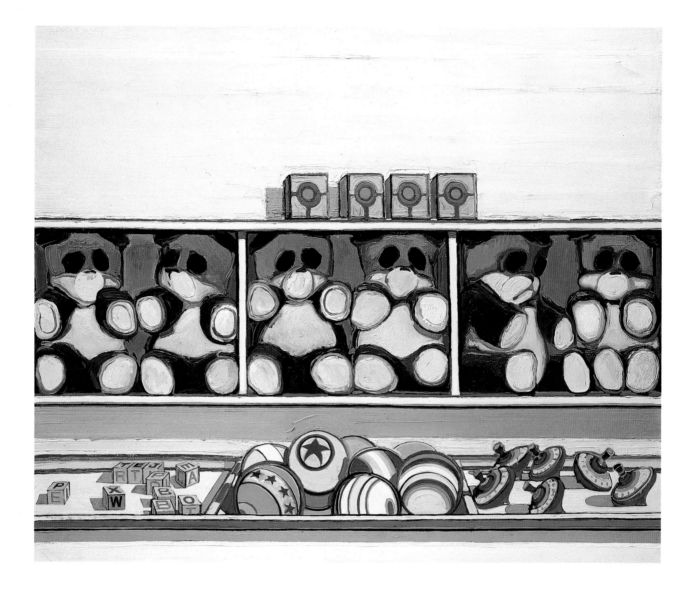

PLATE 6

TOY COUNTER, 1962

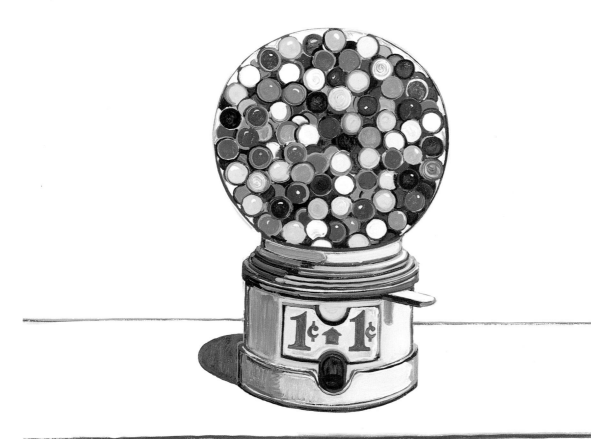

PLATE 7

JAWBREAKER MACHINE (BUBBLE GUM MACHINE), 1963

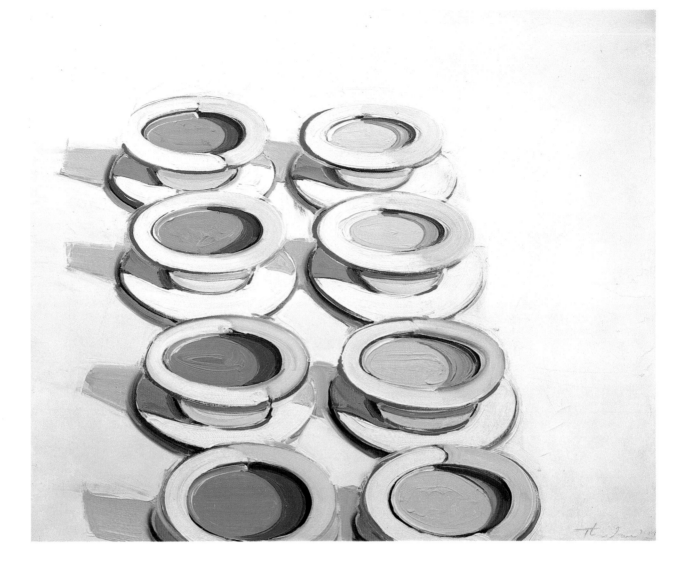

PLATE 8

CREAM SOUPS, 1963

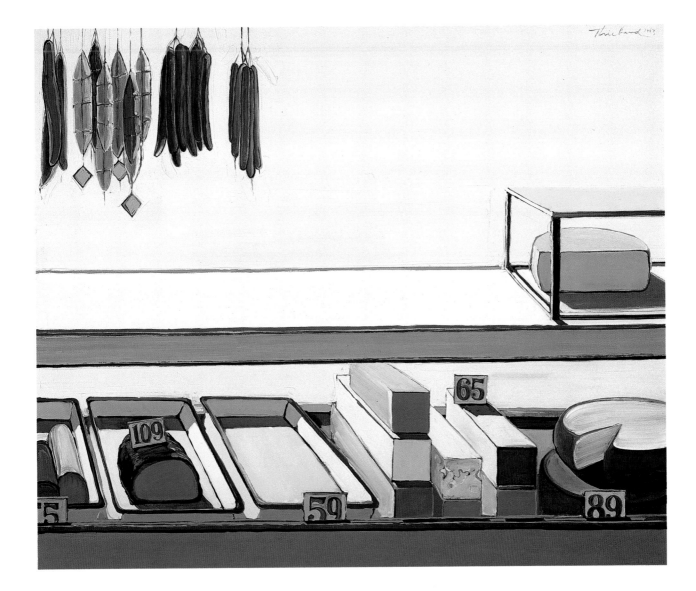

PLATE 9

DELICATESSEN COUNTER, 1963

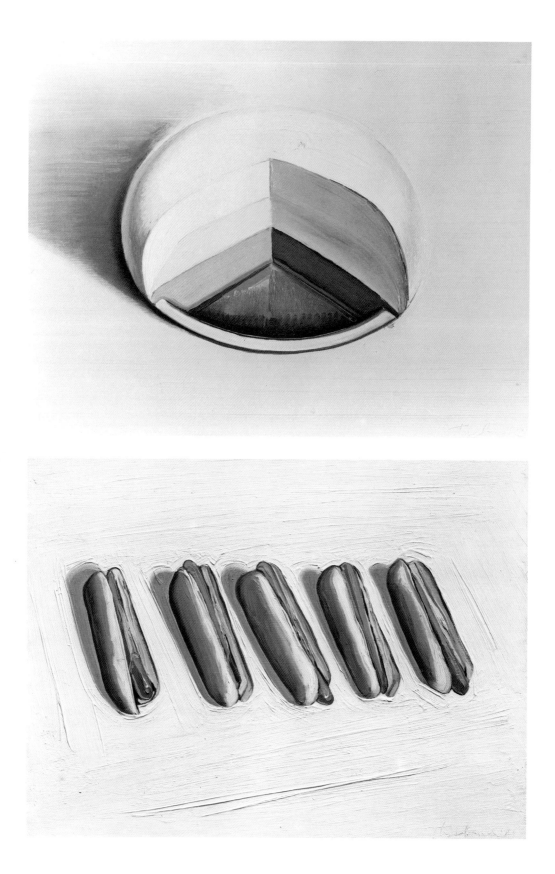

PLATE 10

NEAPOLITAN PIE, 1963/1964−65

PLATE 11

FIVE HOT DOGS, 1961

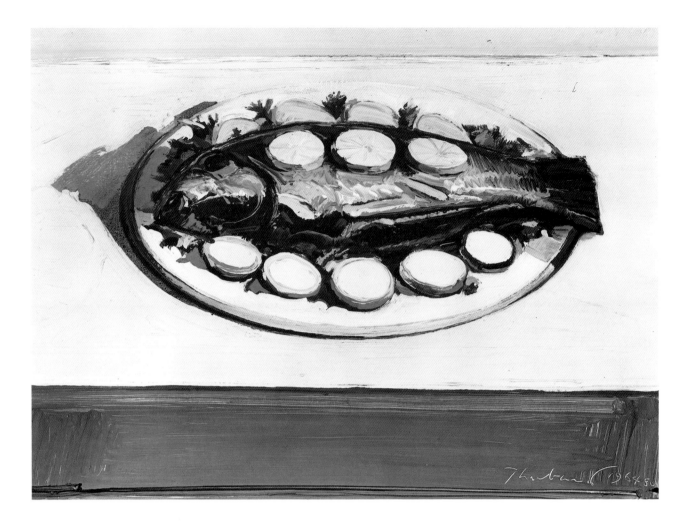

PLATE 12

FISH ON PLATTER (FISH), 1964–80

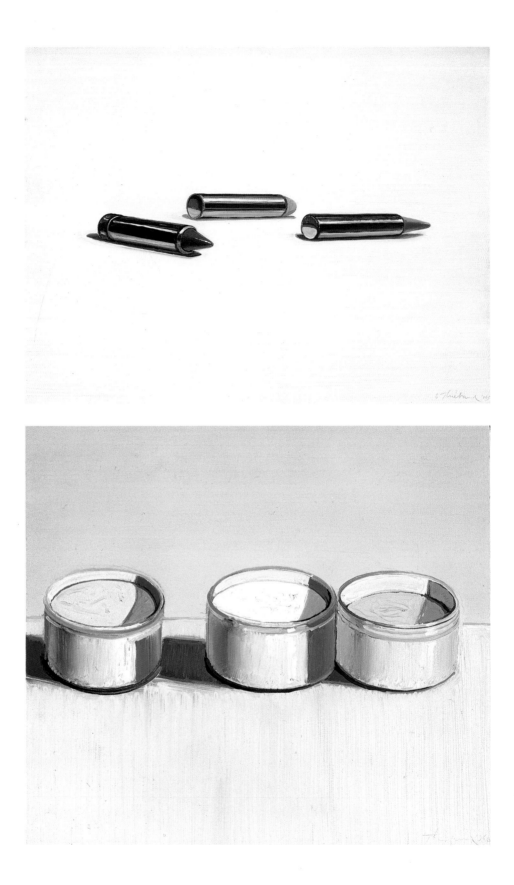

PLATE 13

THREE LIPSTICKS, 1965

PLATE 14

THREE COLD CREAMS, 1966

PLATE 15

TIE PILE, 1969

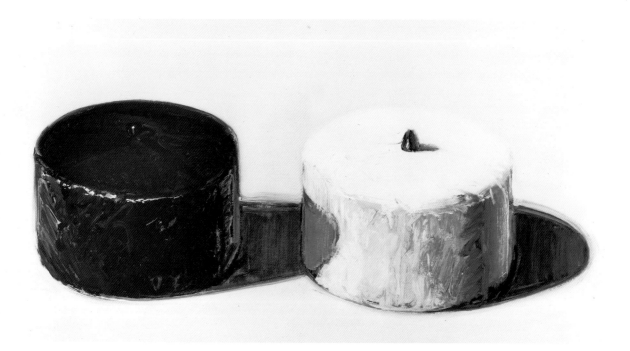

PLATE 16

BLACK & WHITE CAKES, 1980

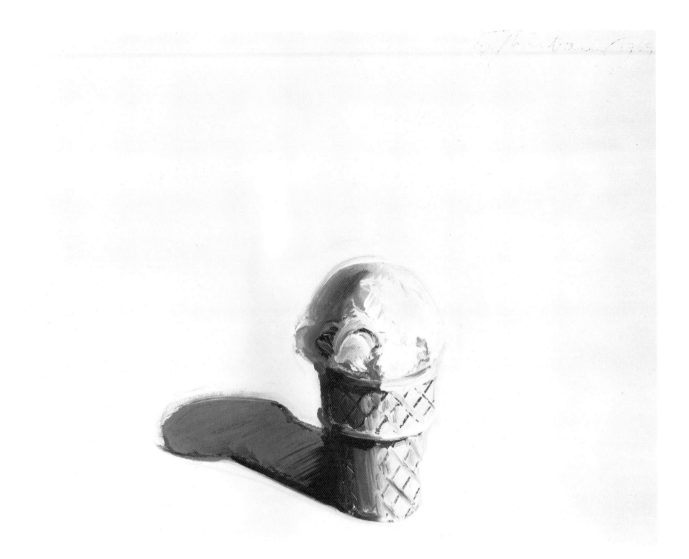

PLATE 17

STRAWBERRY CONE, 1969

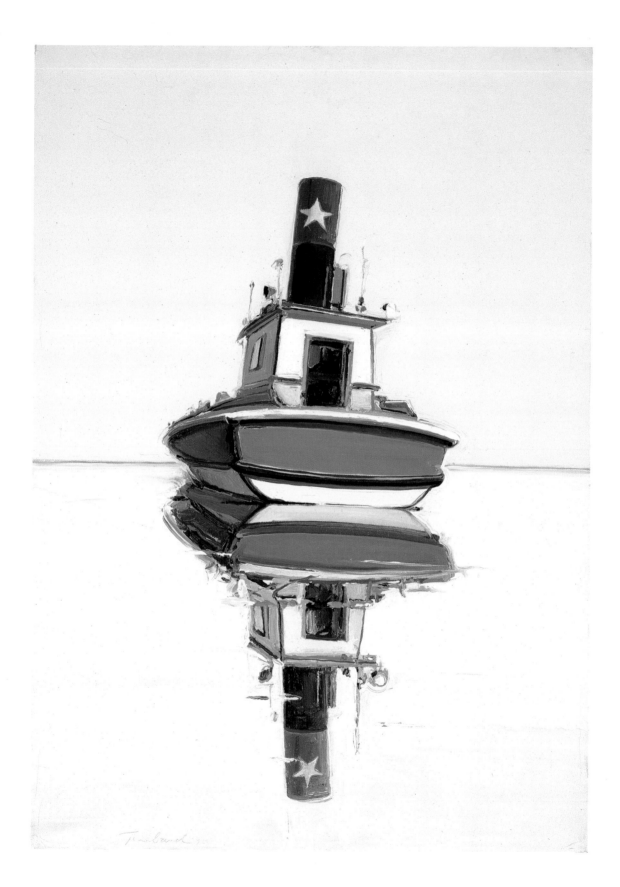

PLATE 18

STAR BOAT (RIVER BOAT), 1966

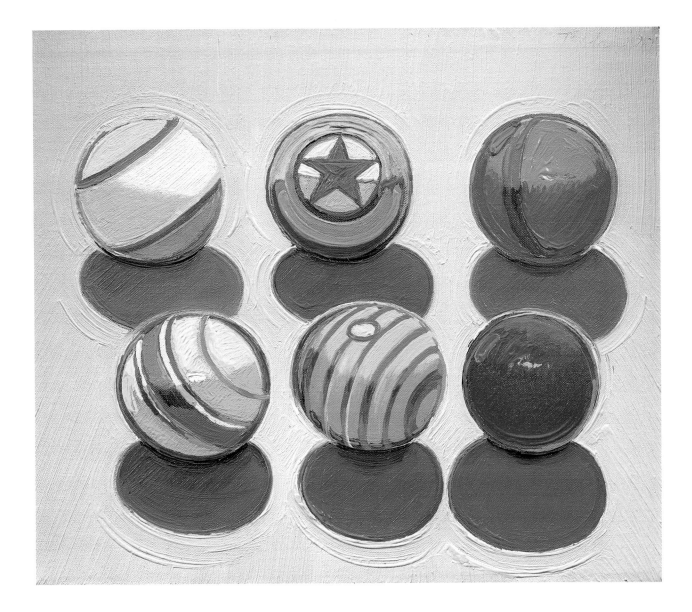

PLATE 19

UNTITLED, 1967

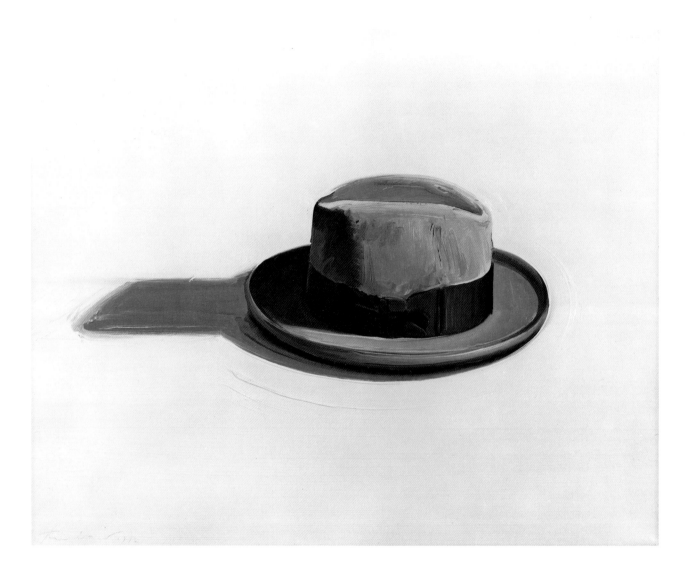

PLATE 20

UNTITLED, 1972

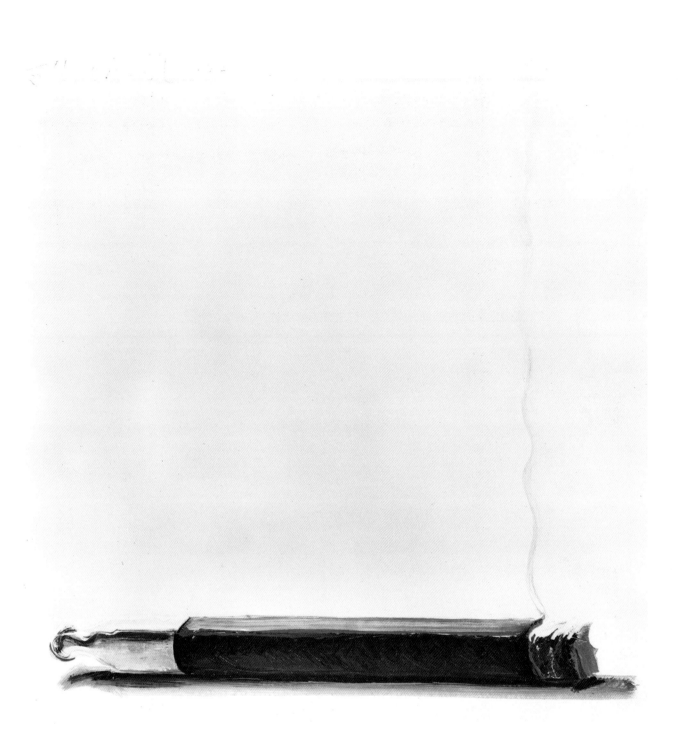

PLATE 21

SMOKING CIGAR, 1974

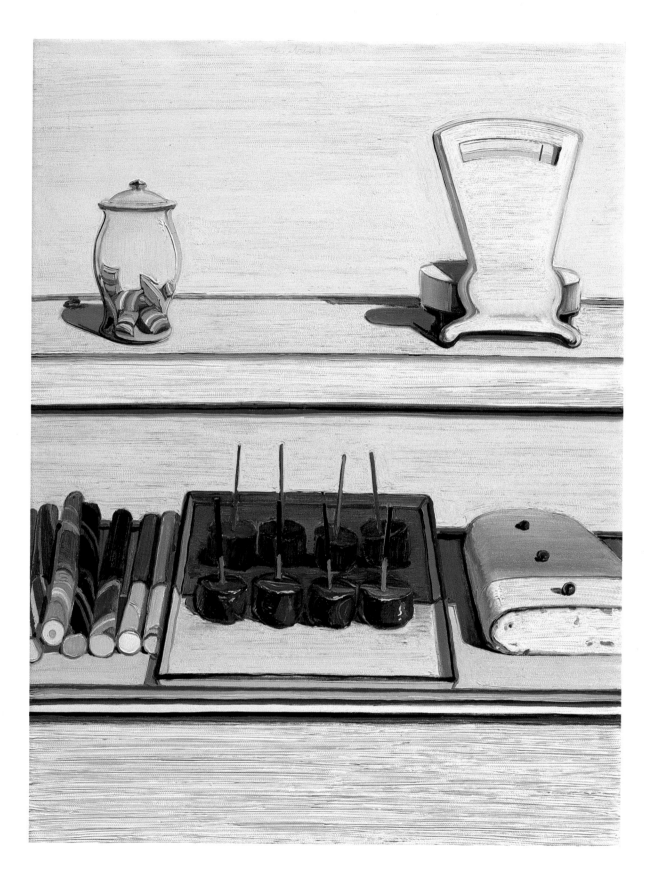

PLATE 22

CANDY COUNTER, 1969

PLATE 23

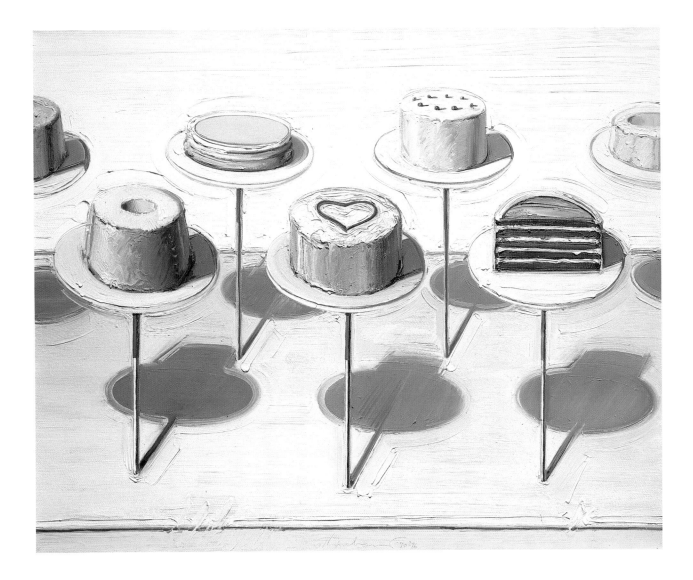

PLATE 23

CAKE WINDOW (SEVEN CAKES), 1970–76

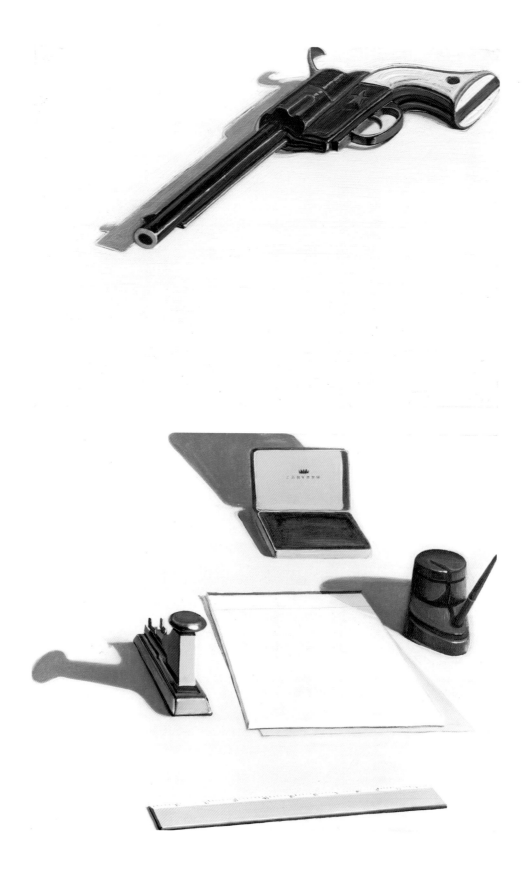

PLATE 24

UNTITLED, 1970−71/1971

PLATE 25

DESK SET, 1971

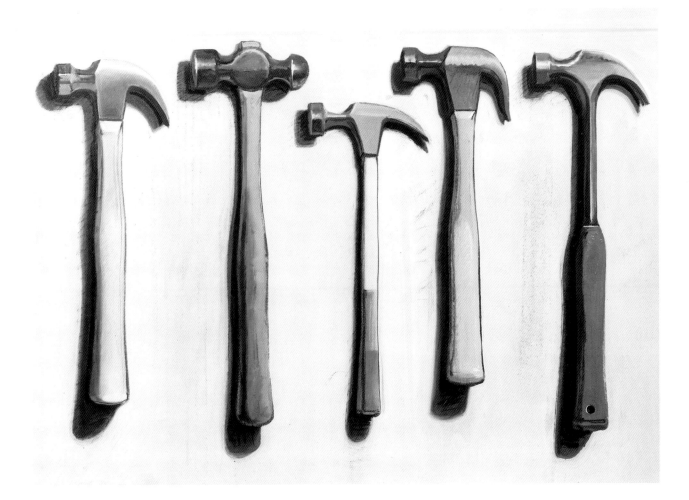

PLATE 26

FIVE HAMMERS, 1972

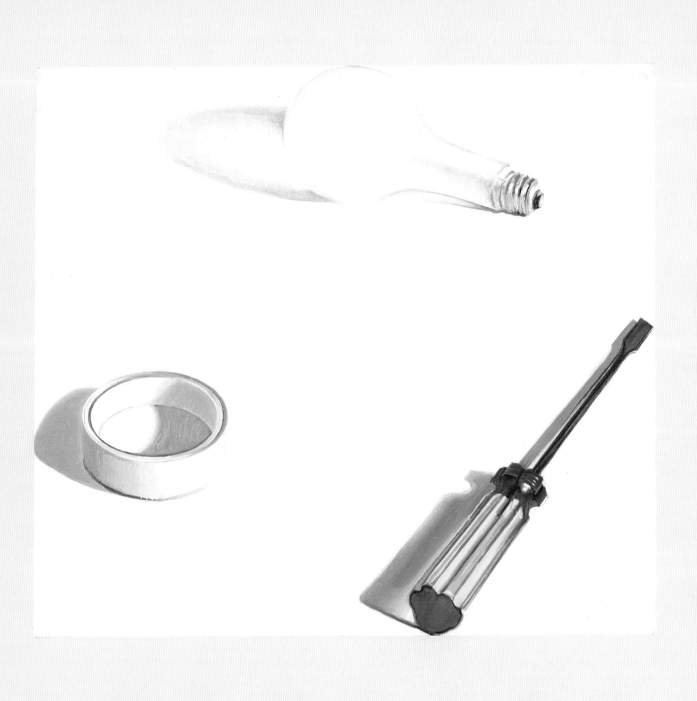

PLATE 27

UNTITLED, 1971

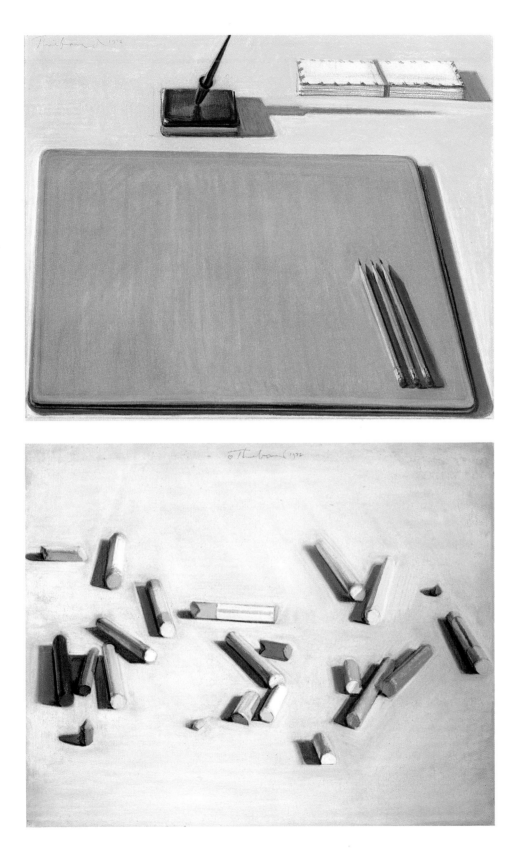

PLATE 28

DESK SET, 1972

PLATE 29

PASTEL SCATTER, 1972

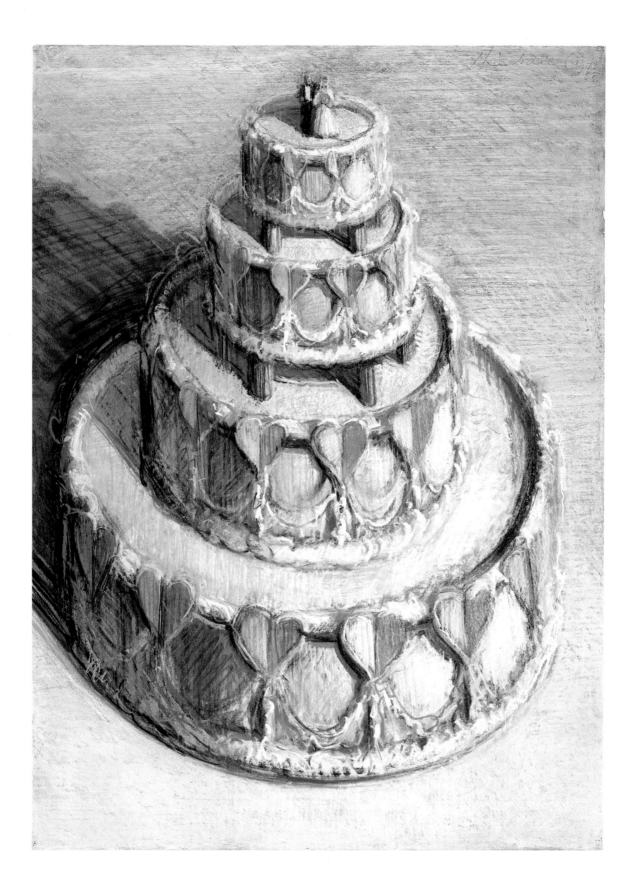

PLATE 30

WEDDING CAKE, 1973–82

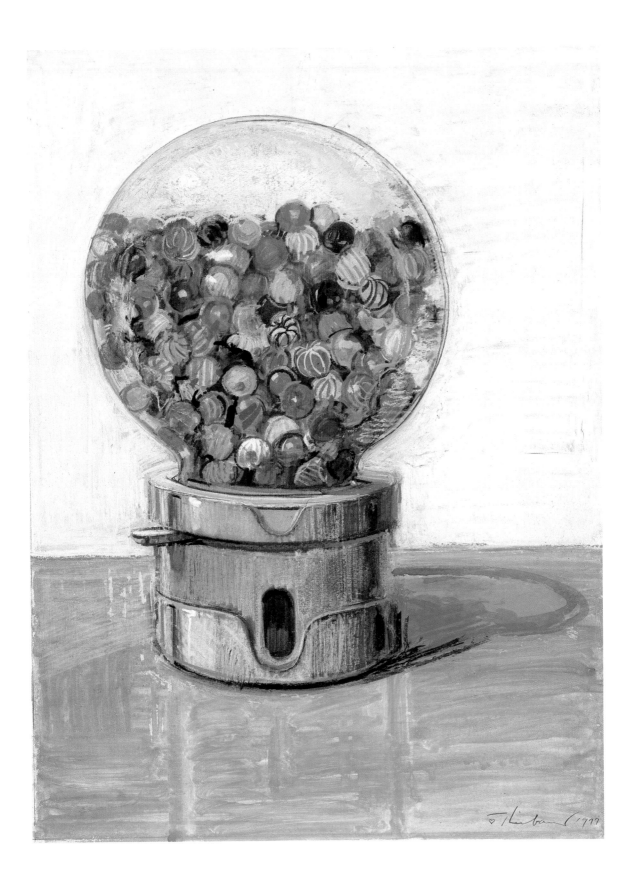

PLATE 31

CANDY BALL MACHINE, 1977

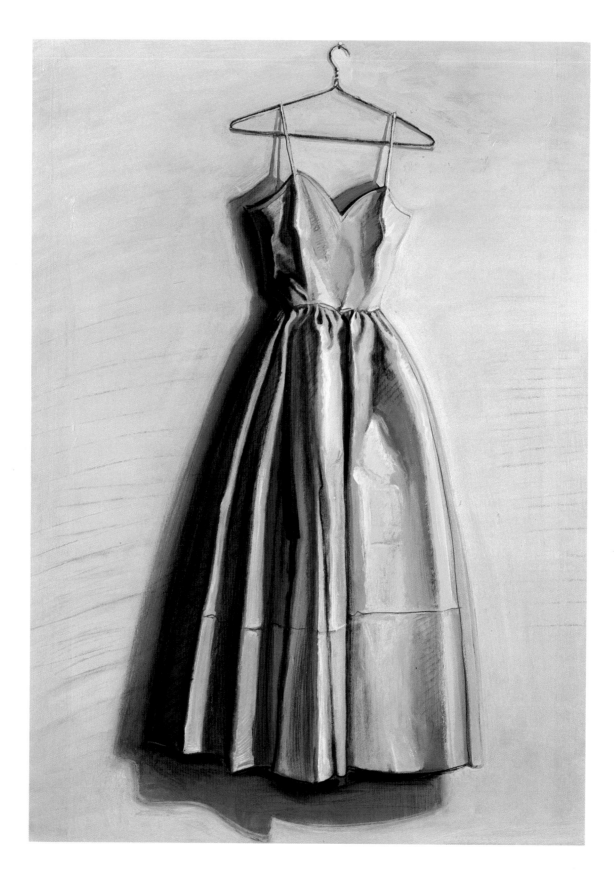

PLATE 32

YELLOW DRESS, 1974

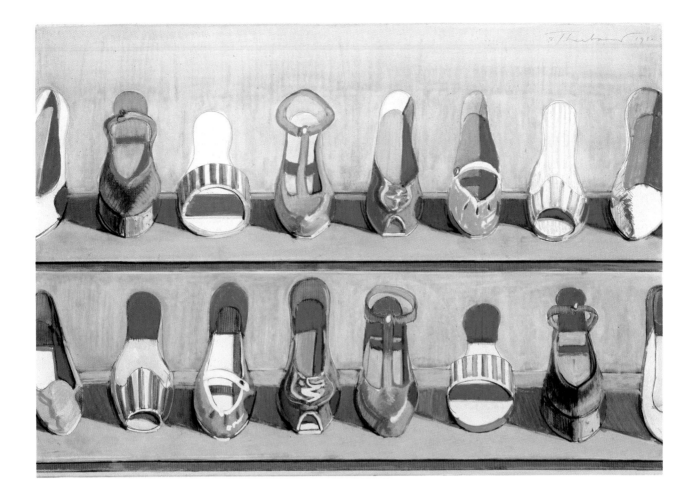

PLATE 33

SHOES (SHOE ROWS), 1980

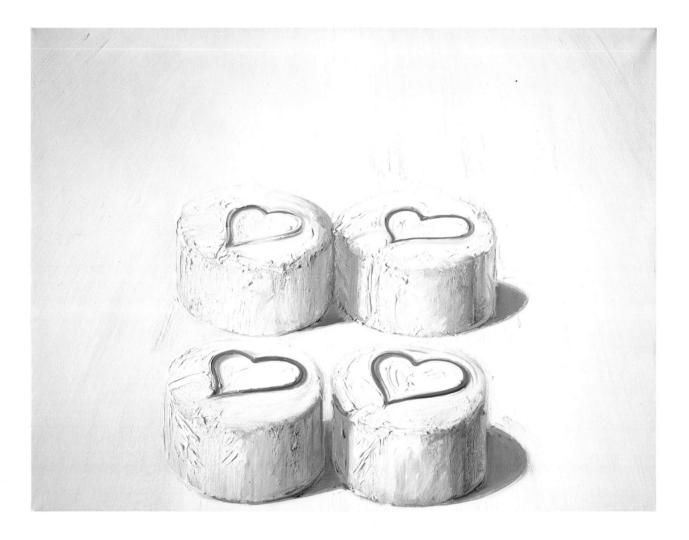

PLATE 34

HEART CAKES (VALENTINE CAKES, FOUR VALENTINE CAKES), 1975

PLATE 35

HYDRANGEA, 1980

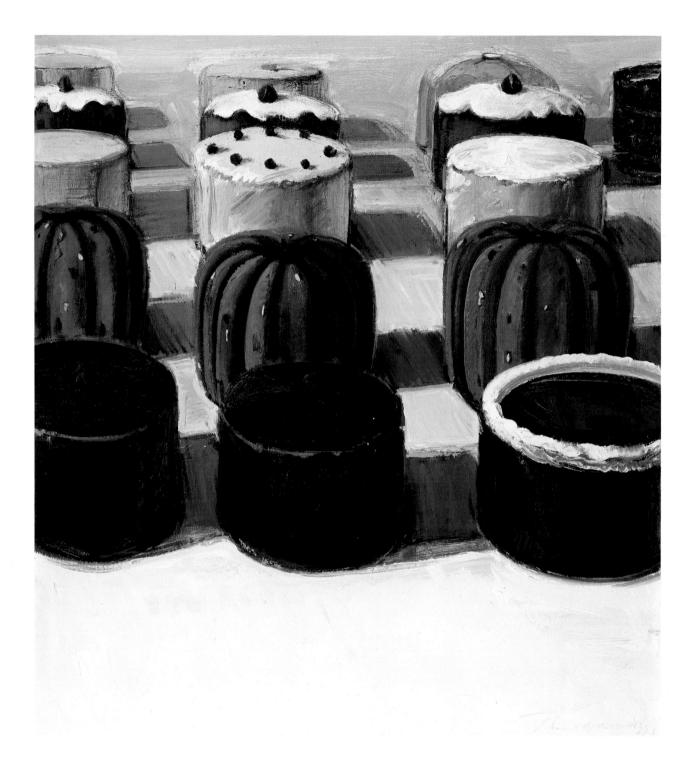

PLATE 36

VARIOUS CAKES, 1981

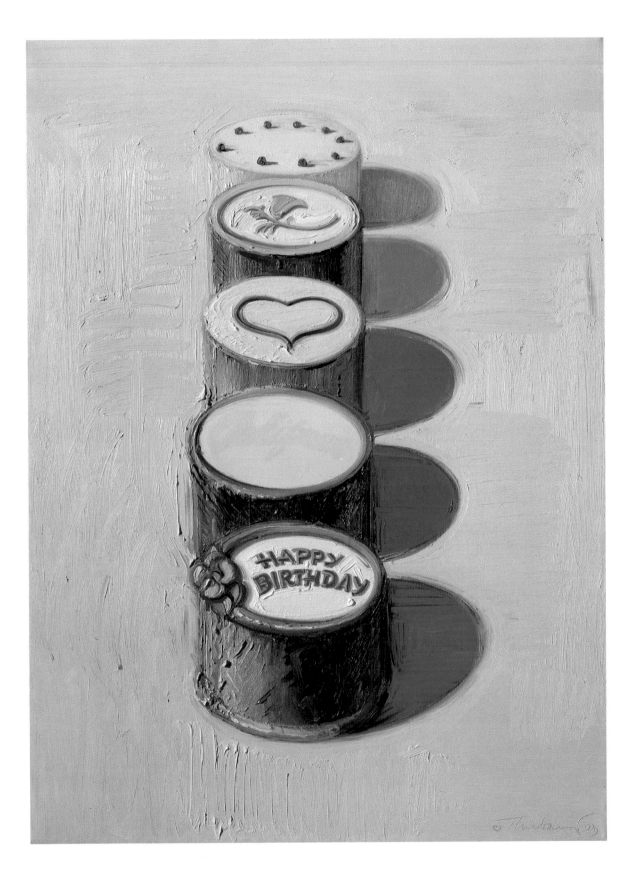

PLATE 37

CALIFORNIA CAKES, 1979

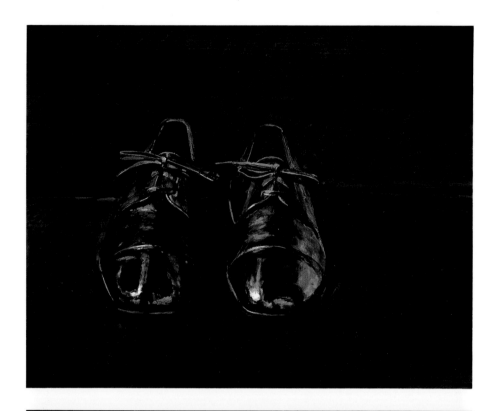

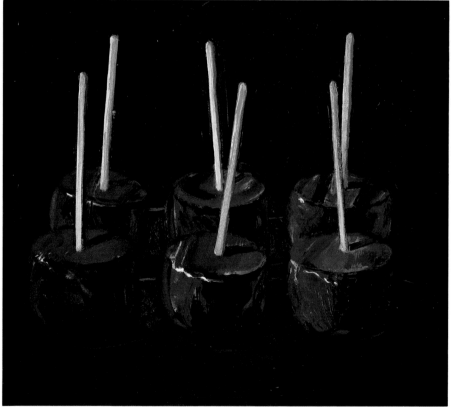

PLATE 38

BLACK SHOES, 1983

PLATE 39

DARK CANDY APPLES, 1983

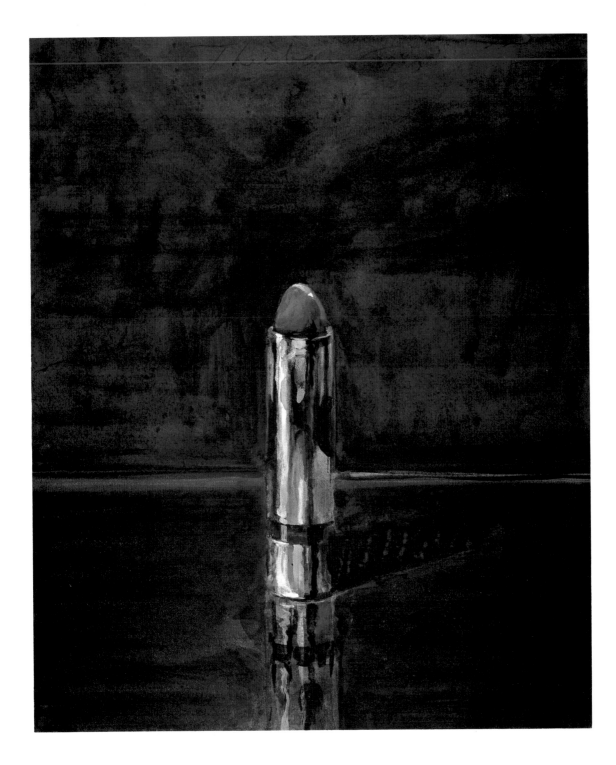

PLATE 40

DARK LIPSTICK, 1983

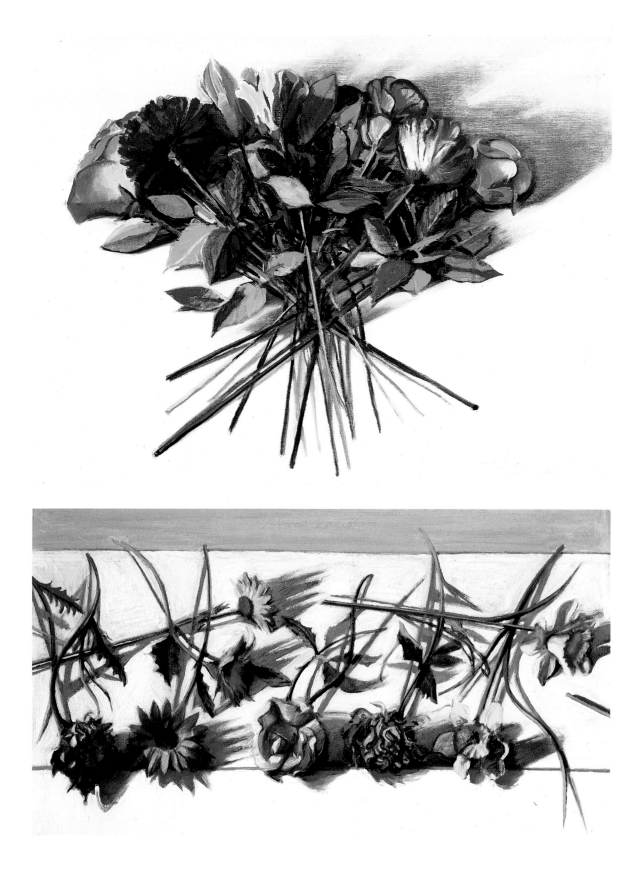

PLATE 41

FLOWER FAN, 1983

PLATE 42

FLOWER SCATTER, 1983

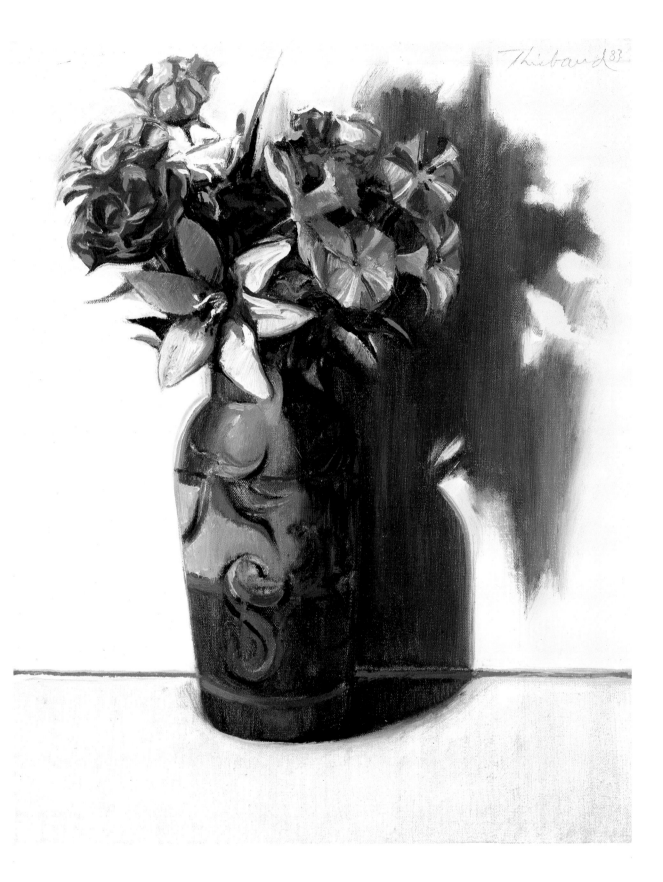

PLATE 43

BOUQUET IN VASE, 1983

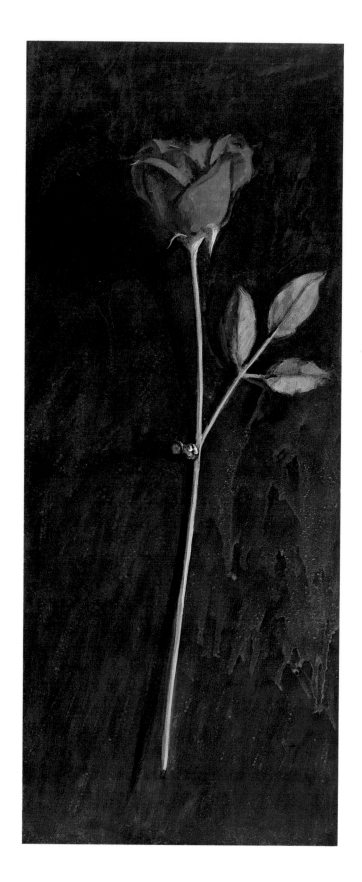

PLATE 44

PINNED ROSE, 1984

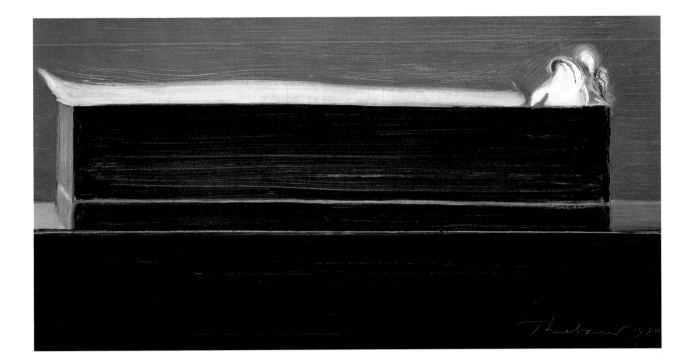

PLATE 45

BOXED ROSE, 1984

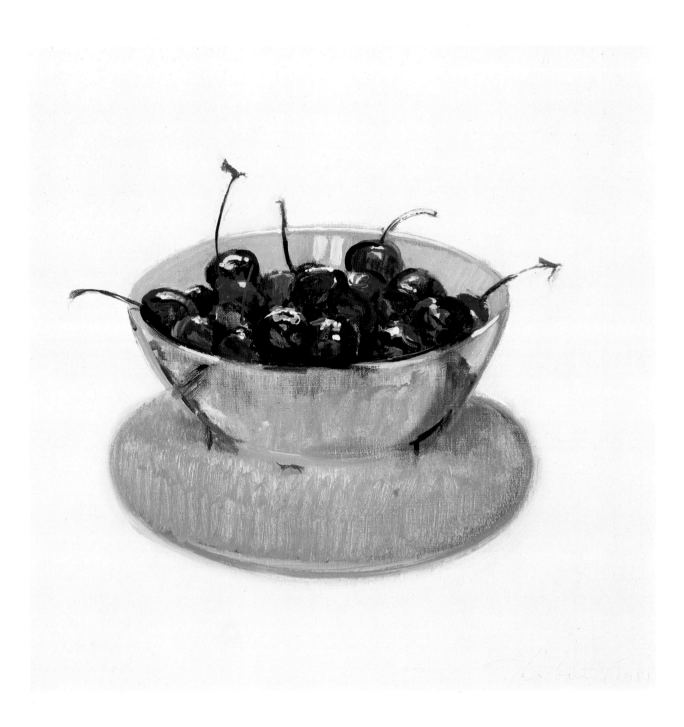

PLATE 46

CHERRIES, 1981

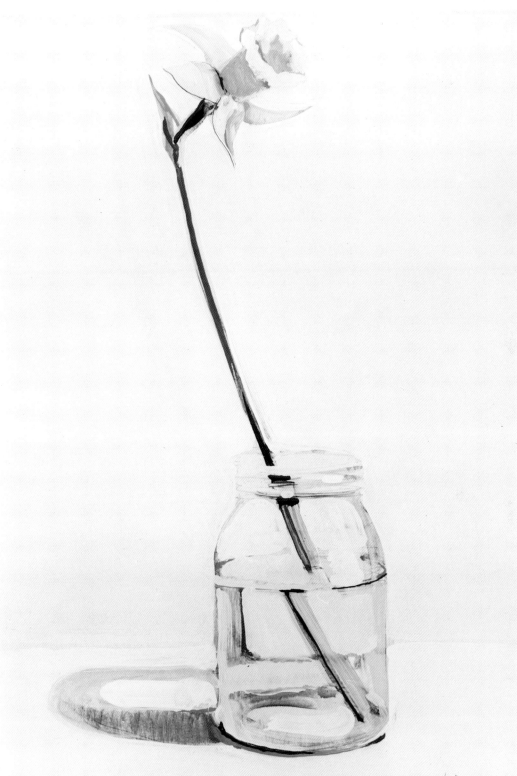

PLATE 47

DAFFODIL, 1971

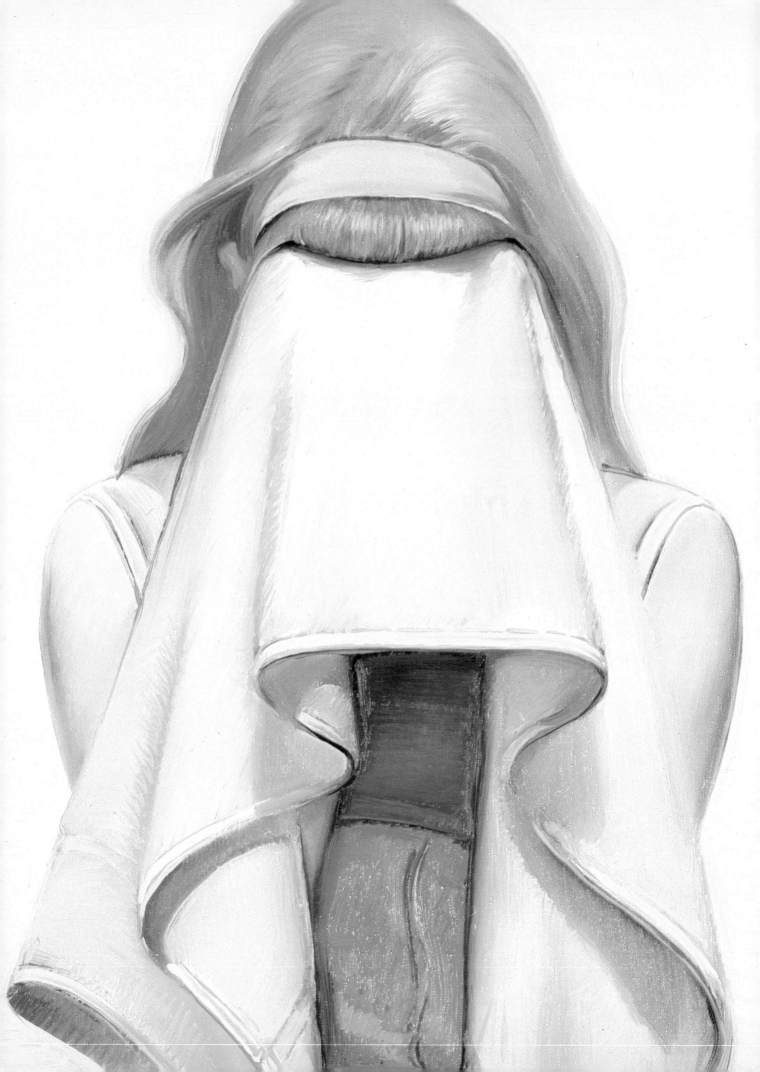

WAYNE THIEBAUD
FIGURE PAINTINGS

BEGINNING IN 1963, THIEBAUD INCREASINGLY turned his attention to the figure. For several years he had been addressing this subject at the same time that he was creating his popular images of food, but the results, he felt, were less than satisfactory. His decision to concentrate on the human figure, although he continued to produce still lifes, was also motivated by a conscious desire to interrupt the preoccupation with consumer imagery that had resulted in his identification as a Pop artist. Like most painters who are stereotyped, Thiebaud never agreed with the classification in which he and his work were placed.

The subject of the human figure in twentieth-century art has remained a constant, if not worrisome, issue. As the critic and art historian Dore Ashton has written: "In the periodic sieges of soul-searching, both among abstract and figurative painters,…the problem of the human figure is never far from the thoughts of any painter. If there is one central conflict common to all painters, it exists in the tension between the thousands of years of figure-painting and sixty years of abstraction. The truth is that no one is fully at ease."[1] The artist Philip Pearlstein has observed: "It seems madness on the part of any painter educated in the twentieth-century modes of picture-making to take as his subject the naked human figure, conceived as a self-contained entity possessed of its own dignity, existing in an inhabitable space, viewed from a single vantage point. For as artists we are too ambitious and conscious of too many levels of meaning. The description of the surface of things seems unworthy. Most of us would rather be Freudian, Jungian, Joycean and portray the human by implication rather than imitation." Yet the desire to paint the human form continues to survive. As Pearlstein has concluded, "There will always be those who want to make paintings of the human form with its parts all where they should be, in spite of Progress."[2]

Thiebaud can be counted among those artists for whom the

Detail, *Toweling Off*, 1968 (Pl. 55)

Fig. 28 Wayne Thiebaud with sons Paul (left) and Matthew (right) at Allan Stone Gallery exhibition, New York, 1965. Painting, *Bikini*, 1964, of Betty Jean Thiebaud.

human figure is a primary interest. He sees the capacity to handle the figure as the most basic measuring device of a painter's ability: "I think it's the *most* important study there is and the most challenging and the most difficult."[3] Although his figure paintings constitute only a modest portion of his total oeuvre and are far less well known than his still lifes, they have been a major preoccupation for the artist over the last twenty years.

Thiebaud's preoccupation with the figure coincided with the interests of several other contemporary painters—Pearlstein, Alex Katz, Sidney Goodman, and others—who turned their attention to this subject in the mid-sixties. Together they were seen as marking the debut of a "new realism" in American art. While their work varied substantially in appearance, Thiebaud shared with these artists a concern for painting the figure without affectation, sentimentality, or evasiveness. He was challenged by the dilemma of providing enough specific information to render the human figure recognizable and accurate yet ensuring that the painting transcended mere illustration. The ordinariness of Thiebaud's artistic statement, even its clumsiness or awkwardness, as in *Standing Man*, 1964 (pl. 53), was precisely the result of trying to reveal how things actually are, rather than how they might or should be.

In 1964, the year after he decided to concentrate on painting the figure, Thiebaud was fortuitously awarded a fellowship from the Creative Research Foundation of the University of California. The financial stipend allowed him to take a year's leave from the rigors of teaching. During this year, Thiebaud focused almost exclusively on studying and working with the human form. The resulting paintings form the core of

his figurative work, although he continues to create work based on this subject.

Thiebaud began working with the figure from memory but with "disastrous results," as he recalls: "I just didn't know enough about the figure and still don't. It's very difficult for me."[4] By the mid-sixties, he had decided to work directly from live models, often using close friends or family. Thiebaud's wife Betty Jean, for example, figures prominently in many of the artist's early and best-known paintings, among them *Bikini*, 1964 (fig. 28, pl. 51), *Woman in Tub*, 1965 (pl. 52), and *Woman Eating Ice Cream Cone*, 1965. His young children were also the subject of many of his finest and earliest figure drawings (pl. 44).

The delicate precision of Thiebaud's early figure drawings offers a striking contrast to the neon colors, thick, rich surfaces of oil paint, and almost caricaturelike description in his still lifes. The challenge of drawing for any artist is the direct and immediate notation. Few mistakes are tolerated, whether in the attenuated lines of pencil or in heavy washes of gouache. In many of his early drawings, such as *Mallary Ann*, 1964 (pl. 44), and *Dog*, 1967 (pl. 50), Thiebaud reveals his consummate skill and expediency in transposing visual observations onto a two-dimensional surface. These drawings are a sensitive synthesis of observation, reflection, and interpretation. Upon studying these works, one can almost visually "feel" a crop of wispy hair, the slight cock of a head, or the warmth of light on a bare leg.

Although many of these drawings possess the quickness of line that suggests a preliminary sketch, they are rarely used as preparatory studies for larger canvases. Rather, they are works complete in themselves. Drawing is, as Thiebaud has written, a way "to test what one can know about the look of such things as grace, sensuality, affectation, tension, repose, ineffableness, and those many mysterious characteristics which remain between a question and an answer."[5] In *Mallary Ann*, for example, Thiebaud coaxed line, form, light, and shadow into a poignant and delicate portrayal of his young daughter in quiet repose. Rendered with supple, delicate strokes of graphite and bathed in a light that gently highlights yet casts bold shadows, the drawing appears as a metaphor for the frailty, strength, and beauty of youth. At the same time, it recalls the probing draftsmanship of Jean Auguste Dominique Ingres, an artist greatly admired by Thiebaud. With its linear nuances, transparent shadows, and graceful gestures of the hand, the drawing can be read as an homage to this acknowledged French master who raised drawing to a level of great elegance and keenness.

To develop further his artistic command of the human figure, Thiebaud has regularly attended life drawing sessions. Since 1976 he has met weekly in San Francisco with fellow artists Mark Adams, Theophilus Brown, Gordon Cook, and Beth Van Hoesen to draw from a model (fig. 29). These sessions are not devoted solely to the academic study of anatomy, however. Thiebaud also seizes upon these opportunities

Fig. 29 Figure drawing group, San Francisco, 1981. From left, Mark Adams, Beth Van Hoesen, Wayne Thiebaud, Theophilus Brown, and Gordon Cook.

to examine the precedents, conventions, and deviations that constitute the rich and varied history of drawing. As he explains, "Through a neutralized and standardized mode [of figure drawing] it becomes possible to feel and think through the hands and minds of others. To sense [the] origins of a Degas back, Holbein's profile lines, of the differences between the eyes drawn by Picasso and Utamaro. By studying both the history of drawing and the practice of drawing it becomes possible to reexamine the variations and novelties extended from prime origins."[6]

The images resulting from these sessions reflect an ongoing investigation into not only anatomy but also technique. For example, many of the drawings, including *Two Figures on Bed*, 1981 (pl. 57), and *Male Nude*, 1982 (pl. 58), are much rougher in texture and more vigorously executed in charcoal than his earlier images. In these drawings, Thiebaud has turned his attention from the delicate nuances of Ingres's line to energized strokes of charcoal that recall Degas's method of creating sketchy, brisk masses of light and shadow that define form. Thiebaud does not totally abandon line but uses it as an accent, to emphasize more sensuously the rounded fullness of a breast or to distinguish more clearly the moment of juncture when flesh meets flesh. Unlike his earlier drawings, such as *Mallary Ann*, the personality of the sitter is negligible in these more recent works. Although Thiebaud moves close to his subjects, the faces are often vague or even left unfinished. He intentionally divests the personal and anecdotal from these images and focuses instead on building form and composition through broad, flickering surfaces of light and shadow.

Thiebaud's figure paintings, like his still lifes, are predicated largely upon formal inquiries. He sees the figure as a basic unit of

research and is challenged by representing accurately its many constituent plastic elements: how to create volumetric form on a flat surface; how to foreshorten a foot; how to distinguish a crease of cloth from a fold of flesh. When an artist paints the figure, what he or she actually sees is a fascinating kaleidoscope of abstract shapes and contours that radically change if the figure is clothed or nude, the pose varied, or the lighting altered. Given these variables, Thiebaud works perceptually, rather than conceptually. He aspires to paint only that which meets the eye, to capture what Pearlstein has described as the "constellation of still-life forms" inherent in the human figure.[7]

To enhance his concentration on the figure, Thiebaud generally places his models against an unadorned white backdrop and illuminates them with intense floodlights. This clinical austerity creates a nonnarrative context that forces the artist, and the viewer, to concentrate on the figure. This lighting technique also allows Thiebaud to explore more fully a concern related to his still lifes: how strong light defines forms, enhances the effects of halation, and alters our perception of reality. Once the model is posed and lit, Thiebaud stares intently at his brightly illuminated subject. By staring rather than merely glancing, he has found, the subject and moment are infinitely expanded and clarified by the total engagement and focus of the eye. This phenomenon, coupled with the spare environment and the intensity of illumination, heightens his perception of visual data. The colors of a yellow and orange polka-dot bikini (pl. 51), for example, appear to his vision almost electric, or, as in *Girl with Pink Hat*, 1973–76 (pl. 56), the warm and cool tones of human flesh are richer and more varied, the shadows more energized and light filled, than normally perceived. The imperfect merging of edges is also made more manifest, resulting in pronounced effects of halation.[8] Thiebaud paints his figures circumscribed by a nimbus of colors—red, yellow, green, blue, orange—calculated to describe the indeterminate contours of forms seen in very bright light.

The settings in Thiebaud's figure paintings are always specifically defined, but the poses are chosen, for the most part, in a random manner. The artist has no preconceived ideas for compositions when he begins a canvas but has the model move about and assume different positions—sitting, standing, crouching, lying down. Thiebaud sometimes spends six or eight hours selecting a pose, but when his decision is finally made, it is based on a strictly intuitive response. Rarely does Thiebaud know, or even care to question, why a particular posture is chosen. Nevertheless his decisions, while intuitive, are not arbitrary. Thiebaud intentionally shuns narrative content, tightly controlling the associative level of his images. "If I come upon something that looks like it might be illustrational, I shy away from it," he has explained.[9] Thus, in many of his paintings Thiebaud selects frugal, unassuming poses that reveal minimal action or intent.

Compounding this sensibility, Thiebaud scrutinizes his subjects with a marked degree of emotional detachment. Not interested in

discovering the psychological sinew of his sitters, he paints them with a sense of distance and reserve. It is as though he were following Gustave Courbet's advice to his students to paint the human figure as one would an apple. "The figures...are not supposed to reveal anything," Thiebaud notes. "It's like seeing a stranger in some place like an air terminal for the first time. You look at him, you notice his shoes, his suit, the pin in his lapel, but you don't have any particular feelings about him."[10] In *Bikini*, 1964 (pl. 51), Thiebaud painted his model face forward, full length, and as stolid and expressionless as an earthenware jug. Though the woman is clad in a colorful bikini, the image is barren of any sexual or erotic overtones. She is as passionless as a participant in a police lineup posing for a mug shot. Thiebaud paints the figure as she simply is: slightly potbellied, thick waisted, totally self-contained, and decidedly unsensuous. The painting is not a portrait in the ordinary sense but a curious dialogue between the general and the particular. While Thiebaud captures the likeness of his model, he is little concerned with reflecting any psychological insights into her personality. He is interested, instead, in what the person is most specifically not: not representative of a philosophical position, lifestyle, or physiological type. She just is. Without any frame of reference, the figure becomes a virtual abstraction, an existential confrontation of facts.

Thiebaud's paintings go well beyond this singular level of interpretation, however. As Gene Cooper has noted, the artist casts his figures in a difficult role by trying to persuade the viewer that they exist solely in a world of formal devices, void of psychic dimensions and symbolic associations.[11] This is no simple task when painting the human figure. The level of common experiences, memories, emotions, and anthropological constants among people cannot be dismissed so easily. The subject, because we know the human figure so intimately, inevitably evokes a reaction no matter how objective or unemotional the artist's portrayal.

Thiebaud's paintings can be read very differently from this point of view. The canvas *Woman in Tub*, 1965 (pl. 52), for instance, is quite simply a brightly lit image of a female figure soaking in a bathtub. Yet the austere simplicity of the composition, the cold light that pervades the canvas, the blank, staring eyes, and the suggestion of a beautiful but severed head evoke a sense of disquietude that contradicts the ordinary content of the image. This sensibility is heightened by the realization that the canvas was inspired, in part, by Jacques Louis David's acclaimed painting *The Death of Marat*, 1798, an homage to a French revolutionary murdered while bathing. Compositionally, the two works share much in common: the reclining figures emphasize the horizontal division of the picture plane, and the environment in which they appear is starkly empty. The grand simplicity of Thiebaud's composition directs the eyes to focus on the enigmatic expression of the woman, just as David's composition leads the viewer to the partly anguished, partly smiling face of the assassinated Marat. Thiebaud's painting obviously lacks the political content of David's masterpiece; nonetheless, a subtle but disarming sense of drama

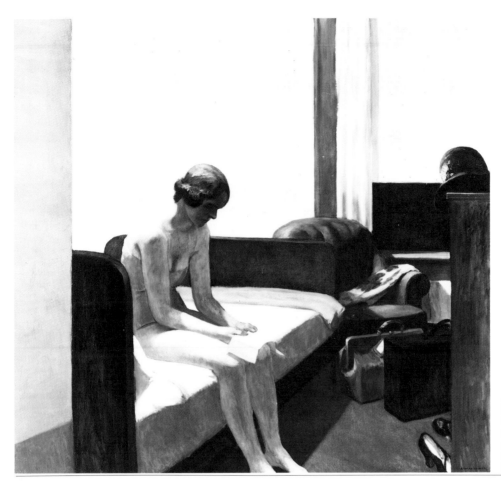

Fig. 30 Edward Hopper, *Hotel Room*, 1931, oil on canvas, 60×65¼" (152.4×165.7 cm.). Thyssen-Bornemisza Collection, Lugano, Switzerland.

is hinted at through the vacant yet forceful expression of the reclining woman.

The evocative quality of Thiebaud's figure paintings is enhanced by the particular aspect of time that marks many of his canvases. Although he eschews storytelling devices, Thiebaud is fascinated by that essential element of narrative art: the passage of time. Traditionally, narrative figure painting suggests action and a sequence of events in which there is an implied cause and effect, an inferred beginning, middle, and end. But Thiebaud is interested in the time in between, when something may be happening or has happened. He has explained: "It occurs to me that most people in figure paintings have always done something. The figures have been standing, posing, fighting, loving, and what I'm interested in, really, is the figure that is about to do something, or has done something, or is doing nothing, and, with that sort of centering device, try to figure out what can be revealed, not only to people, but to myself."[12]

The interest in freezing a moment in time recalls the work of Jan Vermeer and Edward Hopper, two artists held in highest esteem by Thiebaud. The poignant drama of Vermeer's *Girl Reading a Letter at an Open Window*, ca. 1659, hinges on a moment of solitude as a young woman

reads a letter by an open window, the sunlight pouring in, illuminating her body and the room. The figure is momentarily transfixed in time, a delicate porcelain figurine in an intimate still life. Edward Hopper's painting *Hotel Room*, 1931 (fig. 30), likewise depicts the drama of a frozen moment. The partially nude woman sits on the bed, her head downcast, holding a document in her hands, but the exact meaning of the situation is vague. Is the woman distraught, pondering a love letter? Or is she simply fatigued from her day's journey, idly fingering the next day's train schedule? Hopper does not give a specific answer but plants provocative clues.

Thiebaud evokes this sense of time stopped and veiled meaning in works such as *Man Reading*, 1963 (pl. 48), and *Toweling Off*, 1968 (pl. 55). In *Man Reading*, the figure, dressed in a suit and tie, slumps forward in his chair clutching a book. Significantly, the book is unopened. Like Hopper's painting, the import of the image lies in the vague references and the snapshot pause in time. Is the figure simply resting from reading, head down, or is it the anguished and fatigued posture of a man whose burdens literally weigh his shoulders down? In *Toweling Off*, the woman buries her head in a towel between rounds of a tennis match.[13] With her face obscured, the viewer can only guess at her thoughts and feelings. Is she exhausted, angered, disappointed, triumphant? We can never know the answer for sure. Like a voyeur, we catch Thiebaud's figure in an instant of quiet expectancy, a moment of intimate drama. It is the fullness and self-sufficiency of the moment that Thiebaud insists upon, a moment of inexplicable, almost metaphysical evocativeness.

Thiebaud's figure paintings, despite their apparent simplicity and straightforwardness, are enmeshed in a complex dialectic. Many are painted almost life-size, the figures at once disorientingly immediate yet totally inaccessible in their self-contained, imperturbable space. They suggest completeness of physical being, but also aloneness and isolation, painted as they are against a backdrop of emptiness. The figures are enigmatic, prompting questions, because Thiebaud, like Hopper, communicates by reserving comment. By denying specific meaning, he provokes it, intensifying our sensations of consciousness. Upon viewing his enigmatic figures we are prompted to question their meaning and, in the process, are made much more aware of our own solitary existence. It is our life alone that imbues these figures with meaning.

NOTES

1. Dore Ashton, "What About the Human Figure?," *Studio*, August 1962, p. 68.

2. Philip Pearlstein, "Figure Paintings Today Are Not Made in Heaven," *Art News*, Summer 1962, p. 39.

3. Tooker, "Wayne Thiebaud," p. 22.

4. Arthur, *Realists at Work*, p. 124.

5. Thiebaud, untitled article, *Figure Drawings: Five San Francisco Artists* (San Francisco: Charles Campbell Gallery, 1983), n.p.

6. Ibid.

7. Philip Pearlstein, "The Process Is My Goal," in "The Art of Portraiture, in the Words of Four New York Artists," *New York Times*, 31 October 1976, p. D-29.

8. Thiebaud has noted that this colored-edge effect is made even more apparent because he wears glasses. He has also observed that when he stares intently at objects under bright lights for extended periods of time, eye fatigue intensifies this phenomenon.

9. Albright, "Scrambling Around," p. 86.

10. William C. Glackin, "Wayne Thiebaud," *Sacramento Bee*, 3 October 1965, p. L-9.

11. Cooper, "Thiebaud, Theatre, and Extremism," p. 27.

12. Tooker, "Wayne Thiebaud," p. 22.

13. In 1968 Thiebaud was commissioned by *Sports Illustrated* to create work based on a visit to the Wimbledon Tennis Tournament in England. *Toweling Off*, 1968, is one of several works that resulted from this commission.

PLATE 48

MAN READING, 1963

PLATE 49

MALLARY ANN, 1964

PLATE 50

DOG, 1967

PLATE 51

BIKINI, 1964

PLATE 52

WOMAN IN TUB, 1965

PLATE 53

STANDING MAN, 1964

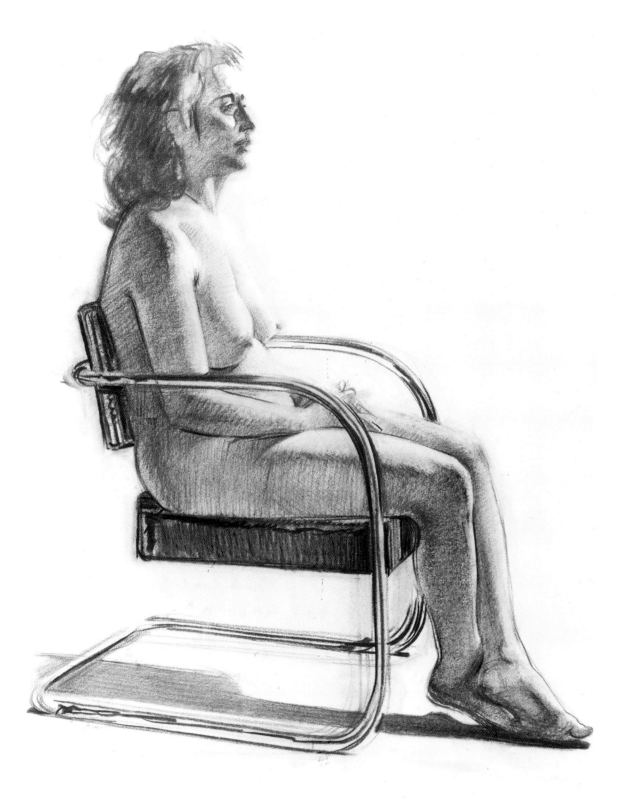

PLATE 54

NUDE IN CHROME CHAIR, 1976

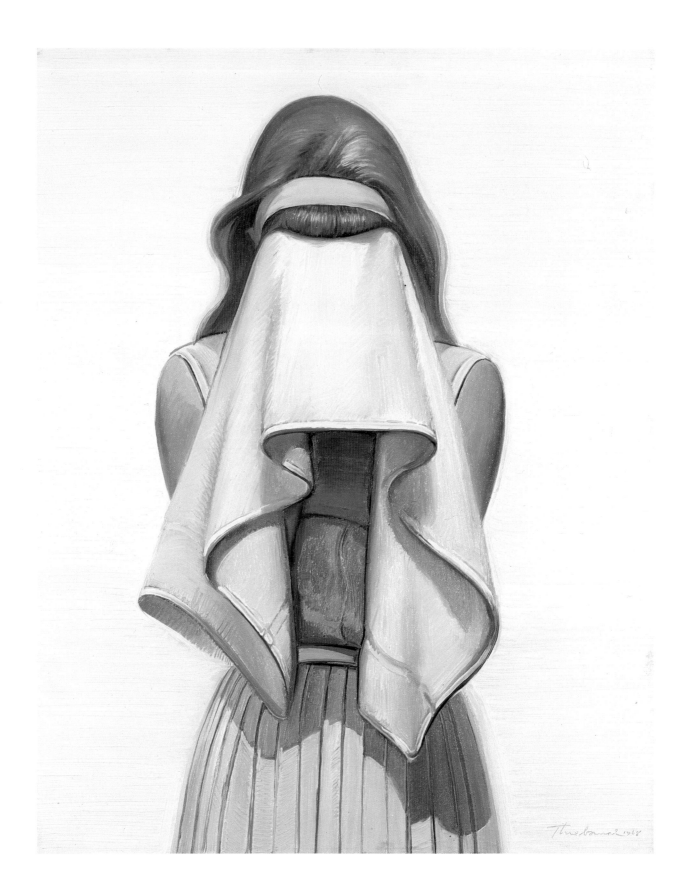

PLATE 55

TOWELING OFF, 1968

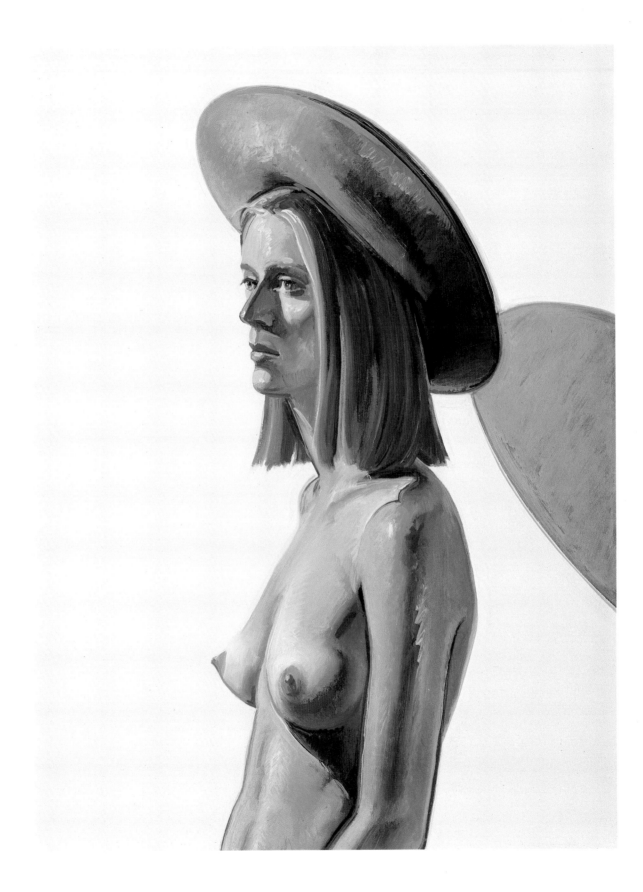

PLATE 56

GIRL WITH PINK HAT (NUDE IN PINK HAT), 1973–76

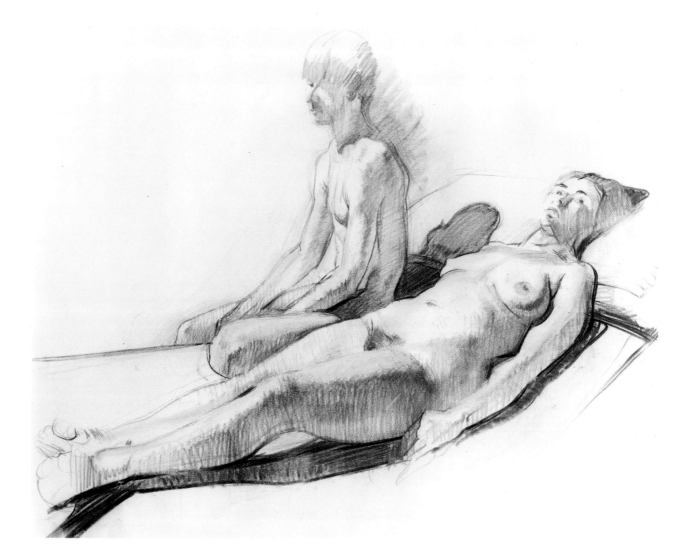

PLATE 57

TWO FIGURES ON BED, 1981

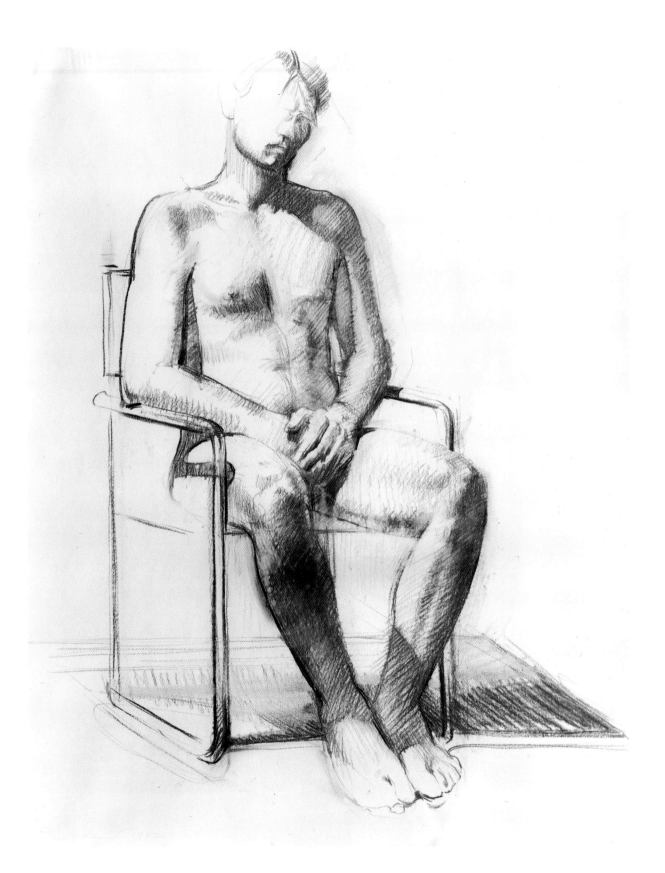

PLATE 58

MALE NUDE, 1982

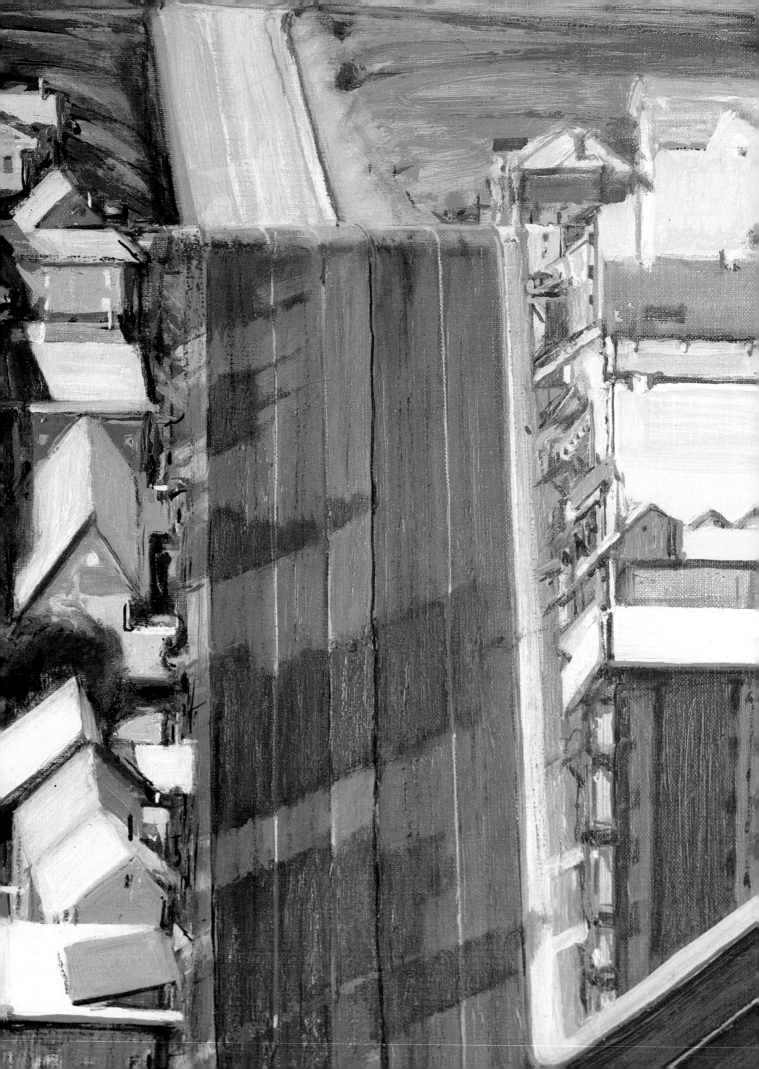

WAYNE THIEBAUD
LANDSCAPES

LANDSCAPES, BOTH RURAL AND URBAN, COMPLETE the triumvirate of Thiebaud's major subjects. In these paintings, Thiebaud works within the most traditional confines of the genre, placing emphasis on the physical qualities of a scene, whether artificially created or natural. People are rarely included. When they do appear, as in *Corner Apartments*, 1980 (pl. 75), they are almost negligible, minor punctuation in the major context of the work.

In his landscapes, as in all his work, Thiebaud looks to historical antecedents, drawing upon the traditions of other painters, whether the French Impressionists or the Chinese landscape artists. But Thiebaud assiduously avoids the allegorical, celebratory, or moralizing stances that characterize many landscape paintings. He neither romanticizes nature nor despairs of our urban centers. The paintings are simply a variation on the underlying thread that weaves his extensive and varied oeuvre together: the landscapes and cityscapes serve as another forum for formal investigation. Thiebaud explains, "I'm not just interested in the pictorial aspects of the landscape—see a pretty place and try to paint it—but in some way to manage it, manipulate it, or see what I can turn it into."[1]

Thiebaud began focusing on landscapes in 1966, soon after his concentrated production of figurative work. His initial paintings and drawings were based on the rural Sacramento valley: the farm ponds, delta sloughs, hay bales, and gently rolling hills of this rich agricultural region. Many of these early works, such as *Pond and Trees*, 1966 (pl. 60), are small experiments in pastel, a soft, pliable medium that allowed Thiebaud to draw and paint at the same time. Although intimate in scale, *Pond and Trees* is impressive in its presence. Thiebaud created a glowing, impressionistic atmosphere by layering contrasting and related hues—vivid reds, opulent oranges, bright yellows, hot pinks, and purple blues

Detail, *Holly Park Ridge*, 1980 (Pl. 69)

—over one another with strokes that vary in size and direction. The precision of form and line that normally characterizes Thiebaud's work here gives way to sketchy, luminous patches of color, not unlike the pastels of Edgar Degas. The drawing is a resonant study in color and light, the brilliant hues evoking the intense heat and radiant atmosphere of a Sacramento summer sunset.

Thiebaud's experiments during this period with different media and techniques were also carried out in large canvases. In *Coloma Ridge*, 1967–68 (pl. 61), and *Cliffs*, 1968 (pl. 62), the succulent impastoes of his earlier oils give way to thinly stained washes of acrylic. Often, as in *Cliffs*, the acrylic paints are applied to simulate the texture and appearance of pastel. This recalls Thiebaud's experiments with object transference in his still lifes—the manipulation of paint to mimic other substances. The thin washes of acrylic in other paintings, such as *Coloma Ridge*, find their precedent in Morris Louis's *Veil* paintings of the late fifties.

Louis was a pioneer in the stain method of color field painting that emphasizes the allover effect of color. He subordinated the individual elements of a composition to a vision of a laterally expanding, continuous picture plane, as in *Tet*, 1958 (fig. 31). But, as the art historian Michael Fried has suggested, Louis may have also found in this technique a means for a new, unimagined type of figuration.[2] In Louis's system, staining one veil of pigment over another, no matter how subtle the change in hue or value, indicates transition. Fried has pointed out that the perception of such changes is the perception of figuration.

Considered in this context, perhaps Louis's paintings had the impact on Thiebaud of a Rorschach test in which a viewer interprets an abstract inkblot as some recognizable form. Psychologists refer to this phenomenon as *projection*: the human propensity to read into vague, accidental shapes images that are stored in the mind. Seeing Louis's amorphous waves of color perhaps prompted Thiebaud to visualize the dramatic breadths and heights of the ridges and mountains just outside of Sacramento into paintings such as *Coloma Ridge*. Here Thiebaud explores the representational possibilities of Louis's stain technique, employing successive waves of thinned acrylic paint to describe the shape of the ridge. In the broad, rich washes of deep blue, the chance fluctuation of colored edges are used to suggest geological striations. Thiebaud further enhanced the textures and forms of the ridge by working rich strokes of pastel into the washes of color.

Thiebaud also introduced dramatic, if somewhat unorthodox, compositions into his landscapes. For example, in *Coloma Ridge* a hillside cuts diagonally across the canvas; and in *Half Dome and Cloud*, 1975 (pl. 63), the image is cropped at a radical angle that minimizes and all but obscures the towering grandeur of this famous granite formation in Yosemite National Park.[3] Instead, a single cloud seems to command the composition. The incongruity of scale and the radical cropping of the image suggest the influence of photography. Thiebaud, however, does not

Fig. 31 Morris Louis, *Tet*, 1958, synthetic polymer on canvas, 93½ × 115½″ (237.5 × 293.4 cm.). Whitney Museum of American Art, New York; Gift of the Friends of the Whitney Museum of American Art 65.9.

use photographs in the creation of his paintings, explaining that he finds photography too one-dimensional. Nonetheless, the arbitrary cropping and the close-up, radical disjunction of scale that modern photography and cinematography have introduced to the visual arts cannot be totally discounted as having had an impact on the artist's work. A more direct influence, however, can be traced to Thiebaud's experience in commercial layout. The use of cropping as a dramatic device and the manipulation of size and scale—for example, bleeding images off sides of layouts or blowing them up for displays—have had a pronounced impact on not only his landscapes but his still lifes and figure paintings as well.

In these paintings, Thiebaud was specifically interested in confusing the reading of space and eliminating the horizon line, the fixed vantage point normally associated with landscape painting. "Landscape for me took on the problem of composition," Thiebaud explains. "I wanted to eliminate the horizon line, to see if I could get a landscape image that didn't use a horizontal fixation. Instead, I try to establish a positional directive for the viewer—whether it's up, down, helicopter view, world view, valley view—to try and get some sense of the loss of the convenience or comfort of standing and looking at things, to throw people off a bit."[4]

Cliffs, 1968 (pl. 62), reflects Thiebaud's experiments with different landscape compositions: its vantage point is from a worm's eye view. From this angle, the richly colored palisades loom above, almost engulfing the viewer in their undulating folds. The imposing height of the bluffs, unfurling in the distance, is reinforced by the tiny toothpick-like trees that suggest the scale of the cliffs and by the sheer size of the painting itself: measuring eight by five feet, the canvas is among the largest Thiebaud has ever painted. Although it is not as massive as the work

of many other modern painters—Morris Louis, Clyfford Still, and others—the size of the canvas nonetheless augments the viewer's loss of position, the feeling of being swallowed by the image.

Although many of these landscapes may appear as exaggerated figments of Thiebaud's imagination, they are the result of actual observations and subsequent visual recollections of natural wonders such as the Grand Canyon, the eroded hills of California's gold and wine country, and the granite heights of Yosemite National Park. The paintings are based on small drawings and paintings executed on site but completed in the artist's studio (fig. 32). The imagery of *Cliffs* is thus grounded in reality but also enriched by Thiebaud's childhood memories of growing up in southern Utah with national parks such as Zion and Bryce as his backyard.[5] As a young boy, the precipitous heights of the cliffs must have seemed even more overwhelming, and it is these vivid recollections that intensify the impact of Thiebaud's landscapes.

The psychologist Rudolf Arnheim has confirmed the powerful role memory plays in visual cognition, explaining that perception cannot be confined only to what the eye records. He has noted that a perceptual act is never isolated, that it is only the most recent phase of a stream of innumerable similar acts performed in the past and surviving in memory. Visual perception is contingent upon both preexisting mental imagery and direct sensory observations. Arnheim concludes, "No neat borderline separates a purely perceptual image—if such there is—from one completed by memory or one not directly perceived at all but supplied entirely from memory residues."[6] Memory thus plays a crucial role in the realization of any artist's work. In Thiebaud's landscapes, memory sharpens, interprets, and clarifies his direct visual observations and gives color, scale, and composition a more brilliant expression.

The concern with spatiality and removing the horizon line, introduced in Thiebaud's landscapes of the sixties, manifests itself even more richly in his San Francisco cityscapes. Next to his still lifes, this is the largest and most varied group of Thiebaud's paintings and drawings and is in part the result of a move to San Francisco in the early seventies.

In 1973, Thiebaud purchased a second home in the city, a Queen Anne cottage located on Potrero Hill, one of the many summits that define San Francisco's unique and renowned terrain. Popular legend has it that the city, like Rome, is defined by seven commanding peaks, but in fact more than forty can be counted. Although not among the tallest, Potrero Hill rises conspicuously just south of San Francisco's busy downtown and financial district. Originally used by the Spanish as a pasture—whence comes its name—it became a popular enclave for Russian immigrants fleeing the Russo-Japanese war in the early 1900s. Today Potrero Hill is a quiet residential community rising serenely above one of San Francisco's busiest industrial sections. The railroads, bridges, piers, and warehouses that punctuate the hill's landscape and the arteries of two major freeways that swirl around its base are the subjects that Thiebaud focuses on in many of his cityscapes, including *Toward 280*, 1978 (pl. 81),

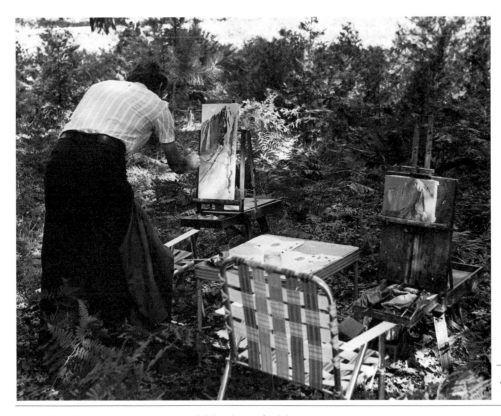

Fig. 32 Wayne Thiebaud, Yosemite National Park, California, ca. 1974–75.

and *San Francisco Freeway*, 1980–81 (pl. 82).

Like many summits in San Francisco, Potrero Hill is harshly marked by angular patterns of cement and blacktopped streets. In the haste to build the city and rebuild it after the Great Fire of 1906, many of the streets were carved straight up the sides of hills instead of being laid out along the contours. Some streets, as seen in Max Yavno's photograph *California Street*, ca. 1960 (fig. 33), rise so abruptly that they appear to shoot perpendicularly into the air, recalling the poet George Sterling's exultation: "At the end of my street are stars!"

Sparked by the unique physiognomy of San Francisco, Thiebaud posed the problem to himself of capturing on canvas the topographical extremes of the city. "Going to San Francisco," he has explained, "I was...fascinated by those plunging streets, where you get down to an intersection and all four streets take off in different directions and positions. There was a sense of displacement, or indeterminate fixed positional stability. That led me to this sense of 'verticality' that you get in San Francisco. You look at a hill, and, visually, it doesn't look as if the cars would be able to stay on it and grip. It's a very precarious state of tension, like a tightrope walk."[7]

Given San Francisco's unique topography and beauty, it is surprising that so few painters have chosen to paint it. The tendency among Northern California artists to move away from realist painting and toward personal metaphor and painterly abstraction mitigates against this city as a subject. This tendency can be traced in part to the influence

of artists, including Clyfford Still and Mark Rothko, who taught in San Francisco in the late forties. Most notable among the few who have chosen to paint the landscape of San Francisco is Richard Diebenkorn, an artist whom Thiebaud acknowledges as having influenced his cityscapes.

In the early sixties, as part of his turn toward figuration, Diebenkorn completed a number of urban landscapes, among them *Cityscape I*, 1963 (fig. 34), and *Ingleside*, 1963 (fig. 35). Early critics remarked on the astute marriage of figurative imagery and expressionistic paint handling in these paintings. But for Thiebaud, the significance of Diebenkorn's work also lay in the unusual perspectives of the cityscapes, which created spatial ambiguities and tension. Often the vantage point is an elevated one, but how high above the horizon line remains unclear. Thiebaud likewise obscures the perspective of his landscapes, often working from an elevated position that destroys any sense of horizontal stability.

Despite their shared interest in painting cityscapes of San Francisco, there are substantial differences between the work of the two artists. Thiebaud is more concerned with problems of spatiality: how to evoke the extreme verticality of the city's terrain and how to confuse the reading of space. By contrast, Diebenkorn sought primarily to discover abstract patterns within the real world. While Diebenkorn's paintings may be seen as representational, they are highly abstract in structure and foreshadow the nonobjective, geometric configurations of his *Ocean Park* series, begun in 1967. In *Cityscape I*, for example, buildings and grassy fields are discernible but so radically simplified that they read as interlocking and abutting planes of color. The elevated perspective of the painting compresses the space, and the tilted planes of the streets and open fields read as flat shapes geometrically dividing the picture's surface.

By contrast, Thiebaud includes numerous details: cars, trees, crosswalks, streetlamps. Although he is not necessarily concerned with the minute accounting of fact, his inclusion of these elements encourages a realistic reading of the paintings. But Thiebaud also employs these elements to confuse the reading of space or to accentuate the vertical thrust of a street. Cars, trucks, and buses appear tiny and buglike, tentatively and uncomfortably poised on steep hillside streets. Trees are sometimes rendered illogically—larger in the background than in the foreground—or the lines of a crosswalk are painted parallel, flattening space, when reason suggests they should converge.

Many of Thiebaud's first cityscapes were small plein air studies, like *Chestnut St. near Hyde*, 1971 (pl. 84), and *Toward Twin Peaks*, 1976 (pl. 85).[8] Painted on site, these works are characterized by quick, impressionistic notations of pigment that capture the urban density, careening streets, and spewing pollution of the city. These studies were often used to complete larger works in the artist's studio. But for the most part, the larger canvases completed in this period did not meet Thiebaud's expectations: the paintings were often too stable and self-contained and lacked the immediacy and vitality of the roller-coaster-like plunges and ascents of the city's thoroughfares.

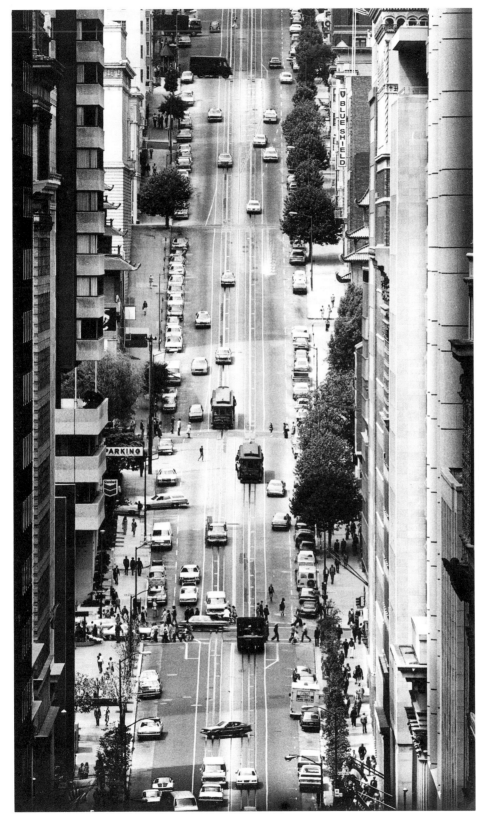

Fig. 33 Max Yavno, *California Street*, ca. 1960, gelatin silver print, 13⅝ × 8¹⁄₁₆″ (134.6 × 20.5 cm.). Courtesy G. Ray Hawkins Gallery, Los Angeles.

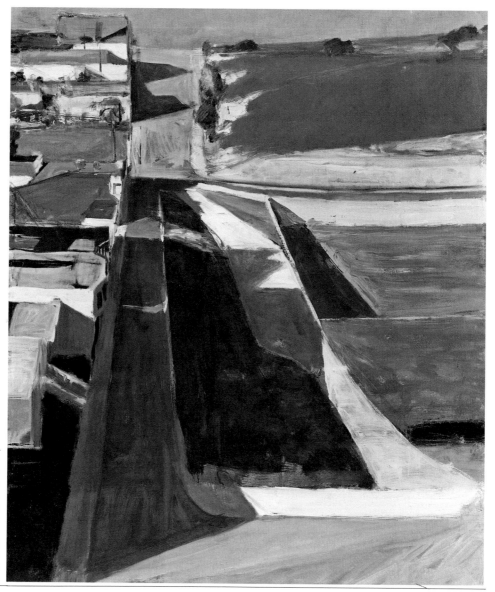

Among the most successful of these early canvases is *24th
Street Intersection*, 1977 (pl. 65). In the painting, Thiebaud portrayed a real
San Francisco hillside intersection where the streets diverge in four sepa-
rate directions at different angles.[9] With its mansarded architecture,
conspicuous absence of people, and hermetic atmosphere, the painting
also reflects an uncanny sense of quietude and urban loneliness not unlike
that found in the paintings of Edward Hopper. But the feeling of urban
desolation was not what Thiebaud was seeking. In subsequent paintings,
he evoked more emphatically—and at the expense of factual information
—the giddy vertigo of San Francisco's streets.

Following his initial attempts at the cityscapes, Thiebaud
temporarily stopped painting and concentrated instead on drawing for
roughly a six-month period. The resulting works, among them *Toward*

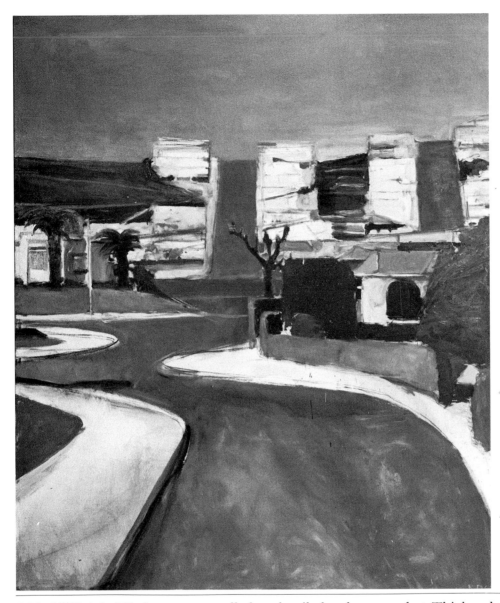

Fig. 35 Richard Dieben-korn, *Ingleside*, 1963, oil on canvas, 81¾ × 69½″ (207.6 × 176.5 cm.). Grand Rapids Art Museum, Michigan; Purchase.

280, 1978 (pl. 81), began as small thumbnail sketches, or what Thiebaud refers to as "visual hunches," executed on site and often nearby Potrero Hill.[10] Thiebaud then reworked the images in a larger format in his studio. Using graphite on large sheets of paper or bristol board, he experimented freely, modifying compositions, erasing, smudging, adding, and moving around forms. Regarding his working method, Thiebaud explains: "If you are there, at the site, the tendency to be realistic is imposed upon you continuously, and that may restrict or cut back your ability to hypothesize."[11] Although *Toward 280* is representational, the emphasis is on the city's mazelike topography and the dynamic thrusts and counterthrusts of its streets, buildings, and freeways. Thiebaud added or rearranged elements of these patterns as he saw fit, relying on memory, sketches from other scenes, and his imagination. These drawings were a

breakthrough for the artist, encouraging him to loosen his grip on visual fact and become more interpretive. They revealed the possibilities of moving his cityscapes in a more expressive and inventive direction.

Thereafter, Thiebaud's paintings became much more audacious. In *California Street*, 1978 (pl. 67), for example, the blacktopped thoroughfare dramatically plunges and crests like a gigantic roller coaster. The painting at first appears highly realistic, with its buildings receding in space and shadows logically falling in the same direction, but a distortion in perspective soon asserts itself in the work. The street does not converge in the distance, as expected, but shoots straight up the canvas, causing a subtle but apparent spatial compression. In *Holly Park Ridge*, 1980 (pl. 69), the streets are so radically foreshortened that they read as almost flat against the picture plane.

The simultaneous reading of depth and flatness in paintings such as *Holly Park Ridge* reflects Thiebaud's grappling with the dilemma that faces all modern painters: how to reconcile three-dimensional space on a two-dimensional surface without adhering to the concept of pictorial space defined in the Renaissance. This dilemma recalls the masterful experiments of Cézanne, who devoted himself to this spatial problem—works to which Thiebaud has referred: "In Cézanne there is always this swelling, like the volume trying to get away from the plane, even though there is also a linear matrix. It's like trying to have both worlds simultaneously. If this kind of anthologizing of procedure and inference of spatial concerns can be evident in [my] painting, I think it's much more interesting."[12]

In his cityscapes, Thiebaud follows Cézanne's lead, neither forsaking the flatness of the picture plane nor totally surrendering his images to volumetric illusion. Instead, in *Holly Park Ridge* and *Down 18th Street*, 1980 (pl. 66), he juggles both sensibilities. Rooftops, building walls, and streets read simultaneously as three-dimensional volumes and as flattened shapes. Thiebaud seeks to create visual tensions between the reading of surface and depth, explaining, "If your space is too extensive in painting, it seems to me that it doesn't really function....For me the problem [is] always attempting to restate the plane in some comforting way where you feel you are 'pushed back' from the space that is actually there."[13]

To create this sense of being "pushed back," the artist often telescopically flattens the space in his paintings. Thiebaud has actually used a telescope at his Potrero Hill home to discover ways to visualize forms radically foreshortened in space. But, more significantly, these paintings are experiments with the Eastern mode of isometric perspective. Devised by the Chinese around the time of Christ, the Asian system of perspective is exactly the opposite of that of the Western world. Asian artists project the center of vision beyond human perspective: the view of the world is open and expansive, rather than closed and converging. In oriental art this sensibility is achieved by two essential principles: lines must converge as they approach in the foreground; and the higher up an

object is placed in a composition, the further back it is meant to be read in space. In a Japanese print, for example, the floorboards of a porch grow wider as they recede and tilt sharply upward so that they are to be read as being in the distance.

This way of describing perspective compresses space and pushes forms out from the picture plane. Though such images may read as spatially incorrect to the Western eye, an English critic with mathematical training, Wilfrid Wells, has analyzed this system of perspective and found that its canons are just as methodical and scientific as those that govern the Western world.[14] In many of his paintings Thiebaud employs this Eastern method of visualizing space: streets or a block of buildings appear to press out toward the viewer as they climb up a hill but simultaneously read as moving back in space.

Often Thiebaud will combine different points of perspective within a single painting to create a completely disorienting sense of space. *Curved Intersection*, 1979 (pl. 68), for example, reads as an outrageous pastiche of three or four different points of view combined in the same canvas. Some buildings converge toward the viewer in the Eastern way of visualizing space, while others recede according to traditional Western perspective. In contrast, the streets and intersection read in a flattened, maplike mode, much in the manner of a primitive painter or Persian miniaturist's work. The steepness and bend of the street are indicated by a curved shape shooting straight up the image; the horizontal plane of the intersection is depicted as a flat shape against the canvas surface. The diagonal cut of the street in the bottom center further adds to the confused reading of space in the picture. Conceptually it appears to be a continuation of the vertical street above, but the contrast between the vertical and the diagonal thrusts of the road is so extreme that this section of street seems lifted from another canvas and superimposed onto the painting. The irrational, if not fantastic, nature of the painting is crowned by a reversed perspective: the palm tree in the middle ground appears taller than the row of trees in front of it.

In *Art and Visual Perception*, Arnheim asserts that the expressive properties of perspective are most apparent when they are not used to reproduce realistic space but are freely modified for certain effects.[15] A striking example of this expressive distortion is found in the work of Giorgio de Chirico. The multiple vanishing points in de Chirico's paintings create contradictory spatial systems in which the viewer feels insecurely suspended and on unsure footing. Thiebaud, like de Chirico, recognizes the psychological impact that variable perspective has in painting, and in his cityscapes he pushes this to an extreme. He creates a network of conflicting spatial tensions that evoke a sense of physical disorientation and psychologically undermine the viewer's impression of stability. Thiebaud places the constituent pictorial elements in his cityscapes, not in obedience to any single law of perspective, but according to what one might call the artist's higher law: Put things where they create the most potent desired effect.

The dramatic impact of the cityscapes is also the result of a sense of physical pressure that Thiebaud seeks to evoke. This "physical empathy transfer," whereby the viewer experiences a sense of tremendous tension through the artist's manipulation of spatial structures, was the same problem addressed in earlier still lifes, such as *Three Cold Creams*, 1966 (pl. 14), and influenced by Morandi.[16] In his cityscapes, Thiebaud achieves this same spatial tension by developing a kind of architectural sensationalism where forms plunge, soar, lean, or float. In *Apartment Hill*, 1981 (pl. 79), for example, the small apartment buildings are wedged so tightly together and balanced so precariously on the brink of a hilltop that they provoke an uneasy instability that is further heightened by the verticality of the sheer clifflike hill, the larger, glittering tower in the background, and the turbulent freeway that rushes far below. An extreme sense of physical disquietude is also prompted in *Hill Street*, 1981 (pl. 73), where the skyscrapers appear claustrophobically crushed into the hillside.

The architecture and streets of San Francisco are not the only urban subjects that have captured Thiebaud's attention in the last few years: automobiles, freeways, and commuter traffic have also been the focus of many of his recent paintings, as in *Urban Freeways*, 1979/1980 (pl. 72), *Freeways*, 1978 (pl. 71), *Freeway Traffic*, 1983 (pl. 78), and *Police Car*, 1984 (pl. 89). Thiebaud's choice of subjects may seem eccentric to some, for many people view the mazes of concrete freeways, traffic congestion, and automobile pollution that ravage our environment as the curse of contemporary life. Why should they be elevated to the level of art? Yet these images easily fall within the canons of accepted subject matter defined by the nineteenth-century French realists upon whose work much of Thiebaud's oeuvre is patterned. "Il faut être de son temps"—"Be of one's time"—became the rallying cry of such artists as Gustave Courbet, Édouard Manet, and Edgar Degas. Degas's radical program of city themes, expressed in his notebooks and innumerable sketches and drawings, offers a cogent parallel to Thiebaud's own interests. Degas wrote in his journal in the 1860s, "No one has ever done monuments or houses from below, from beneath, up close as one sees them going by in the streets."[17] And in another entry he made notes: "On smoke, smoke of smokers, pipes, cigarettes, cigars, smoke of locomotives, of high chimneys, factories, steamboats, etc....Destruction of smoke under the bridges. Steam. In the evening. Infinite subjects."[18]

Marked by a jungle of freeways, wafts of sooty exhaust, and tarry black streets, Thiebaud's paintings seem to answer Degas's call for artists to claim the most mundane of contemporary subjects. *Freeways*, 1978 (pl. 71), can be seen as a visual embodiment of California's polluted commuter lifestyle. Equally important, the ephemeral puffs of smoke and blurred rendition of vehicles speeding along the freeway suggest the artist's preoccupation with the subject of time. But in contrast to the frozen, expanded sense of time and the almost myopic stare that characterize Thiebaud's figure paintings, *Freeways* seems to be reality perceived in a glance. Perception takes time, but it can occur either quickly or slowly.

This difference in the focus and in the engagement of the eye distinguishes works such as *Freeways* from Thiebaud's figure paintings. The figure paintings are concerned with an intensive, almost meditative scrutiny of visual information; *Freeways* with a quick, holistic impression.

This temporal sensibility has its precedents in the work of the French Impressionists. Monet and Pissarro believed that if they stared, they overfocused and oversaw. Pissarro advised a young artist that "the eye should not be fixed on one point, but should take in everything, while observing the reflections that the colors produce on their surroundings."[19] The Impressionists captured the ever-changing spectacle of the natural world in loose, synoptic, allover brushwork. This same quality appears in Thiebaud's abbreviated and stenographic handling of paint in *Freeways*. The urban vista is summarized in sketchy daubs and strokes of pigment, leaving the viewer's mind to weave the sensations of color into perceptions of form. In *Art and Illusion*, E.H. Gombrich has claimed that all forms of representational painting fall on a scale that extends from the schematic to the impressionistic, with a strong tendency among artists to lean toward the schematic.[20] Given the pervasive desire to experiment that directs much of his work, it is not surprising that Thiebaud has chosen to explore an impressionistic mode of representational painting, although it contrasts markedly with the heavily impastoed, schematized canvases for which he is best known.

Thiebaud's cityscapes are thus the result of simultaneous experiments with the perception of time and space. But two additional elements critically inform his paintings: abstraction and caricature. Although his work is representational, Thiebaud has, paradoxically, always seen it as equally abstract in the sense that something reduced to a broad, generative concept can be developed into a more complete image than that described by the concept itself. For example, a rather complete image of an individual can be deduced from the description of a single abstract quality, such as a "warm personality." This is the power of abstraction: universal concepts generate particulars. In Thiebaud's cityscapes, observation, memory, and imagination collaborate to purge specificity. By this process, a generalized statement—an abstraction—of "citiness" is created.

Thiebaud relies on caricature to express these abstract notions. He has retained a high regard for this form of visual expression from his early days as a cartoonist. But Thiebaud does not mean caricature as mockery, travesty, or parody. Instead, he sees it as a measuring device for the analysis of form and as a means to achieve abstraction. Thiebaud explains: "When you reduce a sauce, you do so in order to improve it by taking out those ingredients you no longer need. The same is true of realist painting: you reduce it by essentialization, and what happens…seems like a reduction—or simplification. It is, in reality, a kind of addition. This does not imply a contradiction of terms, but a conscious decision to eliminate certain details, and include selective bits of personal experiences, or perceptual nuances which give the painting more

of a multi-dimension than when it is done directly as visual recording. This process results in a kind of abstraction ...a work that is essentially reduced and abstracted in terms of some particularized feelings or emotion, and thus one that avoids the pitfalls of mere decoration."[21]

Often, Thiebaud's form of caricature is expressed by exaggerated contrasts or by the juxtaposition of extreme opposites—short next to tall, big next to small, crowded next to open forms. A tall building, the dark office tower in *Hill Street*, 1981 (pl. 73), for example, takes on Jack-and-the-beanstalk proportions when contrasted to the Lilliputian cars, trees, and streetlamps that surround it. Or, in *San Francisco Freeway*, 1980–81 (pl. 82), the dense cluster of hilltop buildings appear even more tightly compacted when contrasted to the broad, open expanses of the freeway below.

The caricature found in *Urban Freeways*, 1979/1980 (pl. 72), is more overt. The painting was initially based on an on-the-spot drawing done in San Francisco, not in Los Angeles, as some would presume. It was further revised in the artist's studio on the basis of memory and actual observations. "It was so typically 'freeway-esque' that it offered certain directions," Thiebaud recalls. "I put in components that I felt were reminiscent of Los Angeles, and the abstraction occurred because there is no place like that."[22] In this painting Thiebaud presents an abstracted concept of freeways, those labyrinthine entanglements of cement for which California is infamous. Although the painting incorporates numerous representational details—buildings, cars, trees, smokestacks—they are subordinated to the baroque maze of shapes that snake, curl, and cut across the canvas. The painting is a caricature of the notion of "freeway" rendered as an exaggerated composition of arabesques.

Caricature distinguishes Thiebaud's landscapes and cityscapes as a whole and reflects the extremes to which he will take his art. In confronting the question of space, Thiebaud pushes his solutions to the limit: mountains and skyscrapers soar to giddying heights, buildings and trees teeter on exaggerated bluffs, streets rise and drop like huge slippery slides. "I'm a believer in the notion that artists who do good work believe in the ideas of extremes," he has explained.[23] Painting for Thiebaud is a quest of confronting in the deepest and fullest way possible each problem the artist chooses to face. This often means taking chances, jeopardizing the comfort of known and accepted conventions. One of the terrors Thiebaud sees in painting is consistency, the failure of an artist to interrupt himself or take risks. Increasing one's range increases the possibility of failure, but it is an essential part of the creative process. Thiebaud observes, "Someone must write a book one day very soon about the power and profit of failure. It is very much an aspect of what painting is about."[24]

NOTES

1. Gail Gordon, "Thiebaud Puts a Visual Feast on Canvas," *California Aggie* (University of California, Davis), 9 February 1983, p. 2.

2. Michael Fried, *Morris Louis* (New York: Harry N. Abrams, 1979), p. 22.

3. In 1975 Thiebaud and several other artists received commissions from the United States Department of the Interior to celebrate the country's Bicentennial in 1976. The artists selected their own subjects, which had to be inspired by property under the jurisdiction of the Department of the Interior. Thiebaud chose to create work based on Yosemite National Park in California. *Half Dome and Cloud*, 1975, is one of several images that resulted from this project.

4. Gordon, "Visual Feast," p. 2.

5. Thiebaud, interview with the author, Sacramento, 19 July 1984.

6. Arnheim, *Visual Thinking*, p. 84.

7. Stowens, "Beyond Pop Art," p. 50.

8. *Chestnut St. near Hyde*, 1971, is among the very earliest of Thiebaud's cityscape studies. His concentrated work in this area began after 1973.

9. The street sign in this painting is misleading because it does not accurately identify the site of the image.

10. Thiebaud, interview with the author, Sacramento, 19 July 1984.

11. Hugh J. Delehanty, "Wayne Thiebaud Doesn't Want to Be a Superstar—He Wants to Be a Better Painter," *San Francisco*, December 1982, p. 130.

12. Albright, "Scrambling Around," p. 86.

13. Jan Butterfield, "Wayne Thiebaud: 'A Feast for the Senses,'" *Arts*, October 1977, p. 136.

14. Wilfrid H. Wells, *Perspective in Early Chinese Painting* (London: Goldston, 1935).

15. Rudolf Arnheim, *Art and Visual Perception* (Berkeley and Los Angeles: University of California Press, 1969), p. 288.

16. Thiebaud, interview with the author, Sacramento, 12 February 1984.

17. Linda Nochlin, *Impressionism and Post-Impressionism*, p. 63.

18. Ibid.

19. Rewald, *The History of Impressionism*, p. 60.

20. Gombrich, *Art and Illusion*, p. 293.

21. Andrée Marèchal-Workman, "Wayne Thiebaud's Cityscapes," *Images & Issues*, Winter 1981/82, p. 68.

22. Ibid., p. 70.

23. Stowens, "Beyond Pop Art," p. 103.

24. Thiebaud, "As Far as I'm Concerned," p. 24.

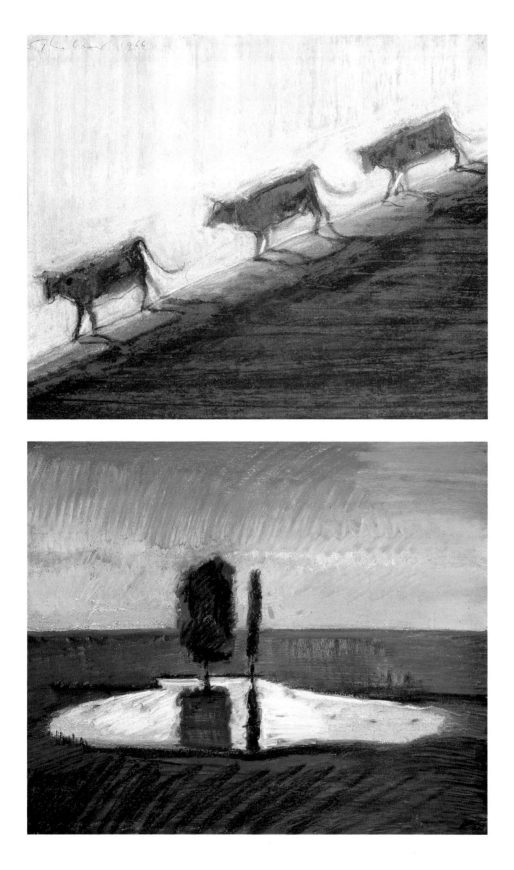

PLATE 59

COW RIDGE, 1966

PLATE 60

POND AND TREES (FARM POND), 1966

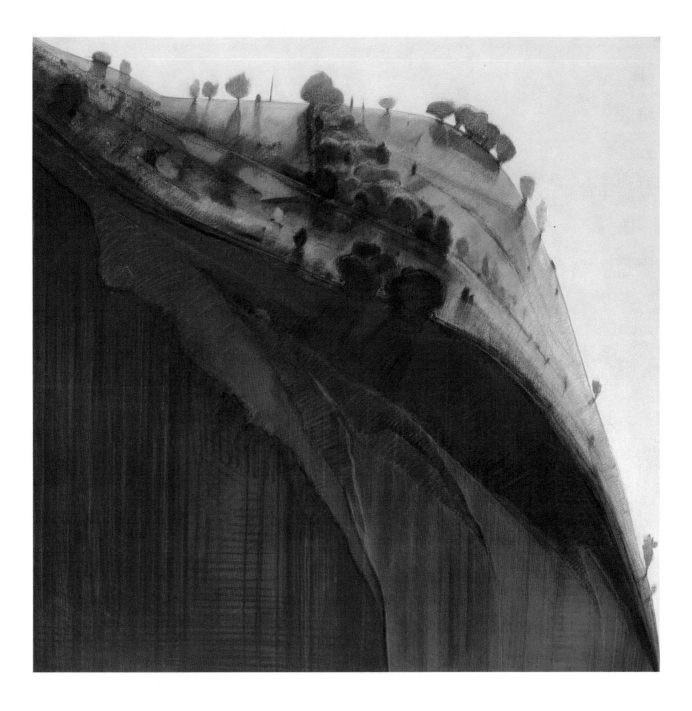

PLATE 61

COLOMA RIDGE, 1967–68

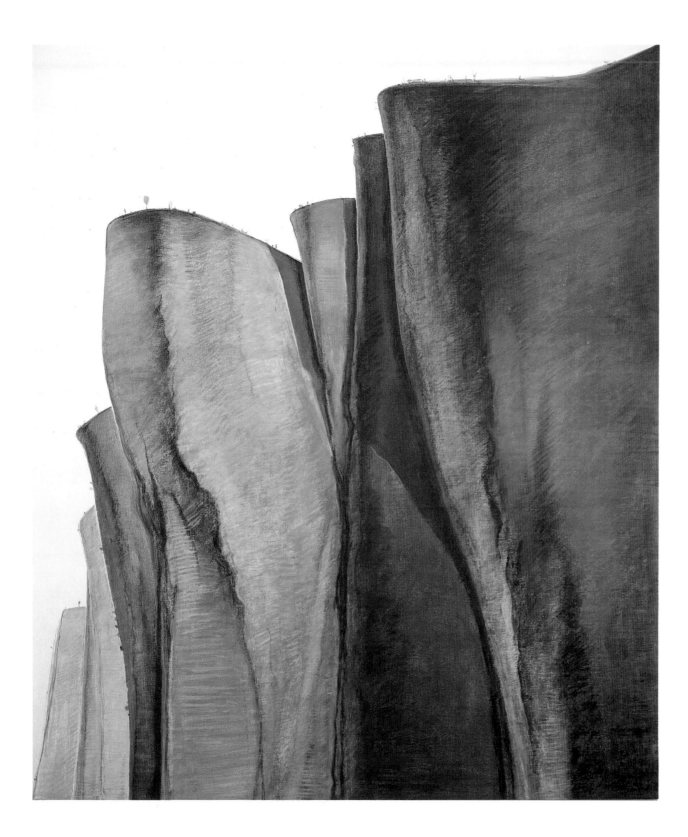

PLATE 62

CLIFFS, 1968

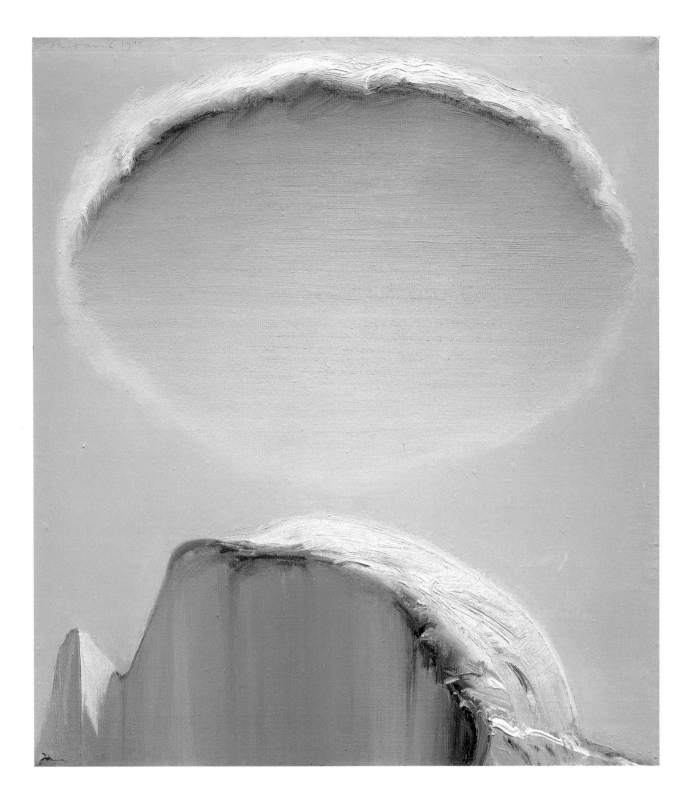

PLATE 63

HALF DOME AND CLOUD, 1975

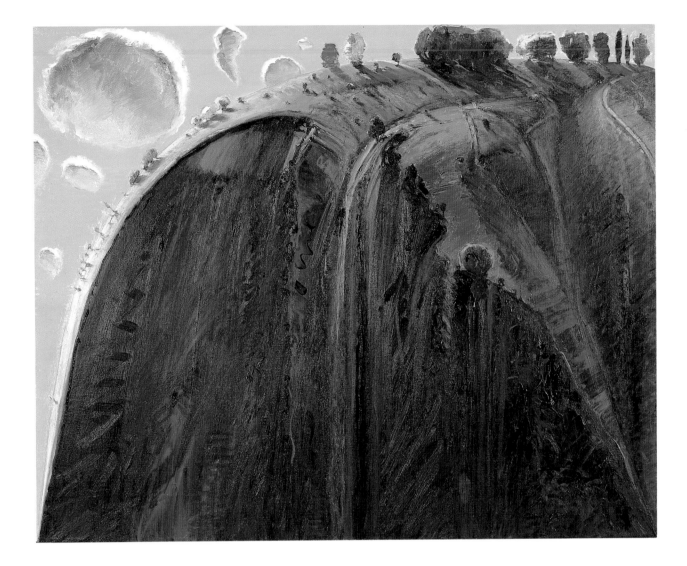

PLATE 64

CLOUDS AND RIDGE (RIDGE AND CLOUDS), 1975–83

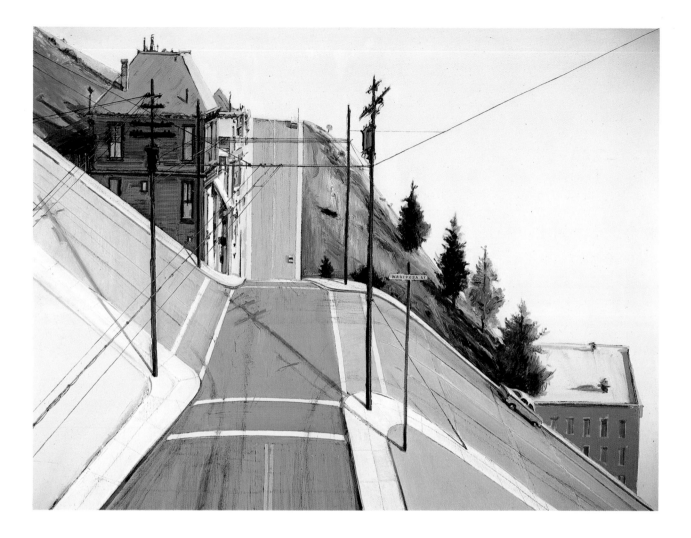

PLATE 65

24TH STREET INTERSECTION (TWENTY-FOURTH STREET RIDGE), 1977

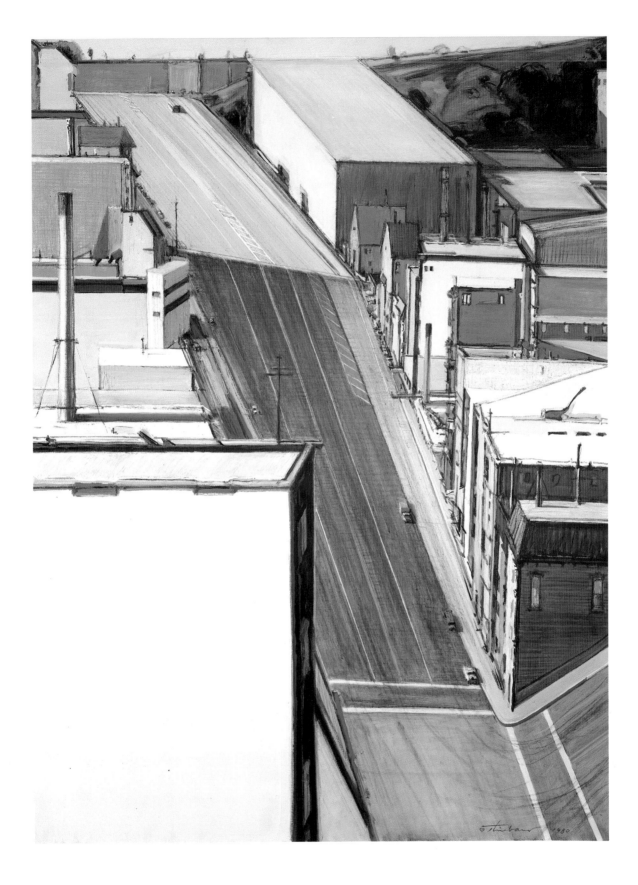

PLATE 66

DOWN 18TH STREET, 1980

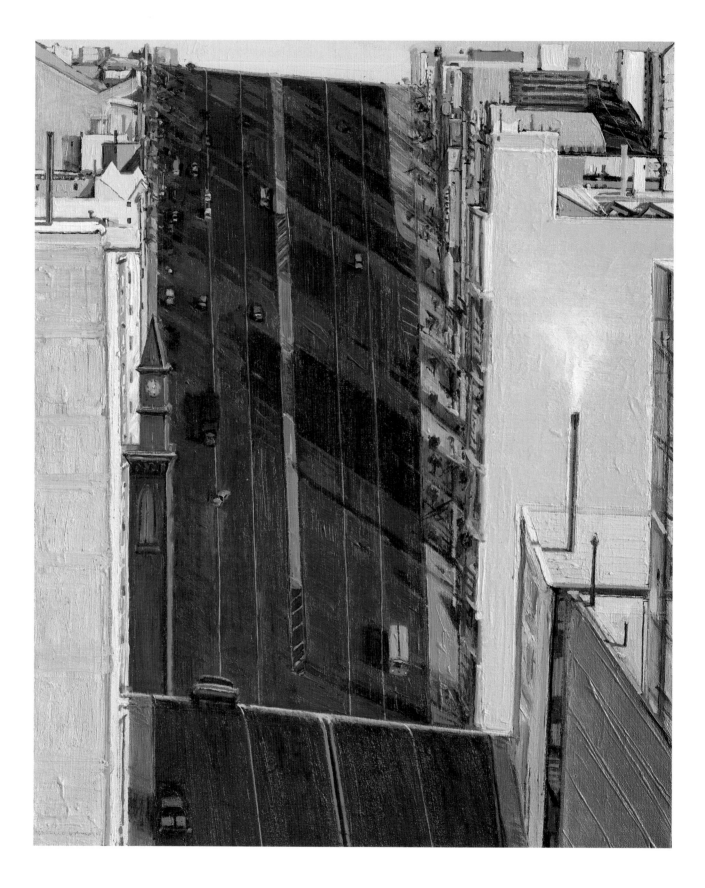

PLATE 67

CALIFORNIA STREET, 1978

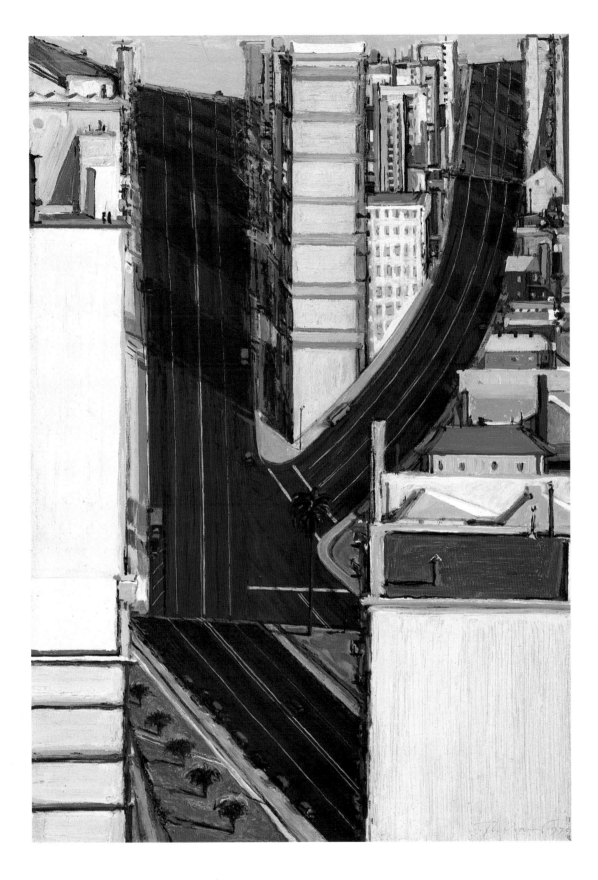

PLATE 68

CURVED INTERSECTION, 1979

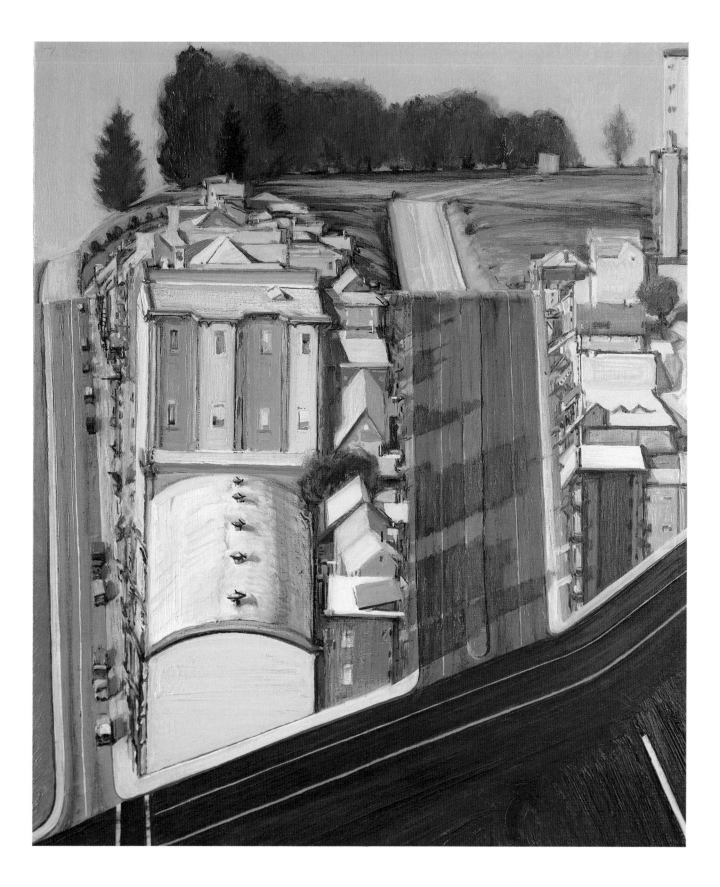

PLATE 69

HOLLY PARK RIDGE, 1980

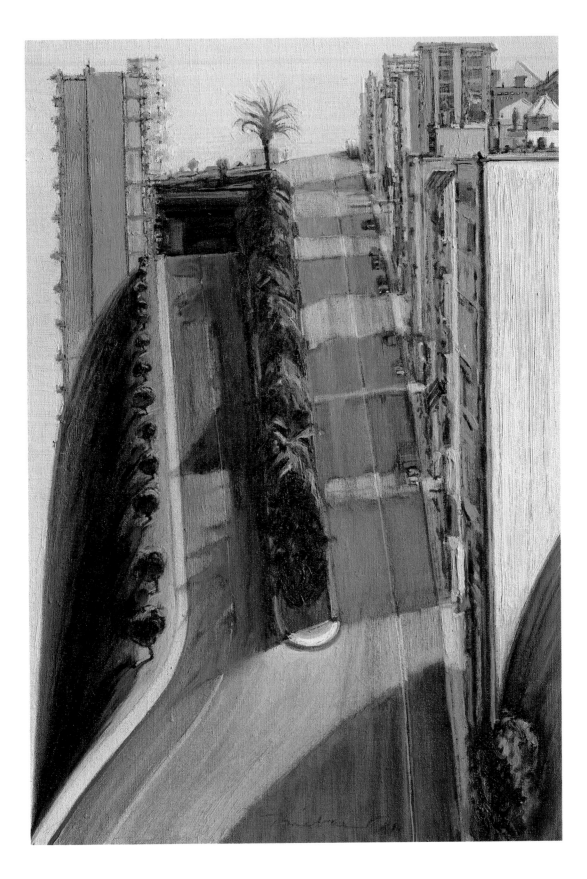

PLATE 70

URBAN DOWNGRADE, 20TH AND NOE, 1981

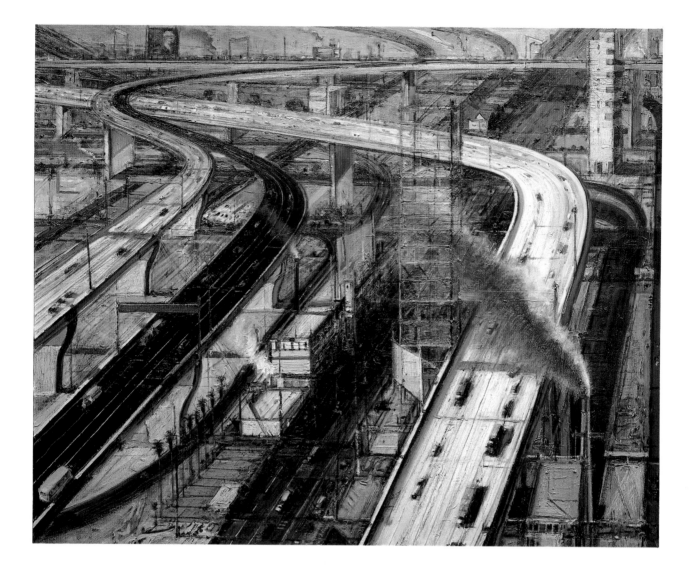

PLATE 71

FREEWAYS, 1978

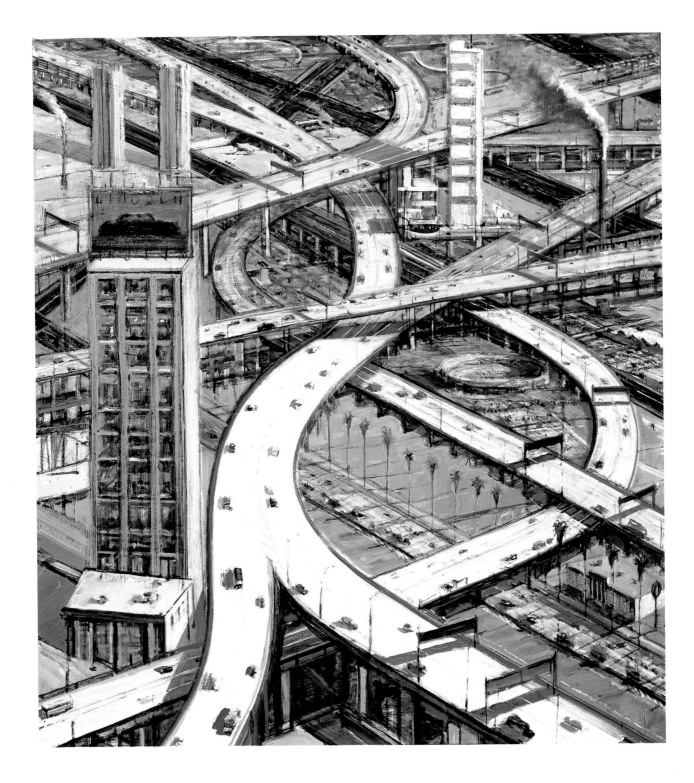

PLATE 72

URBAN FREEWAYS, 1979/1980

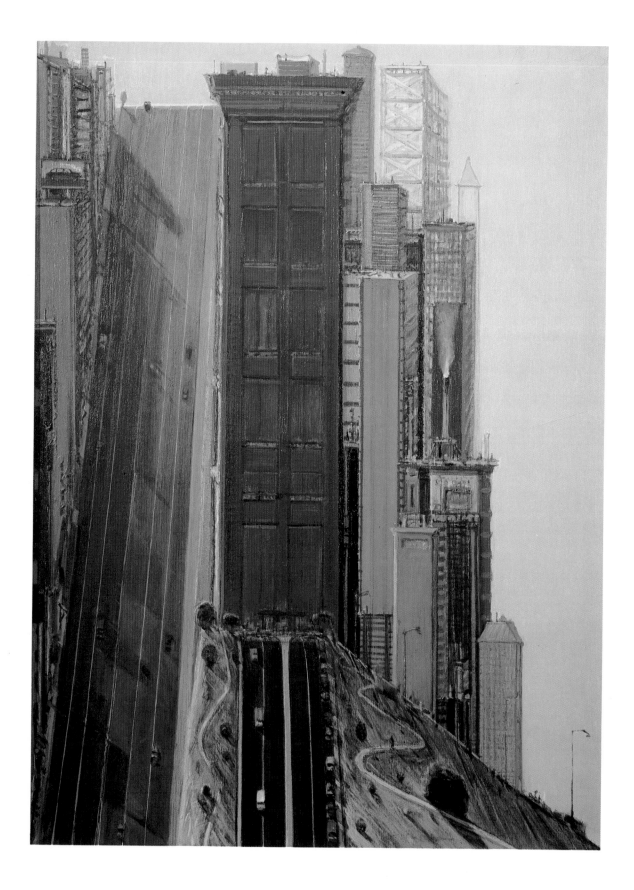

PLATE 73

HILL STREET (DAY CITY), 1981

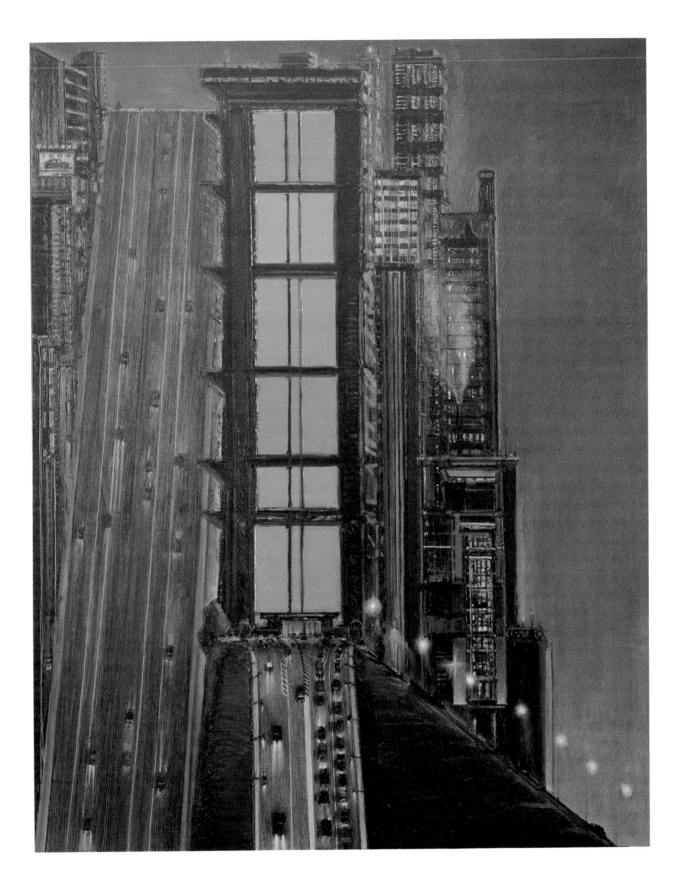

PLATE 74

NIGHT CITY, 1980

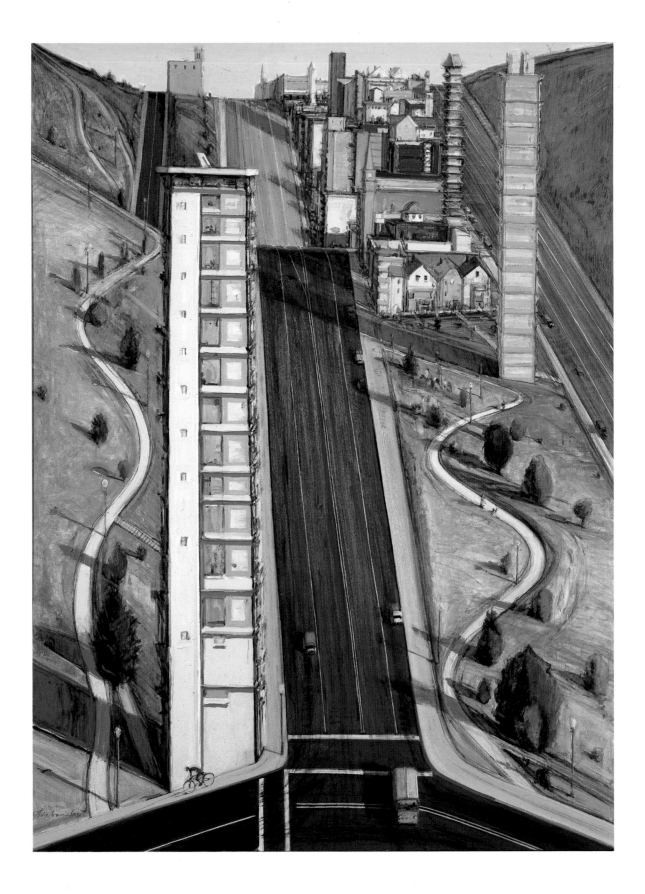

PLATE 75

CORNER APARTMENTS (DOWN 18TH STREET), 1980

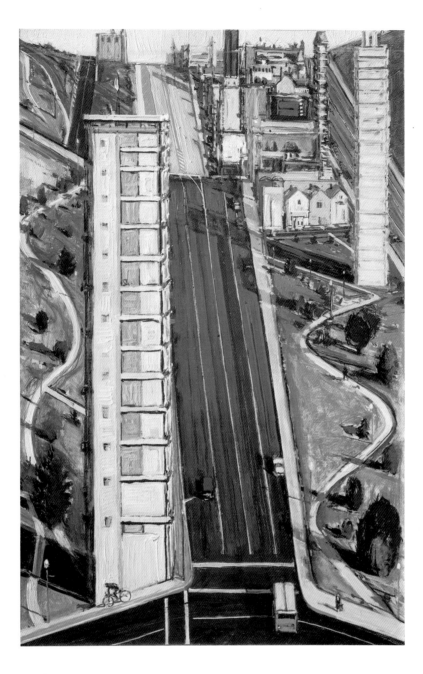

PLATE 76

CORNER APARTMENTS (STUDY), 1979

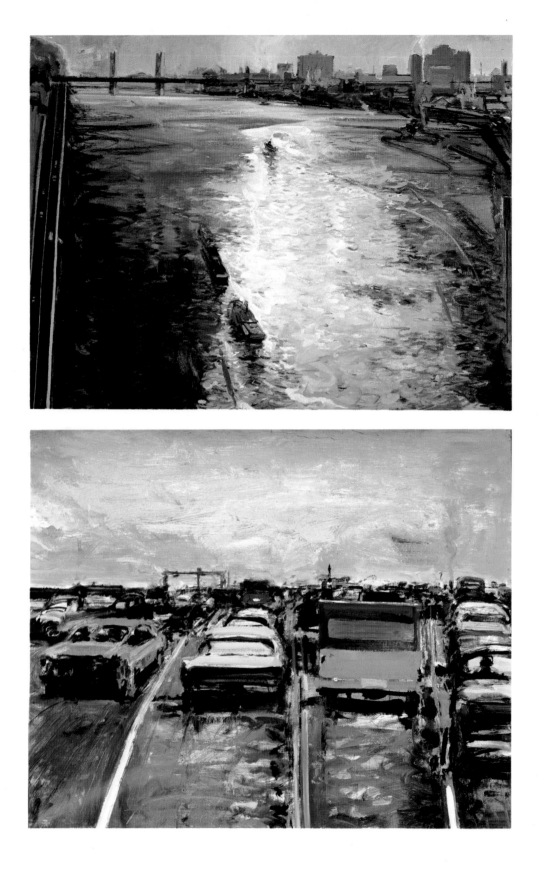

PLATE 77

RIVER CITY (SACRAMENTO), 1982/1983

PLATE 78

FREEWAY TRAFFIC, 1983

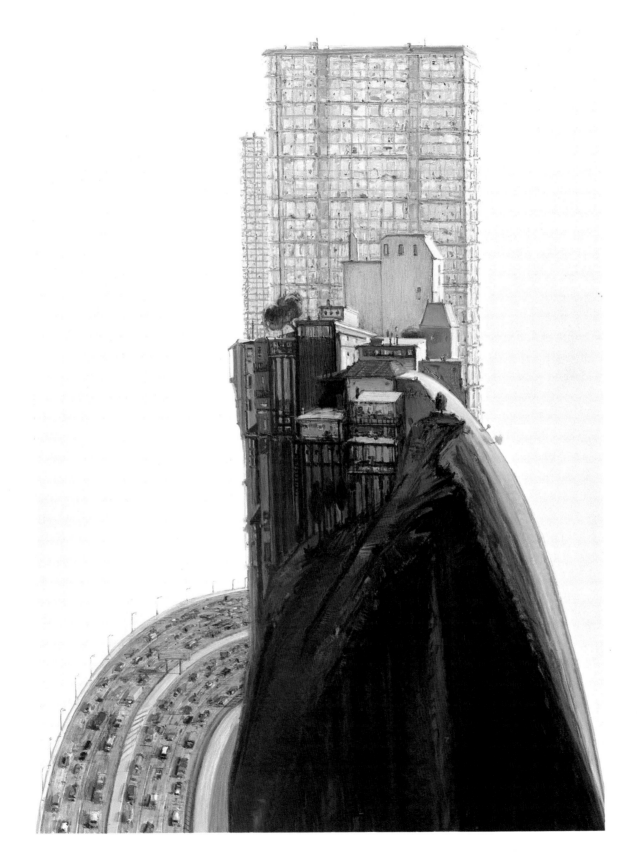

PLATE 79

APARTMENT HILL, 1981

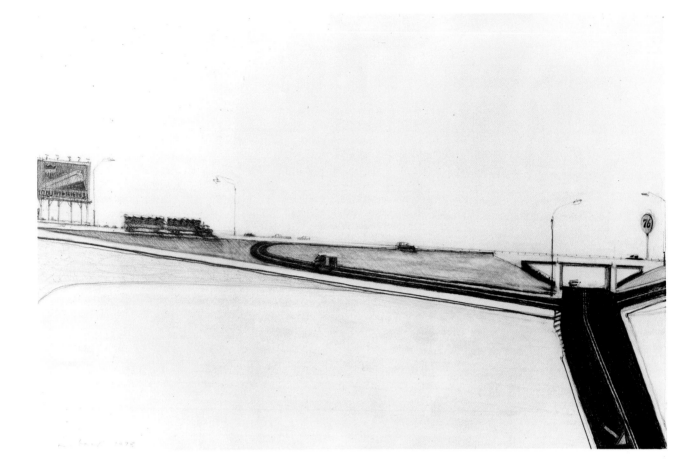

PLATE 80

FREEWAY EXIT, 1975

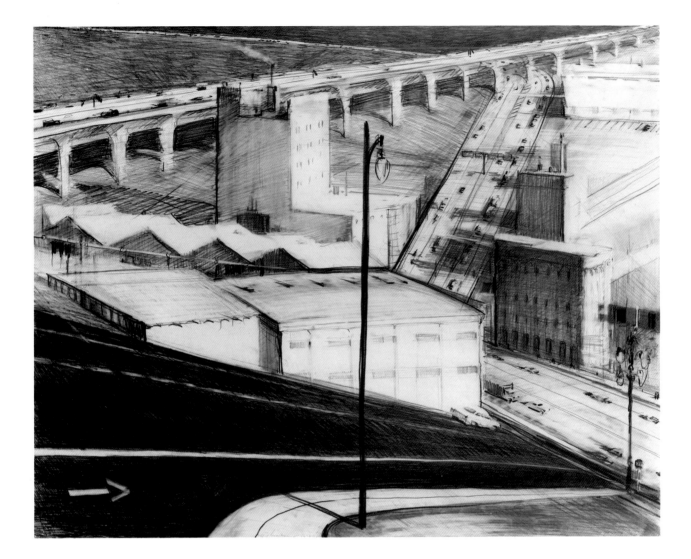

PLATE 81

TOWARD 280, 1978

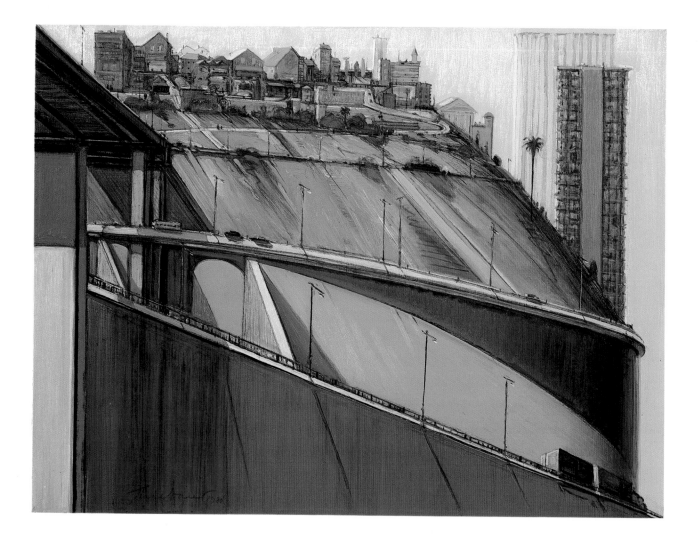

PLATE 82

SAN FRANCISCO FREEWAY, 1980–81

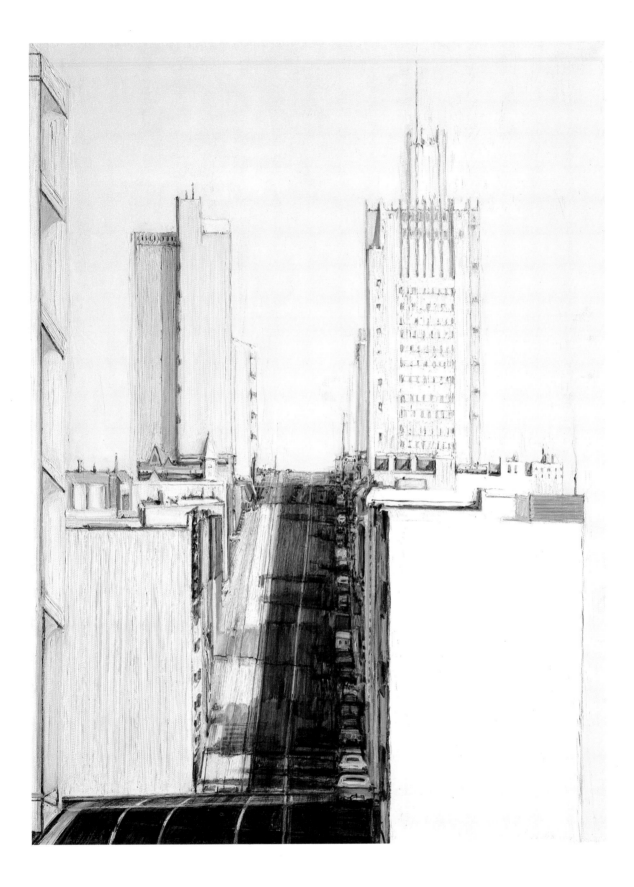

PLATE 83

DAY CITY (BRIGHT CITY), 1982

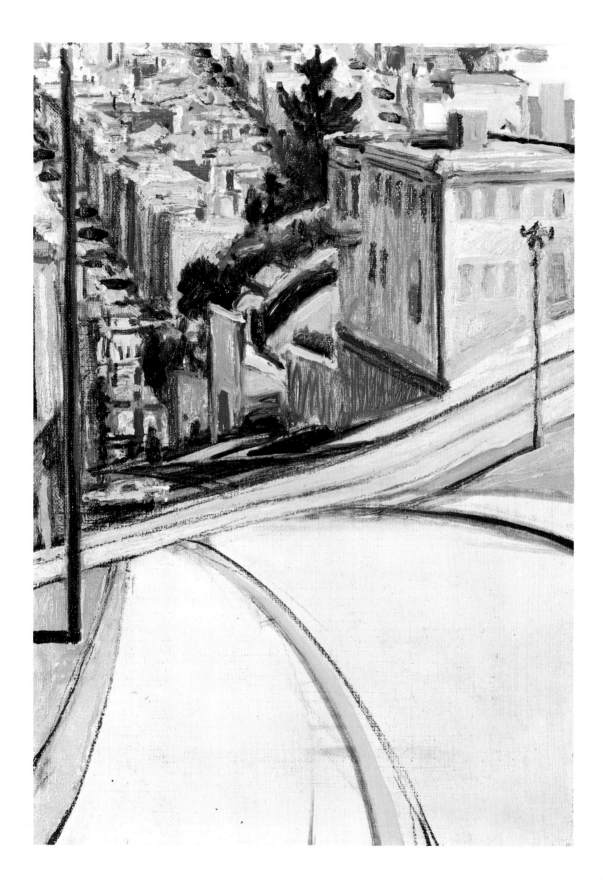

PLATE 84

CHESTNUT ST. NEAR HYDE, 1971

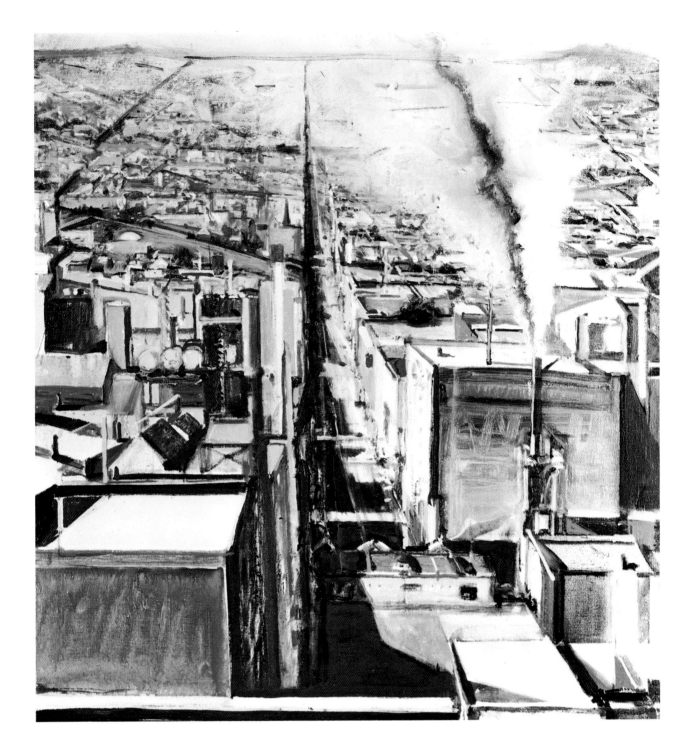

PLATE 85

TOWARD TWIN PEAKS, 1976

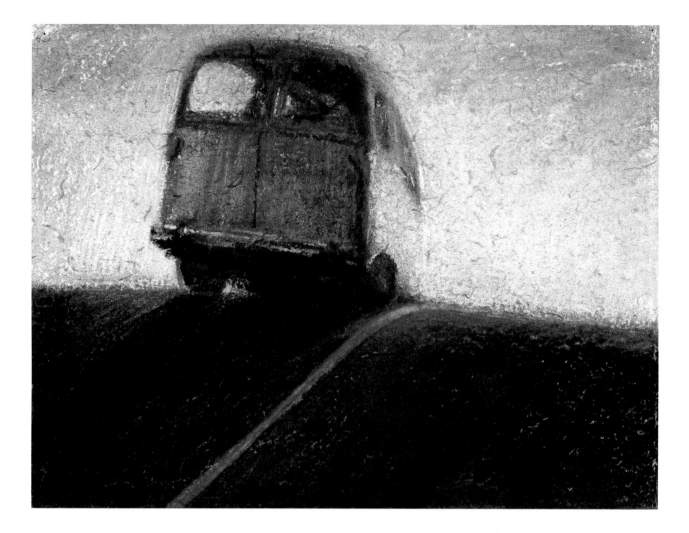

PLATE 86

VAN, 1984

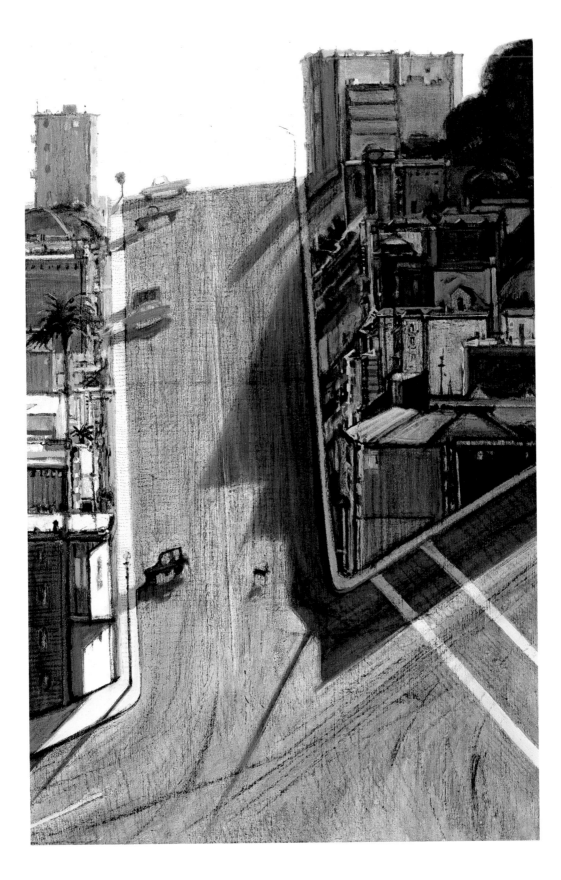

PLATE 87

STREET & SHADOW, 1982–83

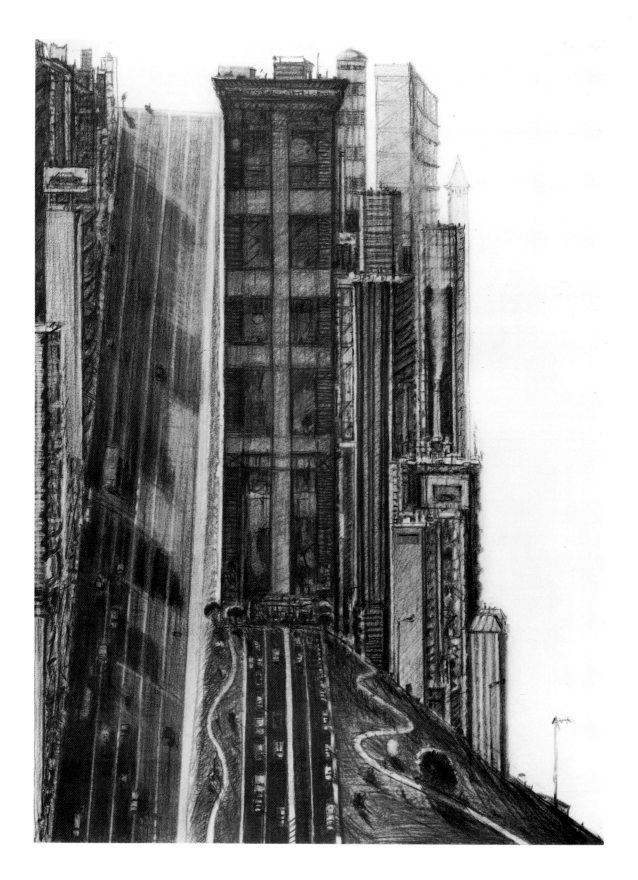

PLATE 88

HILL STREET, 1980–83

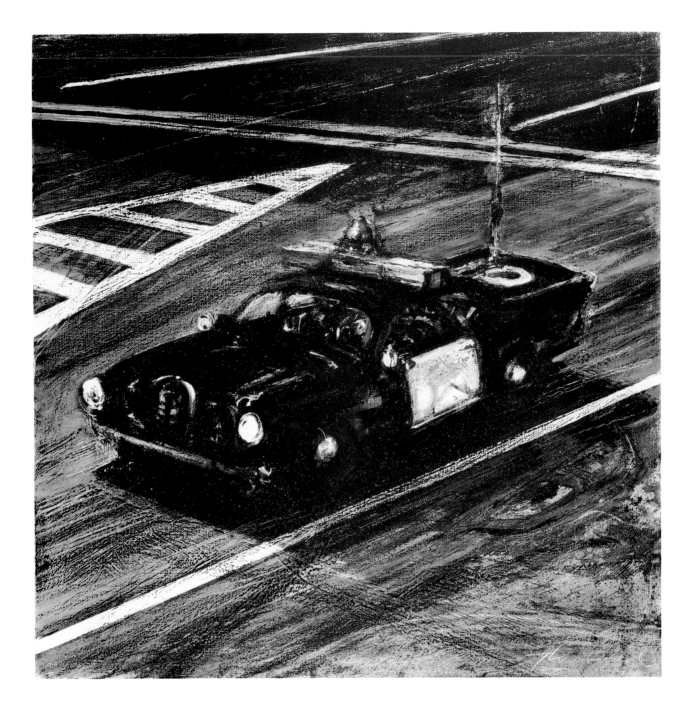

PLATE 89

POLICE CAR, 1984

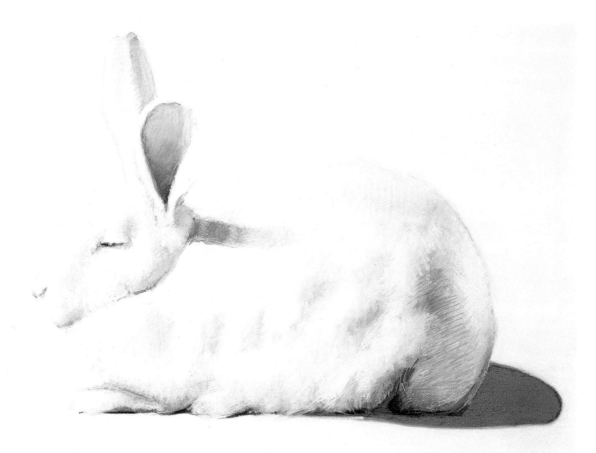

Fig. 36 Wayne Thiebaud, *Rabbit*, 1966,
pastel on paper, 14¾ × 19½″ (sight)
(37.5 × 49.5 cm.). Mr. and Mrs. Edwin A.
Bergman, Chicago.

WAYNE THIEBAUD
PICTURES AS PROPOSITIONS

Wayne Thiebaud is an artist whose work is at once sensuous and cerebral. More consciously than most artists, he sifts and refines everyday experiences, giving visual form to all aspects of life through the seductive manipulation of paint. Thiebaud sets as his challenge the task of painting simple ideas without making them simple-minded. How does one describe light or height in a painting?

To a marked degree, Thiebaud's teaching philosophy reflects the principles that guide his own work. Teaching has been a vital part of Thiebaud's life for more than thirty years, concurrent with his activities as a painter. He is interested, not in training "artists," but rather in teaching his students the basics of painting. He devises exercises for his students and himself that explore problems of color, light, scale, or composition. Discipline, rather than freedom, is the essence of his teaching. Self-expression and emotion are deliberately shunned. "An artist has to train his responses more than other people do," he observes. "He has to be as disciplined as a mathematician. Discipline is not a restriction but an aid to freedom. It prepares an artist to choose his own limitations. ...An artist needs the best studio instruction, the most rigorous demands, and the toughest criticism in order to tune up his sensibilities."[1]

In many respects, Thiebaud can be seen as a formalist painter whose concerns, paradoxically, parallel those of the Minimalists. His work, like Minimal art, searches for essences and attempts to isolate the fundamental processes of perception. But in contrast to the abstract, geometric forms used by the Minimalists, Thiebaud draws subjects from the identifiable and natural world. His images are also often taken from the work of other artists, both historical and contemporary. In his numerous lectures, interviews, and articles, Thiebaud consistently refers to himself as a total thief who unabashedly steals from other painters. To a large extent this is true: his drawing of a rabbit (fig. 36) is inspired by Albrecht

Dürer's etching of the same subject; his painting of a pair of shoes (pl. 38) has its antecedent in Van Gogh's studies of farmer's boots; his color sensibility of juxtaposing warm and cool hues can be traced to Monet's Impressionist color system. Thiebaud's references to himself as a thief, however, disguise the significance of his statement. He believes firmly that all artists participate in a communal enterprise and that art comes from previous art and from nothing else. Thiebaud's painterly investigations are fundamentally grounded in his all-consuming interest in art history and in the cyclical repetition of art forms and ideas.

This cyclical principle finds its most articulate expression in George Kubler's *The Shape of Time*. In his book Kubler proposes that art is a finite invention and that the art object is the expression of those times in human experience when something has been developed to such a degree that further reduction or change is no longer possible. He suggests that the history of art is a succession of these prime works, replicated over the course of time. Kubler writes: "Perhaps all the fundamental technical, formal, and expressive combinations have already been marked out at one time or another, permitting a total diagram of the natural resources of art....Instead of our occupying an expanding universe of forms, which is the contemporary artist's happy but premature assumption, we would be seen to inhabit a finite world of limited possibilities, still largely unexplored, yet still open to adventure and discovery."[2]

For Thiebaud, as for Kubler, the painter's quest is not to be original or invent new subjects but to continue probing and reexamining established primary objects and experiences. As Thiebaud explains, "I think the only way in which, finally, your own activities become substantial and worthwhile...is...to juxtapose what you are doing directly against any combination of experiences or people who have experienced similar things."[3]

Thiebaud measures his work against those painters who have laid the foundation for realist painting, among whom he cites Vermeer, Velázquez, Chardin, Eakins, and Hopper. These artists, according to Thiebaud, could not paint without the object and did not paint with a sense of interpretive or creative necessity. Their art is the result of direct, factual observation. Thiebaud's work begins in this single yet complex premise. Realist painting for Thiebaud is first and foremost a method of interpreting and documenting one's perceptions. But perception is never one-dimensional: it is subjective and mercurial. As Akira Kurosawa's movie *Rashomon* (1950) vividly confirms, one scene can be perceived in radically different ways.[4] This ambiguity intrigues Thiebaud and is the primary focus of his investigations.

The divergent theories of psychologists E.H. Gombrich and Rudolf Arnheim attest to the complexity of perception and its role in realist painting. In his study on the psychology of pictorial representation, *Art and Illusion*, Gombrich makes the point that artists see what they are prepared to see. If a painter trained in the Chinese tradition of landscape painting, for example, paints either Shanghai or Chicago, the work will

reflect oriental schemata and training. According to this theory, painting is a conceptual act. As Gombrich notes, "There is no neutral naturalism....All art originates in the human mind, in our reactions to the world rather than in the visible world itself."[5]

Arnheim advocates the other extreme: Art is the unity of perception and thought. Visual perception is not a passive recording of information but an active stimulation that helps the mind form concepts. The mind, aroused by what the eye sees, draws upon the vast imagery stored in memory patterns and learned responses and organizes them into a system of visual concepts. According to Arnheim, direct perception, stored experience, and the artist's imagination interact simultaneously during the creative process.

As a teacher of painting and a painter of reality, Thiebaud has been fascinated by the duality of perceptual and conceptual information. In his life's work he explores the fertile ground that lies between Gombrich's and Arnheim's theories. His work ranges from the close matching of visual experience seen in his figure paintings to the free invention of his cityscapes. But even where fidelity to perceptual data is his primary concern, Thiebaud finds substantial room for interpretation and manipulation. As he has stated, "If you stare at an object, as you do when you paint, there is no point at which you can stop learning about things. You can just look and look and look." But Thiebaud continues, "If you really are a realist painter, you finally realize that what you are doing is a tremendous amount of adoption, adaption, and change. And what is vexing is that there's no end to it."[6]

The problem is that observation is an open-ended proposition. The eternal questions that Thiebaud confronts lend diversity and richness to his oeuvre, which ranges from paintings of cream pies to images of traffic congestion. The translation of normal, everyday impressions onto flat surfaces marked by patches of color is the challenge Thiebaud has set for himself. Each new painting is a different adventure and carries the potential for new discovery. "I think of myself as a beginner," he once said. "Sometimes that's the whole joy. If you could just do it, there'd be no point in doing it."[7]

NOTES

1. Thiebaud, quoted in Ruth Latter, "British Born Pop Art: The Big Put-On," *Daily Progress* (Charlottesville, Va.), 6 May 1973, p. E-8.

2. George Kubler, *The Shape of Time* (New Haven, Conn.: Yale University Press, 1962), pp. 125–126.

3. Thiebaud, "As Far as I'm Concerned," p. 23.

4. Kurosawa depicted in visual terms the theme that Ryunosuke Akutagawa earlier explored in his 1915 story *Rashomon*.

5. E.H. Gombrich, *Art and Illusion*, p. 87.

6. Stowens, "Beyond Pop Art," p. 48.

7. Diane Hellekson, "Touring the Landscape with Thiebaud," *Minnesota Daily* (University of Minnesota, Minneapolis), 26 February 1981, *d'Art*, p. 7d.

CHRONOLOGY

Compiled by Donna Graves

Only major exhibitions of the artist's work are included here. A complete list of exhibitions is found in the Exhibition History.

1920 Born 15 November in Mesa, Arizona, to Alice Eugenia Le Baron and Morton J. Thiebaud. Older of two children; sister Marjory Jean.

1921 Family moves to Long Beach, California.

1931–1933 Family moves briefly to southern Utah, then returns to Long Beach.

1936–1938 While attending Long Beach Polytechnic High School, develops interest in drawing. Works briefly in animation department of Walt Disney Studios, Los Angeles (1936–1937). Attends Frank Wiggins Trade School, Los Angeles, to study commercial art (1938).

1938–1940 Works at odd jobs and as free-lance cartoonist and illustrator in Long Beach.

1940–1941 Attends Long Beach Junior College (now Long Beach City College).

1942–1945 Serves in United States Army Air Force, Mather Army Air Field (now Mather Air Force Base), near Sacramento. Works as cartoonist for base newspaper *Wing Tips*; as muralist; and as illustrator. In last months of service is transferred to first Air Force Motion Picture Unit, Culver City, California.

1943 Marries Patricia Patterson.

1945 Daughter Twinka born.

1945–1946 Works in Los Angeles and New York in a variety of commercial positions: free-lance cartoonist, illustrator and layout designer.

1946–1949 Works as layout designer and cartoonist for Rexall Drug Company, Los Angeles.

Meets artist Robert Mallary, a co-worker at Rexall Drug Company, who becomes an influential artistic and intellectual catalyst.

Decides to become a painter.

1949–1950 Attends San Jose State College (now San Jose State University), California.

1950–1953 Attends California State College (now California State University), Sacramento. Receives B.A., 1951; M.A., 1953, with art major.

1950–1959 Summers. Serves as exhibit designer for annual art exhibition of the California State Fair and Exposition, Sacramento.

1951 Has first one-person exhibition, *Influences on a Young Painter*, E.B. Crocker Art Gallery (now Crocker Art Museum), Sacramento.

1951–1960 Receives appointment as instructor of art, Sacramento Junior College (now Sacramento City College). Chairman of art department, 1954–1956, 1958–1960.

1952 Daughter Mallary Ann born.

1954–1959 Establishes company, Patrician Films, to produce educational art films. In 1956 the film *Space* wins Chicago Golden Reel Award and first prize at Art Film Festival, California State Fair, Sacramento.

1956–1957 Takes sabbatical from teaching to live in New York City. Meets Elaine and Willem de Kooning, Franz Kline, Barnett Newman, Philip Pearlstein, Milton Resnick, and Harold Rosenberg, among others.

Supports himself as an advertising art director, working at Deutsch and Shea Advertising Agency and Frederick A. Richardson Advertising Agency, New York.

1958 Summer. Serves as guest instructor in printmaking, California School of Fine Arts (now San Francisco Art Institute), substituting for Nathan Oliveira.

Cofounds Artists Cooperative Gallery (now Artists Contemporary Gallery), Sacramento.

Wins Osborn Cunningham Award to create mural for Sacramento Municipal Utility District building. Mosaic mural completed in 1959.

1959 Divorces Patricia. Marries Betty Jean Carr. Adopts son Matthew Bult Carr.

Receives award in national contest sponsored by Columbia Records for album cover design, *Jazz Impressions of Eurasia* by Dave Brubeck.

1960 Appointed assistant professor, Department of Art, University of California, Davis. Subsequently appointed associate professor, 1963–1967, and professor, 1967 to the present.

Son Paul Le Baron born.

Begins painting still lifes of pies, cakes, and other objects.

1961 Summer. Receives University of California Faculty Fellowship. Visits New York. Meets Allan Stone, Allan Stone Gallery, New York.

November. Has one-person exhibition, *An Exhibition of Recent Works by Thiebaud*, Art Unlimited, San Francisco.

1962 April. Has first one-person show in New York, *Wayne Thiebaud: Recent Paintings*, Allan Stone Gallery.

July. Has first one-person museum exhibition in San Francisco, *An Exhibition of Paintings by Wayne Thiebaud*, M.H. de Young Memorial Museum.

October. Included in the group exhibition *New Realists*, Sidney Janis Gallery, New York.

1963 Takes first trip to Europe, in conjunction with first one-person exhibition there, *Wayne Thiebaud*, Galleria Schwarz, Milan.

1964–1965 Receives creative research grant, University of California, Davis. Concentrates on painting the figure. Resulting work shown in 1965 exhibition *Figures: Thiebaud*, Stanford Art Museum, Stanford University, California (travels nationally).

1965 Portfolio of etchings, *Delights*, published by Crown Point Press, Oakland.

1967 Appointed visiting professor of art and artist-in-residence, Cornell University, Ithaca, New York. Subsequently visits numerous colleges and universities as artist-in-residence or visiting professor of art, including University of Victoria, British Columbia, 1970; Rice University, Houston, 1974; Colorado State University, Fort Collins, 1975; University of Utah, Salt Lake City, 1976; Stanford University, California, 1977; Skowhegan School of Painting and Sculpture, Maine, 1978; Laguna Beach School of Art, California, 1981; and New York Studio School, 1984.

1968 Has one-person exhibition, *Wayne Thiebaud*, Pasadena Art Museum (now Norton Simon Museum), California (travels nationally).

Receives commission from *Sports Illustrated* to paint Wimbledon Tennis Tournament, England. Paintings reproduced in June issue.

Edition of lithograph *Lollipops* published by Gemini G.E.L., Los Angeles.

1970 Works on series of linocuts, Arnera Printshop, Vallauris, France.

1971 Has one-person exhibition, *Thiebaud Graphics: 1964–1971*, organized by Parasol Press, Ltd., New York. Exhibition opens at Whitney Museum of American Art, New York (travels nationally and internationally).

Two portfolios of prints, *Seven Still Lifes and a Rabbit* and *Seven Still Lifes and a Silver Landscape*, published by Parasol Press, Ltd., New York.

1972 Has one-person exhibition, *Wayne Thiebaud: Survey of Painting 1950–72*, The Art Museum and Galleries, California State University, Long Beach.

Serves as national juror for the National Endowment for the Arts, Washington, D.C.

1973 Appointed thirty-first Faculty Research Lecturer, University of California, Davis.

Receives Golden Apple Award for distinguished teaching, University of California, Davis.

Receives honorary doctorate, California College of Arts and Crafts, Oakland.

Establishes second home in San Francisco. Begins painting cityscapes.

1975 Receives commission from United States Department of the Interior for Bicentennial exhibition, *America 1976* (travels nationally). Paints images based on visits to Yosemite National Park, California.

1976 Has one-person exhibition, *Wayne Thiebaud: Survey 1947–1976*, Phoenix Art Museum (travels nationally).

Begins weekly drawing sessions in San Francisco with group of Bay Area artists including Mark Adams, Theophilus Brown, Gordon Cook, and Beth Van Hoesen.

1978 Serves on Prix de Rome Award Panel for painting.

Serves as advisory consultant to Idaho Governor's Conference on the Arts.

1981 Receives citation from College Art Association of America as Most Distinguished Studio Teacher of the Year, 1980–1981

Commissioned to create image for poster celebrating the Los Angeles Bicentennial.

Has one-person exhibition, *Wayne Thiebaud: Painting*, Walker Art Center, Minneapolis (travels nationally).

1983 Receives honorary doctorate, Dickinson College, Carlisle, Pennsylvania, on occasion of one-person exhibition *Wayne Thiebaud: Paintings, Drawings, Graphics 1961–1983*.

Travels to Japan under auspices of Crown Point Press, Oakland, to work with traditional Japanese woodblock printers.

1984 Receives Faculty Research Lecture medal, presented in conjunction with fiftieth anniversary of University of California, Davis.

Receives Award of Distinction from National Art Schools Association.

Receives special citation award from National Association of Schools of Art and Design.

CHECKLIST OF THE EXHIBITION

Titles, dates, media, and measurements have been provided, for the most part, by the owners or custodians of the works. In the listing of dimensions, height precedes width; the first measurements listed are in inches, and the centimeter measurements appear in parentheses. For works on paper, measurements indicate sheet size unless otherwise noted. Information appearing in parentheses indicates other titles by which a work has been identified. To help identify untitled works, parenthetical descriptions are provided. Two dates separated by a slash indicate that a work is inscribed with more than one date.

1. CLUB SANDWICH, 1961 (Pl. 2)
oil on canvas
12⅛ × 14¼″ (30.8 × 36.2)
Dorry Gates, Kansas City, Missouri

2. FIVE HOT DOGS, 1961 (Pl. 11)
oil on canvas
18 × 24″ (45.7 × 61.0)
John Bransten, San Francisco
(For exhibition in San Francisco and Newport Beach only)

3. PENNY MACHINES, 1961 (Pl. 4)
oil on canvas
24 × 30″ (61.0 × 76.2)
John Berggruen, San Francisco

4. PIES, PIES, PIES, 1961 (Pl. 3)
oil on canvas
20 × 30″ (50.8 × 76.2)
Crocker Art Museum, Sacramento; Gift of Philip L. Ehlert in memory of Dorothy Evelyn Ehlert

5. CONFECTIONS, 1962 (Pl. 1)
oil on linen
16 × 20″ (40.6 × 50.8)
Byron Meyer, San Francisco

6. FOUR PINBALL MACHINES, 1962 (Pl. 5)
oil on canvas
67½ × 72″ (171.5 × 182.9)
Mr. and Mrs. Ken Siebel
(For exhibition in San Francisco and Newport Beach only)

7. TOY COUNTER, 1962 (Pl. 6)
oil on canvas
60 × 72″ (152.4 × 182.9)
Mr. and Mrs. Thomas W. Weisel, San Francisco
(For exhibition in San Francisco only)

8. CREAM SOUPS, 1963 (Pl. 8)
oil on canvas
30 × 36″ (76.2 × 91.4)
Private Collection; courtesy Allan Stone Gallery, New York

9. DELICATESSEN COUNTER, 1963 (Pl. 9)
oil on canvas
60½ × 73″ (153.7 × 185.4)
Private Collection, Boston

10. JAWBREAKER MACHINE (BUBBLE GUM MACHINE), 1963 (Pl. 7)
oil on canvas
25⅞ × 31⅝″ (65.7 × 80.3)
The Nelson-Atkins Museum of Art, Kansas City, Missouri; Gift of Mr. and Mrs. Jack Glenn through The Friends of Art

11. MAN READING, 1963 (Pl. 48)
oil on canvas
48 × 36¼″ (121.9 × 92.1)
Private Collection; courtesy Allan Stone Gallery, New York

12. NEAPOLITAN PIE, 1963/1964–65 (Pl. 10)
oil on canvas
17 × 22⅛″ (43.2 × 56.2)
Mrs. Louis Sosland

13. BIKINI, 1964 (Pl. 51)
oil on canvas
72 × 35⅞″ (182.9 × 91.1)
The Nelson-Atkins Museum of Art, Kansas City, Missouri; Gift of Mr. and Mrs. Louis Sosland

14. MALLARY ANN, 1964 (Pl. 49)
graphite on illustration board
14⅞ × 9⅞″ (sight) (37.8 × 25.1)
Private Collection

15. STANDING MAN, 1964 (Pl. 53)
oil on canvas
60¼ × 36″ (153.0 × 91.4)
Private Collection; courtesy Allan Stone Gallery, New York

16. FISH ON PLATTER (FISH), 1964–80 (Pl. 12)
oil on linen
14 × 19″ (35.6 × 48.3)
Private Collection

17. THREE LIPSTICKS, 1965 (Pl. 13)
oil on canvas board
12 × 16⅛″ (30.5 × 41.0)
Private Collection; courtesy Allan Stone Gallery, New York

18. WOMAN IN TUB, 1965 (Pl. 52)
oil on canvas
36 × 60″ (91.4 × 152.4)
Private Collection, Saint Louis

19. COW RIDGE, 1966 (Pl. 59)
pastel on illustration board
5¹¹⁄₁₆ × 7″ (14.5 × 17.8)
Private Collection

20. POND AND TREES (FARM POND), 1966 (Pl. 60)
pastel on illustration board
10 × 12¹⁄₁₆″ (25.4 × 30.6)
Private Collection

21. STAR BOAT (RIVER BOAT), 1966 (Pl. 18)
oil on canvas
28 × 20⅛″ (71.1 × 51.1)
Mr. and Mrs. C. Humbert Tinsman, Shawnee Mission, Kansas

22. THREE COLD CREAMS, 1966 (Pl. 14)
oil on canvas
14⅛ × 16″ (35.9 × 40.6)
Private Collection

23. DOG, 1967 (Pl. 50)
graphite on illustration board
9⅛ × 7⅜″ (sight) (23.2 × 18.7)
Private Collection

24. UNTITLED (SIX BALLS), 1967 (Pl. 19)
oil on canvas
12¼ × 14¼″ (31.1 × 36.2)
Private Collection; courtesy Allan Stone Gallery,
 New York

25. COLOMA RIDGE, 1967–68 (Pl. 61)
acrylic and pastel on canvas
74 × 75¾″ (188.0 × 192.4)
Private Collection

26. CLIFFS, 1968 (Pl. 62)
acrylic on canvas
101¼ × 88″ (257.2 × 223.5)
Mr. and Mrs. Graham Gund

27. TOWELING OFF, 1968 (Pl. 55)
oil on canvas
30⅝ × 24⅝″ (77.8 × 62.6)
Private Collection, Greenwich, Connecticut

28. CANDY COUNTER, 1969 (Pl. 22)
oil on canvas
47½ × 36⅛″ (120.7 × 91.8)
Private Collection

29. STRAWBERRY CONE, 1969 (Pl. 17)
oil on paper
11 × 14″ (27.9 × 35.6)
Private Collection

30. TIE PILE, 1969 (Pl. 15)
oil on canvas
19¾ × 23¾″ (50.2 × 60.3)
Private Collection; courtesy Allan Stone Gallery,
 New York

31. UNTITLED (GUN), 1970–71/1971 (Pl. 24)
oil on canvas mounted on wood
12 × 16″ (30.5 × 40.1)
Mr. and Mrs. Thomas W. Weisel, San Francisco

32. CAKE WINDOW (SEVEN CAKES), 1970–76 (Pl. 23)
oil on canvas
48 × 59⅜″ (121.9 × 150.8)
Private Collection, New York

33. CHESTNUT ST. NEAR HYDE, 1971 (Pl. 84)
oil on canvas
14 × 10″ (35.6 × 25.4)
Private Collection; courtesy Allan Stone Gallery,
 New York

34. DAFFODIL, 1971 (Pl. 47)
oil on paper
14 × 9½″ (35.6 × 24.1)
Private Collection

35. DESK SET, 1971 (Pl. 25)
oil on canvas
18 × 22¼″ (45.7 × 56.5)
Howard and Gwen Laurie Smits

36. UNTITLED (SCREWDRIVER, LIGHT BULB, AND TAPE),
 1971 (Pl. 27)
oil on linen
16⅛ × 18⅛″ (41.0 × 46.1)
Mr. and Mrs. Julian I. Edison, Saint Louis

37. DESK SET, 1972 (Pl. 28)
pastel on illustration board
16 × 20″ (40.6 × 50.8)
The Southland Corporation, Dallas

38. FIVE HAMMERS, 1972 (Pl. 26)
pencil, pastel, and oil on paper
21½ × 29½″ (54.6 × 74.9)
Private Collection; courtesy Allan Stone Gallery,
 New York

39. PASTEL SCATTER, 1972 (Pl. 29)
pastel on paper
16 × 20⅛″ (40.6 × 51.1)
Private Collection

40. UNTITLED (HAT), 1972 (Pl. 20)
oil on canvas
20 × 25″ (50.8 × 63.5)
Mr. and Mrs. Ken Siebel

41. GIRL WITH PINK HAT (NUDE IN PINK HAT), 1973–
 76 (Pl. 56)
oil on canvas
28 × 21″ (71.1 × 53.3)
Mr. and Mrs. Robert Powell, Sacramento

42. WEDDING CAKE, 1973–82 (Pl. 30)
pastel on paper
32 × 28″ (81.3 × 71.1)
Private Collection

43. SMOKING CIGAR, 1974 (Pl. 21)
oil on linen
14 × 12″ (35.6 × 30.5)
Private Collection

44. YELLOW DRESS, 1974 (Pl. 32)
oil and charcoal on paper
30 × 22⅜″ (76.2 × 56.8)
Charles and Esther Campbell, San Francisco

45. FREEWAY EXIT, 1975 (Pl. 80)
graphite on paper
15⅛ × 22½″ (38.4 × 57.2)
Private Collection

46. HALF DOME AND CLOUD, 1975 (Pl. 63)
oil on canvas
25⅞ × 23″ (65.7 × 58.4)
Allan Stone Gallery, New York

47. HEART CAKES (VALENTINE CAKES, FOUR VALENTINE
 CAKES), 1975 (Pl. 34)
oil on canvas
36 × 48″ (91.4 × 121.9)
H. Christopher J. Brumder, New York

48. CLOUDS AND RIDGE (RIDGE AND CLOUDS),
 1975–83 (Pl. 64)
 oil on linen
 48 × 60″ (121.9 × 152.9)
 Private Collection

49. NUDE IN CHROME CHAIR, 1976 (Pl. 54)
 charcoal on paper
 30⅛ × 22⅜″ (76.5 × 56.8)
 Private Collection

50. TOWARD TWIN PEAKS, 1976 (Pl. 85)
 oil on canvas
 25¼ × 24″ (64.3 × 61.0)
 Private Collection, New York

51. CANDY BALL MACHINE, 1977 (Pl. 31)
 gouache and pastel on paper
 24 × 18″ (61.0 × 45.7)
 John Berggruen, San Francisco
 (For exhibition in San Francisco only)

52. 24TH STREET INTERSECTION (TWENTY-FOURTH
 STREET RIDGE), 1977 (Pl. 65)
 oil on canvas
 35⅝ × 48″ (90.5 × 121.9)
 H. Christopher J. Brumder, New York

53. CALIFORNIA STREET, 1978 (Pl. 67)
 oil on canvas
 26⅞ × 22⅛″ (68.3 × 56.2)
 Mr. and Mrs. Thomas W. Weisel, San Francisco

54. FREEWAYS, 1978 (Pl. 71)
 oil on canvas
 48 × 60⅛″ (121.9 × 152.7)
 Private Collection

55. TOWARD 280, 1978 (Pl. 81)
 graphite on paper
 23 × 29″ (58.4 × 73.7)
 Private Collection

56. CALIFORNIA CAKES, 1979 (Pl. 37)
 oil on linen
 48 × 36″ (121.9 × 91.4)
 Private Collection

57. CORNER APARTMENTS (STUDY), 1979 (Pl. 76)
 oil on masonite
 18 × 12″ (45.7 × 30.5)
 Private Collection

58. CURVED INTERSECTION, 1979 (Pl. 68)
 oil on linen
 23⅛ × 16″ (58.8 × 40.6)
 Mr. and Mrs. Alan L. Stein, San Francisco

59. URBAN FREEWAYS, 1979/1980 (Pl. 72)
 oil on canvas
 44⅜ × 36⅛″ (112.7 × 91.8)
 Private Collection

60. BLACK & WHITE CAKES, 1980 (Pl. 16)
 oil on linen
 18 × 33¾″ (45.7 × 85.7)
 Private Collection

61. CORNER APARTMENTS (DOWN 18TH STREET), 1980
 (Pl. 75)
 oil and charcoal on canvas
 48 × 35⅞″ (121.8 × 91.2)
 Hirshhorn Museum and Sculpture Garden,
 Smithsonian Institution, Washington, D.C.;
 Museum purchase with funds donated by Edward
 R. Downe, Jr., 1980

62. DOWN 18TH STREET, 1980 (Pl. 66)
 oil and charcoal on canvas
 48¾ × 35⅞″ (122.9 × 91.1)
 Malcolm Holzman, New York

63. HOLLY PARK RIDGE, 1980 (Pl. 69)
 oil on canvas
 26 × 22″ (66.0 × 55.9)
 Charles and Esther Campbell, San Francisco

64. HYDRANGEA, 1980 (Pl. 35)
 watercolor on paper
 12¹⁄₁₆ × 12″ (30.6 × 30.5)
 Private Collection

65. NIGHT CITY, 1980 (Pl. 74)
 oil on canvas
 60 × 48″ (152.4 × 121.9)
 Private Collection, California
 (For exhibition in Newport Beach only)

66. SHOES (SHOE ROWS), 1980 (Pl. 33)
 watercolor and pastel on etching
 17⅞ × 26½″ (sight) (45.4 × 67.3)
 Mr. and Mrs. Edwin A. Bergman, Chicago

67. SAN FRANCISCO FREEWAY, 1980–81 (Pl. 82)
 oil on canvas
 36 × 48″ (91.4 × 121.9)
 Mr. and Mrs. William C. Janss, Sun Valley, Idaho

68. HILL STREET, 1980–83 (Pl. 88)
 charcoal on paper
 29¹⁵⁄₁₆ × 22¼″ (76.0 × 56.5)
 Private Collection

69. APARTMENT HILL, 1981 (Pl. 79)
 oil on linen
 60 × 48″ (152.4 × 121.9)
 Private Collection

70. CHERRIES, 1981 (Pl. 46)
 oil on linen
 12⅝ × 12⅝″ (32.1 × 32.1)
 Private Collection

71. HILL STREET (DAY CITY), 1981 (Pl. 73)
 oil on canvas
 48 × 36⅛″ (121.9 × 91.8)
 Mr. and Mrs. Richard Hedreen, Bellevue,
 Washington

72. TWO FIGURES ON BED, 1981 (Pl. 57)
 charcoal on paper
 23⅛ × 29⅛″ (58.8 × 74.0)
 Private Collection

73. URBAN DOWNGRADE, 20TH AND NOE, 1981 (Pl. 70)
oil on canvas
26 × 18″ (66.0 × 45.7)
John Berggruen, San Francisco

74. VARIOUS CAKES, 1981 (Pl. 36)
oil on canvas
25 × 23″ (63.5 × 58.4)
Private Collection; courtesy Allan Stone Gallery,
 New York

75. DAY CITY (BRIGHT CITY), 1982 (Pl. 83)
oil on canvas
47¾ × 36″ (121.3 × 91.4)
Mr. and Mrs. Thomas W. Weisel, San Francisco
(For exhibition in San Francisco only)

76. MALE NUDE, 1982 (Pl. 58)
charcoal on paper
29 × 33″ (73.7 × 83.8)
Private Collection

77. RIVER CITY (SACRAMENTO), 1982/1983 (Pl. 77)
oil on linen
36 × 48″ (91.4 × 121.9)
Mr. and Mrs. Thomas W. Weisel, San Francisco

78. STREET & SHADOW, 1982–83 (Pl. 87)
oil on linen
35¾ × 23¾″ (sight) (90.8 × 60.3)
Private Collection

79. BLACK SHOES, 1983 (Pl. 38)
acrylic on illustration board
11½ × 13″ (29.2 × 33.0)
Private Collection

80. BOUQUET IN VASE, 1983 (Pl. 43)
oil on linen
20 × 16⅜″ (50.8 × 41.6)
Private Collection

81. DARK CANDY APPLES, 1983 (Pl. 39)
oil on wood
11⅝ × 13″ (sight) (29.5 × 33.0)
Private Collection

82. DARK LIPSTICK, 1983 (Pl. 40)
acrylic on paper
8⅞ × 7″ (22.6 × 17.9)
Private Collection

83. FLOWER FAN, 1983 (Pl. 41)
oil on linen
18 × 24⅛″ (45.7 × 61.3)
Private Collection

84. FLOWER SCATTER, 1983 (Pl. 42)
oil on linen
15⅛ × 28″ (38.4 × 71.1)
Private Collection

85. FREEWAY TRAFFIC, 1983 (Pl. 78)
oil on wood
15⅞ × 19¾″ (sight) (40.3 × 50.2)
Private Collection

86. BOXED ROSE, 1984 (Pl. 45)
oil on wood
8¼ × 16″ (21.0 × 40.6)
Private Collection

87. PINNED ROSE, 1984 (Pl. 44)
acrylic on paper
22 × 9″ (sight) (55.9 × 22.9)
Private Collection

88. POLICE CAR, 1984 (Pl. 89)
oil on linen
16 × 16⅛″ (40.6 × 41.0)
Private Collection

89. VAN, 1984 (Pl. 86)
pastel on paper
8⅞ × 11½″ (sight) (22.6 × 29.2)
Private Collection

EXHIBITION HISTORY

Compiled by Donna Graves and Kathleen Butler

An * indicates that according to our research, documentation for this exhibition is unavailable. A *catalog* is defined as any publication that includes a checklist of the exhibition. A † indicates that more detailed catalog information can be found in the Bibliography.

ONE-PERSON EXHIBITIONS

1951 *Influences on a Young Painter*
E.B. Crocker Art Gallery (now Crocker Art Museum), Sacramento, 1–31 March 1951.

Wayne Thiebaud: Prints
California State Library, Sacramento, 1951.*

Wayne Thiebaud
Contemporary Gallery, Sausalito, California, 1951.*

1953 *Wayne Thiebaud*
Zivile Gallery, Los Angeles, December 1953.

Wayne Thiebaud
California State Library, Sacramento, 1953.*

1954 *Paintings: Wayne Thiebaud*
Gump's Gallery, San Francisco, 8–27 May 1954.

Wayne Thiebaud
Pioneer Museum and Haggin Galleries, Stockton, California, 1954.*

1956 *Wayne Thiebaud*
Little Gallery, Sacramento Junior College (now Sacramento City College), September 1956.*

1957 *Thiebaud—Recent Works*
E.B. Crocker Art Gallery, Sacramento, 22 September–27 October 1957.

Wayne Thiebaud
California State Library, Sacramento, September 1957.*

Wayne Thiebaud
Little Gallery, Sacramento Junior College, September 1957.*

1958 *Recent Works of Wayne Thiebaud*
Artists Cooperative Gallery (now Artists Contemporary Gallery), Sacramento, August–September 1958.

1959 *Wayne Thiebaud—Recent Works*
Artists Cooperative Gallery, Sacramento, 15 August–5 September 1959.

Wayne Thiebaud
San Jose State College, California, 1959.*

1960 *Wayne Thiebaud*
Artists Cooperative Gallery, Sacramento, 4 March–April (n.d.) 1960.*

Wayne Thiebaud
Art Gallery, Humboldt State College (now Humboldt State University), Arcata, California, 25 April–14 May 1960.

Paintings by Wayne Thiebaud
The Nut Tree, Vacaville, California, 4 May–28 August 1960.

1961 *Wayne Thiebaud*
Artists Cooperative Gallery, Sacramento, 19 May–15 June 1961.

An Exhibition of Recent Works by Thiebaud
Art Unlimited, San Francisco, 30 November–20 December 1961.

Wayne Thiebaud
Seven Arts Gallery, Bakersfield, California, 1961.*

1962 *Wayne Thiebaud: Recent Paintings*
Allan Stone Gallery, New York, 17 April–5 May 1962.

An Exhibition of Paintings by Wayne Thiebaud
M.H. de Young Memorial Museum, San Francisco, 10 July–10 August 1962.

1963 *Wayne Thiebaud*
Little Gallery, Sacramento City College, February 1963.*

Wayne Thiebaud: Recent Paintings
Allan Stone Gallery, New York, 9–27 April 1963.

Wayne Thiebaud
Galleria Schwarz, Milan, 25 June–15 July, 1963.
†Catalog published.

1964 *Thiebaud*
Allan Stone Gallery, New York, 24 March–11 April 1964.
†Brochure published.

1965 *Prints, Drawings, and Paintings by Wayne Thiebaud*
San Francisco Museum of Art (now San Francisco Museum of Modern Art), 12 January–21 February 1965.

Wayne Thiebaud
Allan Stone Gallery, New York, 5–30 April 1965.

Figures: Thiebaud
Stanford Art Museum (now Stanford University Museum and Art Gallery), California, 26 September–31 October 1965.
†Catalog published.
TRAVELED TO:
Allan Stone Gallery, New York, 5–30 April 1966.
Albrecht Gallery of Fine Arts, Saint Joseph, Missouri, 6 May–3 June 1966.

Delights
E.B. Crocker Art Gallery, Sacramento, 5 December 1965–2 January 1966.

1966 *Wayne Thiebaud: Paintings, Drawings, Prints, and Watercolors*
Art Gallery, Humboldt State College, Arcata, California, 25 April–14 May 1966.

1967 *Wayne Thiebaud*
Allan Stone Gallery, New York, 21 March–15 April 1967.
†Catalog published.

1968 *Wayne Thiebaud*
Pasadena Art Museum (now Norton Simon Museum), California, 13 February–17 March 1968.
†Catalog published.

TRAVELED TO:

Walker Art Center, Minneapolis, 1 April–5 May 1968.

San Francisco Museum of Art, 23 May–23 June 1968.

The Contemporary Arts Center, Cincinnati, 8 July–11 August 1968.

Utah Museum of Fine Arts of the University of Utah, Salt Lake City, 22 September–27 October 1968.

Wayne Thiebaud
Artists Contemporary Gallery, Sacramento, 26 May–11 July 1968.

Wayne Thiebaud
Allan Stone Gallery, New York, 2–27 November 1968.

Thiebaud
Milwaukee Art Center, Wisconsin, 7 November–1 December 1968.
†Catalog published.

1969 *Recent Works of Wayne Thiebaud*
Allan Stone Gallery, New York, 6 March–16 April 1969.

1970 *Recent Works by Wayne Thiebaud*
E.B. Crocker Art Gallery, Sacramento, 9 January–8 February 1970.
†Catalog published.

Wayne Thiebaud: Recent Works
Allan Stone Gallery, New York, March–April 1970.*

Wayne Thiebaud
Fresno State College Art Gallery, California, 19–28 June 1970.

1971 *Wayne Thiebaud Graphics: 1964–1971*
Whitney Museum of American Art, New York, 11 June–18 July 1971 (organized by Parasol Press, Ltd., New York).
†Catalog published.

TRAVELED TO:

William Rockhill Nelson Gallery and Atkins Museum of Fine Arts (now The Nelson-Atkins Museum of Art), Kansas City, 2 September–3 October 1971.

Corcoran Gallery of Art, Washington, D.C., 10 December 1971–30 January 1972.

Fort Wayne Museum of Art, 11 December 1971–31 January 1972.

Fort Worth Art Center Museum (now Fort Worth Art Museum), Texas, 16 February–12 March 1972.

Des Moines Art Center, 24 March–30 April 1972.

Achenbach Foundation for Graphic Arts, California Palace of the Legion of Honor, San Francisco, 1 June–3 July 1972.

Wadsworth Atheneum, Hartford, 1 September–14 October 1972.

Baltimore Museum, 2 November–3 December 1972.

Phoenix Art Museum, 17 February–18 April 1973.

Wallraf-Ritchartz Museum, Cologne, West Germany, 11 July–31 August 1975.

Arnolfini Gallery, Bristol, England, 24 February–27 March 1976.

Bard College, Annandale-on-Hudson, New York, September 1979.

Wayne Thiebaud—Delights
Artists Contemporary Gallery, Sacramento, 27 June–10 August 1971.

Wayne Thiebaud: Paintings, Pastels, Drawings, and Prints
John Berggruen Gallery, San Francisco, 1971.*

1972 *Wayne Thiebaud*
Allan Stone Gallery, 14 March–6 April 1972.

Wayne Thiebaud
Art Gallery, Fullerton Junior College, California, 21 April–10 May 1972.

Wayne Thiebaud: Survey of Painting 1950–72
The Art Museum and Galleries (now University Art Museum), California State University, Long Beach, 20 November–17 December 1972.
†Catalog published.

1973 *Wayne Thiebaud—Recent Paintings*
Artists Contemporary Gallery, Sacramento, 11 February–8 March 1973.

Works by Wayne Thiebaud
South Teaching Gallery, Miami Dade Community College, Florida, 11 February–8 March 1973.

Wayne Thiebaud: Paintings, Pastels, and Prints
John Berggruen Gallery, San Francisco, 14 February–14 March 1973.

Wayne Thiebaud, Paintings and Drawings 1958–1973
Portland Center for the Visual Arts, Oregon, 15 April–13 May 1973.

Works on Paper and Other Edibles: An Exhibition of the Works of Wayne Thiebaud
Holland Union Gallery, Dickinson College, Carlisle, Pennsylvania, 5–31 October 1973.

Wayne Thiebaud: Recent Work
Allan Stone Gallery, New York, 6 November–1 December 1973.

1974 *Thiebaud in Dakota*
University Art Gallery, University of North Dakota, Grand Forks, 19 February–8 March 1974.

Paintings and Graphics by Wayne Thiebaud
Genevieve and Donald Gilmore Art Center, Kalamazoo Institute of Arts, Michigan, 3–31 March 1974.

Wayne Thiebaud: Paintings, Drawings, and Prints
Church Fine Arts Gallery (now Sheppard Gallery), University of Nevada, Reno, 13 September–2 October 1974.

1975 *Wayne Thiebaud: Prints, Drawings, Paintings*
Colorado State University, Fort Collins, 2–19 February 1975.
†Brochure published.

TRAVELED TO:

The Denver Art Museum, 28 February–30 March 1975.

Wayne Thiebaud
Edwin A. Ulrich Museum of Art, Wichita State University, Kansas, 12 February–2 March 1975.

Wayne Thiebaud
Little Gallery, Sacramento City College, 13–31 October 1975.

1976 *Wayne Thiebaud: Paintings and Works on Paper*
Mary Porter Sesnon Art Gallery, University of California, Santa Cruz, 18 February–10 April 1976.
†Catalog published.

Wayne Thiebaud
Allan Stone Gallery, New York, May 1976.

Wayne Thiebaud: Survey 1947–1976
Phoenix Art Museum, 10 September–17 October 1976.
†Catalog published.

TRAVELED TO:
The Oakland Museum, 19 November 1976–12 January 1977.

University of Southern California Art Galleries, Los Angeles, 31 January–6 March 1977.

Des Moines Art Center, 5 April–15 May 1977.

Neuberger Art Museum, State University of New York, Purchase, 17 July–28 August 1977.

Institute of Contemporary Art, Boston, 15 September–30 October 1977.

1977 *Wayne Thiebaud/Strictly Personal*
Delphian Gallery, Sheridan, Oregon, 16 January–6 February 1977.

Wayne Thiebaud: Delights
John Berggruen Gallery, San Francisco, 23 February–26 March 1977.

Wayne Thiebaud: Drawings
Memorial Union Art Gallery, University of California, Davis, 18 April–10 May 1977.

Wayne Thiebaud: Recent Paintings and Drawings
Diablo Valley Junior College, Pleasant Valley, California, 12 May–3 June 1977.

Wayne Thiebaud: Creations on Paper
Visual Arts Gallery, College of Saint Catherine, Saint Paul, Minnesota, 3–31 October 1977.
†Catalog published.

1978 *Wayne Thiebaud*
Boehm Gallery, Palomar College, San Marcos, California, 15 February–16 March 1978.
†Brochure published.

Wayne Thiebaud: Delights
Yarlow/Salzman Gallery, Toronto, 6–31 May 1978.

Wayne Thiebaud: Recent Work
San Francisco Museum of Modern Art, 17 May–25 June 1978.

Wayne Thiebaud: Works on Paper
Boise Gallery of Art, Idaho, 5 October–5 November 1978.

1979 *Wayne Thiebaud: San Francisco Paintings*
Allan Stone Gallery, New York, 3–28 April 1979.

1980 *Wayne Thiebaud: Paintings, Pastels, and Prints*
John Berggruen Gallery, San Francisco, 15 January–16 February 1980.

Wayne Thiebaud: Paintings and Drawings
Charles Campbell Gallery, San Francisco, 16 January–1 March 1980.

Wayne Thiebaud
Art Gallery, College of the Mainland, Texas City, Texas, 5 March–8 April 1980.

Thiebaud
Allan Stone Gallery, New York, 2–30 April 1980.

Wayne Thiebaud
Van Staveren Fine Art, Sacramento, 2–31 May 1980.

Wayne Thiebaud
Art Center College of Design, Pasadena, California, 23 June–11 July 1980.

Wayne Thiebaud: Etchings and Serigraphs
University Union Gallery, California State University, Sacramento, 15–31 October 1980.

1981 *Wayne Thiebaud: Painting*
Walker Art Center, Minneapolis, 8 February–22 March 1981.
†Catalog published.

TRAVELED TO:
Fort Worth Art Museum, Texas, 26 April–17 June 1981.

Museum of Fine Arts of Saint Petersburg, Florida, 5 July–6 September 1981.

Institute of Contemporary Art, University of Pennsylvania, Philadelphia, 13 September–25 October 1981.

Wayne Thiebaud
Laguna Beach School of Art, California, 29 June–24 July 1981.

Wayne Thiebaud
Santa Barbara Contemporary Arts Forum, California, 20 October–28 November 1981.

Paintings and Prints by Wayne Thiebaud
Robert Mondavi Winery, Oakville, California, 25 October–20 November 1981.

Wayne Thiebaud: Works on Paper
Art Gallery, California State College, Stanislaus, Turlock, 9 November–3 December 1981.

1982 *Wayne Thiebaud: Recent Drawings*
Eloise Pickard Smith Gallery, University of California, Santa Cruz, 10 January–7 February 1982.
†Catalog published.

Wayne Thiebaud
Art Museum of Santa Cruz County, Santa Cruz, California, 17 January–27 February 1982.
†Catalog published.

Wayne Thiebaud: Prints
Gallery Hiro, Tokyo, 25 January–5 February 1982.
†Catalog published.

TRAVELED TO:
Yoh Art Gallery, Osaka, 18 February–13 March 1982.

Wayne Thiebaud Prints
Davis Art Center, California, 30 April–21 May 1982.

Wayne Thiebaud: Recent Paintings
Allan Stone Gallery, New York, May 1982.

Thiebaud Graphics
Sheehan Gallery, Whitman College, Walla Walla, Washington, 1–30 September 1982.

Prints and Paintings by Wayne Thiebaud
Marsh Gallery, University of Richmond, Virginia, 26 September–14 October 1982.

1983 *Wayne Thiebaud: Landscapes & City Views*
Crocker Art Museum, Sacramento, 5 February–20 March 1983.
†Brochure published.

Wayne Thiebaud: Paintings, Drawings, Graphics 1961–1983
The Trout Gallery, Emil R. Weiss Center for the Arts, Dickinson College, Carlisle, Pennsylvania, 29 April–12 June 1983.
†Catalog published.

1984 *Wayne Thiebaud*
Davidson Galleries, Seattle, 8–30 March 1984.

Wayne Thiebaud: Drawings
Jeremy Stone Gallery, San Francisco, 1 August–12 September 1984.

1985 *Wayne Thiebaud*
Van Staveren Fine Art Gallery, Sacramento, 26 April–24 May 1985.

GROUP EXHIBITIONS

1945 *Kingsley Art Club 20th Annual Local Exhibit*
E.B. Crocker Art Gallery (now Crocker Art Museum), Sacramento, April 1945.
Catalog published.

1948 *1948 Annual Exhibition: Artists of Los Angeles and Vicinity*
Los Angeles County Museum (now Los Angeles County Museum of Art), 15 May–30 June 1948.
Catalog published.

1949 *24th Annual Exhibition: Work of Resident Artists*
E.B. Crocker Art Gallery, Sacramento, 18 May–18 June 1949.

Artists under Thirty-three
Los Angeles Art Association Galleries, 1949.*

1950 *25th Annual Exhibition: Work of Resident Artists*
E.B. Crocker Art Gallery, Sacramento, 17 May–21 June 1950.

Arts Exhibition
California State Fair, Sacramento, 31 August–10 September 1950.
Catalog published, foreword by T.P. Tupman.

1951 *Third Annual Art Show*
Placer College, Auburn, California, 27–29 April 1951.

26th Annual Exhibition: Work of Resident Artists
E.B. Crocker Art Gallery, Sacramento, 16 May–22 June 1951.

1952 *27th Annual Exhibition: Work of Resident Artists*
E.B. Crocker Art Gallery, Sacramento, 21 May–29 June 1952.

Arts
California State Fair, Sacramento, 28 August–7 September 1952.
Catalog published.

1953 *28th Annual Exhibition: Work of Artists of the Central Valleys*
E.B. Crocker Art Gallery, Sacramento, 20 May–28 June 1953.

Arts Exhibit
California State Fair, Sacramento, 1953.
Catalog published.

1954 *29th Annual Exhibition: Work of Artists of the Central Valleys*
E.B. Crocker Art Gallery, Sacramento, 19 May–27 June 1954.

1955 *30th Annual Exhibition: Work of Artists of the Central Valleys*
E.B. Crocker Art Gallery, Sacramento, 18 May–26 June 1955.

1956 *31st Annual Exhibition: Work of Artists of the Central Valleys*
E.B. Crocker Art Gallery, Sacramento, 16 May–1 July 1956.

1957 *32nd Annual Exhibition: Work of Artists of Northern California*
E.B. Crocker Art Gallery, Sacramento, 15 May–30 June 1957.

Annual Watercolor, Drawing, and Print Exhibition of the San Francisco Art Association
San Francisco Museum of Art (now San Francisco Museum of Modern Art), 19 September–6 October 1957.
Catalog published, foreword by Grace McCann Morley.

Bay Printmakers' Society Third National Exhibition of Prints
Oakland Art Museum (now The Oakland Museum), 5–27 October 1957.
Catalog published, introduction by Eldon N. Mills.

Seven Painters under Thirty
E.B. Crocker Art Gallery, Sacramento, November 1957.*

1958 *Artist's League Exhibition*
E.B. Crocker Art Gallery, Sacramento, 12 January–March (n.d.) 1958.*

Fifth International Biennial of Contemporary Color Lithography
Cincinnati Art Museum, 28 February–15 April 1958.
Catalog published, foreword by Philip R. Adams, essay by Gustave von Groschwitz.

Tenth Annual Auburn Arts Festival
Fair Grounds, Auburn, California, 25–27 April 1958.
Catalog published.

Group exhibition
Artists Cooperative Gallery, Sacramento, April–May 1958.*

16th Annual Exhibition of Prints Made during the Current Year
The Library of Congress, Washington, D.C., 1 May–1 September 1958.
Catalog published.

33rd Annual Exhibition: Work of Artists of Northern California
E.B. Crocker Art Gallery, Sacramento, 21 May–29 June 1958.

Northern California Artists Open
E.B. Crocker Art Gallery, Sacramento, 26 October–29 November 1958.

Bay Printmakers' Society Fourth National Exhibition
Oakland Art Museum, 2–25 November 1958.
Catalog published, foreword by Karl Kasten,
introduction by E. Gunter Troche.

*Twenty-second Annual Drawing and Print Exhibition
of the San Francisco Art Association*
San Francisco Museum of Art, 4–28 December
1958.
Catalog published.

1959 *Eleventh Annual Arts Festival*
Placer County Fair Grounds, Auburn, Califor-
nia, 17–19 April 1959.
Catalog published.

*34th Annual Exhibition: Work of Artists of Northern
California*
E.B. Crocker Art Gallery, Sacramento, 20
May–29 June 1959.

Bay Printmakers' Society Fifth National Exhibition
Oakland Art Museum, 14 November–8 Decem-
ber 1959.
Catalog published, foreword by Paul Mills, intro-
duction by Jules Heller.

1960 *Twenty-third Annual Drawing, Print, and Watercolor
Exhibition of the San Francisco Art Association*
San Francisco Museum of Art, 15 January–14
February 1960.
Catalog published, foreword by George D.
Culler.

Second Winter Invitational Exhibition
California Palace of the Legion of Honor, San
Francisco, 23 January–28 February 1960.
Catalog published, introduction by Howard Ross
Smith.

*35th Annual Exhibition: Work of Artists of Northern
California*
E.B. Crocker Art Gallery, Sacramento, 18
May–26 June 1960.

1961 *1961 Northern California Painters' Annual*
Oakland Art Museum, 7–29 January 1961.
Catalog published, introduction by Paul Mills.

Lodi's 1st Annual Art Show
Lodi Art Center, California, 13–14 May 1961.
Catalog published.

*36th Annual Exhibition: Work of Artists of Northern
California*
E.B. Crocker Art Gallery, Sacramento, 17
May–25 June 1961.

Eleventh Annual Exhibition: Painting and Sculpture
Richmond Art Center, California, 8–26 Novem-
ber 1961.
Catalog published.

Third Winter Invitational Exhibition
California Palace of the Legion of Honor, San
Francisco, 3 December 1961–21 January 1962.
Catalog published, introduction by Howard Ross
Smith.

1962 *Prints: The Californians 1962*
Eric Locke Gallery, San Francisco, 10 April–19
May 1962.

Group exhibition
Pioneer Museum and Haggin Galleries, Stock-
ton, California, April 1962.*

*37th Annual Exhibition: Work of Artists of Northern
California*
E.B. Crocker Art Gallery, Sacramento, 16
May–24 June 1962.

*An International Selection of Contemporary Painting
and Sculpture*
Dayton Art Institute, 14 September–14 October
1962.

New Painting of Common Objects
Pasadena Art Museum (now Norton Simon
Museum), California, 25 September–19 October
1962.

New Realists
Sidney Janis Gallery, New York, 31 October–1
December 1962.
Catalog published, essays by John Ashbery and
Sidney Janis.

Recent Acquisitions
The Museum of Modern Art, New York, 20
November 1962–13 January 1963.

Fourth Winter Invitational Exhibition
California Palace of the Legion of Honor, San
Francisco, 15 December 1962–27 January 1963.
Catalog published, introduction by Howard Ross
Smith.

1963 *The New Art*
Davison Art Center, Wesleyan University,
Middletown, Connecticut, 1–22 March 1963.
Catalog published, essay by Lawrence Alloway.

Contemporary Painting
Smith College Museum of Art, Northampton,
Massachusetts, 7 April–10 May 1963.
Catalog published, foreword by Charles Chetam.

Popular Art
William Rockhill Nelson Gallery and Atkins
Museum of Fine Arts (now The Nelson-Atkins
Museum of Art), Kansas City, Missouri, 28
April–26 May 1963.
Catalog published, introduction by Ralph T. Coe.

Pop! Goes the Easel
Contemporary Arts Museum, Houston, April
1963.
Catalog published, essay by Douglas MacAgy.

Some New Art in the Bay Area
San Francisco Art Institute, 8–24 May 1963.
Brochure published, essay by Fred Martin.

*A Selection of Works from the Art Collections of the
University of Nebraska*
Sheldon Memorial Art Gallery, University of Ne-
braska, Lincoln, 16 May–4 August 1963.
Catalog published, introduction by Norman A.
Geske.

Six More
Los Angeles County Museum of Art, 24 July–25
August 1963.
Catalog published, foreword by James Elliott, es-
say by Lawrence Alloway.

Pop Art U.S.A.
Oakland Art Museum, 7–29 September 1963.
Catalog published, foreword by Paul Mills, essay
by John Coplans.

The Art of Things
Jerrold Morris International Gallery, Toronto,
19 October–6 November 1963.

The Popular Image
Institute of Contemporary Arts, London, 24
October–23 November 1963.
Catalog published, essay by Alan Solomon.

Harvest of Plenty
Wadsworth Atheneum, Hartford, 24 October–1
December 1963.
Catalog published, introduction by C.C.
Cunningham.

Mixed Media and Pop Art
Albright-Knox Art Gallery, Buffalo, 19 November–15 December 1963.
Catalog published, foreword by Gordon M.
Smith.

Signs of the Time
Des Moines Art Center, 6 December 1963–19
January 1964.
Catalog published, essay by Thomas S. Tibbs.
TRAVELED TO:
Addison Gallery of American Art, Phillips Academy, Andover, Massachusetts, 15 February–22
March 1964.

New Directions in American Painting
Munson-Williams-Proctor Institute, Utica, New
York, 10 December 1963–5 January 1964 (organized by The Poses Institute of Fine Arts,
Brandeis University, Waltham, Massachusetts).
Catalog published, introduction by Sam Hunter.
TRAVELED TO:
Isaac Delgado Museum of Art, New Orleans, 7
February–8 March 1964.
Atlanta Art Association, 18 March–22 April
1964.
The J.B. Speed Museum, Louisville, Kentucky, 4
May–7 June 1964.
Indiana University Art Museum, Bloomington,
22 June–20 September 1964.
Washington University, Saint Louis, 5–30 October 1964.
The Detroit Institute of Arts, 10 November–6
December 1964.

1964 *Bay Area Art for the Collector*
San Francisco Museum of Art, 15 January–9
February 1964.

Fifth Winter Invitational
California Palace of the Legion of Honor, San
Francisco, 18 January–23 February 1964.
Catalog published, introduction by Howard Ross
Smith.

Art Becomes Reality
Fine Arts Gallery, University of British Columbia, Vancouver, 29 January–8 February 1964.
Catalog published, introduction by Alvin
Balkind.

Recent American Drawings
Rose Art Museum, Brandeis University, Waltham, Massachusetts, 19 April–17 May 1964.
Catalog published, foreword by Sam Hunter,
introduction by Thomas Garver.

Iconographical Paintings
Sander Gallery, La Jolla, California, 28 April–23
May 1964.

Contemporary American Figure Painting
Wadsworth Atheneum, Hartford, 7–31 May
1964.

24th Annual Exhibition by the Society for Contemporary Art
The Art Institute of Chicago, 8–31 May 1964.
Catalog published.

New Collectors
San Francisco Museum of Art, 12 May–15 June
1964.

39th Annual Exhibition: Work of Artists of Northern California
E.B. Crocker Art Gallery, Sacramento, 20
May–21 June 1964.

Work of the University of California, Davis, Artists
Artists Cooperative Gallery, Sacramento, May
1964.*

Nieuwe Realisten
Gemeentemuseum, The Hague, The Netherlands, 24 June–30 August 1964.
Catalog published, essays by L.J.F. Wijsebeek,
Jasia Reichardt, Pierre Restany, and W.A.L.
Beeren.

TRAVELED TO:
Museum des 20. Jahrhunderts, Vienna (retitled
Pop Etc.), 19 September–31 October 1964.
Akademie der Kunst, Berlin (retitled *Neue
Realisten und Pop Art*), 11 November 1964–3 January 1965.
Catalog published, introduction by Friedrich
Ahlers-Hestermann, essay by Werner
Hoffmann.

*An Exhibition of Sculpture and Graphic Art by Faculty
of the Departments of Art at Berkeley and Davis,
University of California*
University Art Gallery (now University Art
Museum), University of California, Berkeley, 1
July–31 August 1964.
Catalog published, foreword by Donald Coney,
introduction by Herschel B. Chipp.

From the Sterling Holloway Collection
UCLA Art Galleries (now the Frederick S. Wight
Art Gallery), University of California, Los Angeles, 20 September–25 October 1964.
Catalog published, foreword by Henry Dora.

Current Painting and Sculpture of the Bay Area
Stanford University Art Museum (now Stanford
University Museum and Art Gallery), California,
8 October–29 November 1964.
Catalog published, introduction by Lorenz
Eitner, essay by Joanna Magloff.

Art since 1889
Art Gallery, University of New Mexico, Albuquerque, 20 October–15 November 1964.
Catalog published, foreword by C[linton]
A[dams].

The Nude in Art
Vancouver Art Gallery, British Columbia, 3–29
November 1964.

Catalog published, foreword by Richard B. Simmons.

Alumni Exhibition
Sacramento State College (now California State University, Sacramento), 1964.*

From the West
San Francisco Art Institute, 1964.*

1965 *Crocker Art Gallery Association Invitational Exhibition*
E.B. Crocker Art Gallery, Sacramento, 17 January–28 February 1965.
Catalog published.

Kansas City Collects
William Rockhill Nelson Gallery and Atkins Museum of Fine Arts, Kansas City, Missouri, 22 January–28 February 1965.
Catalog published, introduction by Ralph T. Coe.

The New American Realism
Worcester Art Museum, Massachusetts, 18 February–4 April 1965.
Catalog published, preface by Daniel Catton Rich, essay by Martin Carey.

The Drawing Society—Regional Exhibition
California Palace of the Legion of Honor, San Francisco, 27 February–11 April 1965.
Catalog published, introduction by E. Gunter Troche.

Some Aspects of California Painting and Sculpture
La Jolla Museum of Art, California, 28 February–11 April 1965.
Catalog published, introduction by Donald J. Brewer.

Contemporary American Painting and Sculpture 1965
Krannert Art Museum, University of Illinois, Champaign, 7 March–11 April 1965.
Catalog published, introduction by Allen S. Weller.

CSE '65: California Society of Etchers 1965 Members' Exhibition
San Francisco Art Institute, 7 April–2 May 1965.

Pop Art and the American Tradition
Milwaukee Art Center, 9 April–9 May 1965.
Catalog published, essay by Tracy Atkinson.

40th Annual Exhibition: Work of Artists of Northern California
E.B. Crocker Art Gallery, Sacramento, 19 May–27 June 1965.

Far West Regional Exhibition of Art across America
San Francisco Museum of Art, 30 June–1 August 1965.
Catalog published, foreword by George H. Pringle, introduction by George D. Culler.

Paintings by U.C. Artists
University Art Gallery, University of California, Berkeley, 13 July–31 August 1965.
Catalog published, introduction by Herschel B. Chipp.

Eighty-fourth Annual Exhibition of the San Francisco Art Institute
San Francisco Museum of Art, 13 August–12 September 1965.
Catalog published.

The Figure International
State University College, Plattsburgh, New York, 1–22 September 1965 (organized by The American Federation of Arts, New York).
TRAVELED TO:
Schenectady Museum Association, New York, 6–27 October 1965.
Saint Lawrence University, Canton, New York, 10 November–1 December 1965.
A.D. White Museum (now Herbert F. Johnson Museum), Cornell University, Ithaca, New York, 19 January–9 February 1966.
State University College, Oneonta, New York, 23 February–16 March 1966.
State University College, Brockport, New York, 30 March–20 April 1966.
Everson Museum of Art, Syracuse, New York, 4–25 May 1966.
Oswego Art Guild, New York, 8–29 June 1966.
State University of New York, Buffalo, 13 July–3 August 1966.
East Meadow Public Library, Long Island, New York, 21 September–12 October 1966.

The San Francisco Collector
M.H. de Young Memorial Museum, San Francisco, 21 September–17 October 1965.
Catalog published, introduction by Jack R. McGregor.

Modern Realism and Surrealism
State University College, Oneonta, New York, 6–27 October 1965 (organized by The American Federation of Arts, New York).
TRAVELED TO:
East Meadow Public Library, Long Island, New York, 10 November–1 December 1965.
Saint Lawrence University, Canton, New York, 19 January–9 February 1966.
Elmira College, New York, 23 February–16 March 1966.
Schenectady Museum Association, New York, 30 March–20 April 1966.
State University College, Brockport, New York, 4–25 May 1966.
Everson Museum of Art, Syracuse, New York, 8–29 June 1966.
Ithaca College Museum of Art, New York, 13 July–3 August 1966.
State University of New York, Buffalo, 30 August–30 September 1966.

Selections from the Work of California Artists
Witte Memorial Museum, San Antonio, Texas, 10 October–14 November 1965.
Catalog published.

Sterling Holloway's "Especially for Children"
The Pavilion Gallery, Newport Beach, California, 5–31 December 1965.
TRAVELED TO:
Los Angeles County Museum of Art, 11 February–6 March 1966.

1965 Annual Exhibition of Contemporary American Painting
Whitney Museum of American Art, New York, 8

December 1965–30 January 1966.
Catalog published.

1966 *Painting & Sculpture Today—1966*
Herron Museum of Art, Indianapolis, 1–30 January 1966.
Catalog published.

Contemporary Urban Visions
New School Art Center, New York, 25 January–24 February 1966.
Catalog published, introduction by Paul Mocsanyi.

Recent Still Life
Museum of Art, Rhode Island School of Design, Providence, 23 February–3 April 1966.
Catalog published, essay by Daniel Robbins.

Pop and Op Art
Philbrook Art Center, Tulsa, 1–29 March 1966.

Contemporary Prints from Northern California: For the Art in the Embassies Program 1966–68: United States State Department
Oakland Art Museum, 5–25 March 1966.
Catalog published, essays by Therese Heyman and Dennis Beall.
TRAVELED TO:
I.B.M. Gallery, New York, 5–23 April 1966.

Thirteen Views of the West
The Arts Council of Philadelphia, 9–31 March 1966.
Brochure published.

The Second Bucknell Annual National Drawing Exhibition
Bucknell University Art Gallery, Lewisburg, Pennsylvania, 2 April–1 May 1966.
Catalog published, foreword by William Lieberman, introduction by Gerald Eager.

The Current Moment in Art
San Francisco Art Institute, 6–31 April 1966.
Catalog published.

Twenty-five Still Life Paintings
Indiana University Art Museum, Bloomington, 15 April–15 May 1966.

The Harry N. Abrams Collection
The Jewish Museum, New York, 29 June–5 September 1966.
Catalog published, introduction by Sam Hunter, interview with Harry Abrams.

New Art in Philadelphia
Institute of Contemporary Art, University of Pennsylvania, Philadelphia, 30 September–11 November 1966.
Catalog published, introduction by Samuel Adams Green.

Sculpture and Painting Today: Selections from the Collection of Susan Morse Hilles
Museum of Fine Arts, Boston, 7 October–6 November 1966.
Catalog published, foreword by Susan Morse Hilles.

Art on Paper 1966
Weatherspoon Art Gallery, University of North Carolina, Greensboro, 6 November–16 December 1966.
Catalog published.

1967 *Exchange Exhibition/Exhibition Exchange: From the Collection of the Rose Art Museum, Brandeis University*
Museum of Art, Rhode Island School of Design, Providence, 15 February–31 March 1967.
Catalog published, essays by Daniel Robbins and William C. Seitz.

Contemporary American Painting and Sculpture 1967
Krannert Art Museum, University of Illinois, Champaign, 5 March–9 April 1967.
Catalog published, introduction by Allen S. Weller.

The West—80 Contemporaries
University of Arizona Museum of Art, Tucson, 19 March–30 April 1967.
Catalog published, introduction by William E. Steadman.

Four California Painters
Art Gallery, California State University, Hayward, March 1967.*

The Organizers, 10th Year
Artists Cooperative Gallery, Sacramento, 30 April–27 May 1967.

Painters behind Painters
California Palace of the Legion of Honor, San Francisco, 13 May–25 June 1967.
Catalog published, introduction by Thomas C. Howe.

Mixed Masters
Art Department, University of Saint Thomas, Houston, May–September 1967.
Catalog published, introduction by Kurt von Meier.

São Paulo 9: Environment U.S.A.: 1957–1967
São Paulo, Brazil, 22 September 1967–8 January 1968.
Catalog published, essay by William C. Seitz and Lloyd Goodrich.
TRAVELED TO:
Rose Art Museum, Brandeis University, Waltham, Massachusetts, 26 February–31 March 1968.

1967 Annual Exhibition of Contemporary Painting
Whitney Museum of American Art, New York, 13 December 1967–4 February 1968.
Catalog published.

1968 *Pop Art Drawings*
Hilles Library, Radcliffe College, Cambridge, Massachusetts, 7 January–1 February 1968.
Catalog published.

Popular Images and Sensibility
Cleveland Museum of Art, 2 July–15 September 1968.
Catalog published, essay by Edward B. Henning.

Contemporary Paintings from the Wellington-Ivest Collection
Museum of Fine Arts, Boston, 15 September–27 October 1968.

Prints of the '60s from Boston Area Collections
Museum of Fine Arts, Boston, 11 December 1968–26 January 1969.
Catalog published, introduction by Clifford S. Ackley.

An Exhibition of Small Prints
San Francisco Art Institute, 1968.*

The Contemporary Landscape
San Francisco Art Institute, 1968.*

1969 *Lithographs from Gemini*
Memorial Union Art Gallery, University of California, Davis, 13 January–15 February 1969.
Catalog published, introduction by Fred Parker, essay by Kenneth Tyler.

Contemporary American Painting and Sculpture 1969
Krannert Art Museum, University of Illinois, Champaign, 2 March–6 April 1969.
Catalog published, introduction by James R. Shipley and Allen S. Weller.

The American Sense of Reality
Philbrook Art Center, Tulsa, 4–25 March 1969.
Catalog published, introduction by Donald G. Humphrey.
TRAVELED TO:
Museum of Art, University of Oklahoma, Norman, 6 April–11 May 1969 (presented concurrently at Oklahoma Art Center, Oklahoma City).

Painting and Sculpture Today—1969
Indianapolis Museum of Art, May (n.d.)–4 June 1969.
Catalog published, introduction by Richard Warrum.*

Directions 2: Aspects of a New Realism
Milwaukee Art Center, 21 June–10 August 1969.
Catalog published, essays by Tracy Atkinson and John Lloyd Taylor.
TRAVELED TO:
Contemporary Arts Museum, Houston, 17 September–19 October 1969.
Akron Art Institute (now Akron Art Museum), 9 November–14 December 1969.

34th Annual Midyear Show
The Butler Institute of American Art, Youngstown, Ohio, 29 June–1 September 1969.

Pop Art
Hayward Gallery, London, 3 July–3 September 1969.
Catalog published, introduction by John Russell and Suzi Gablik.

Gallo/Pearlstein/Thiebaud
Van Deusen Hall, Kent State University, Ohio, 24 July–20 August 1969.
Catalog published, introduction by Harold Kitner.

Views of Sacramento '69
Artists Contemporary Gallery, Sacramento, July 1969.*

American Painting: The 1960s
Georgia Museum of Art, The University of Georgia, Athens, 22 September–3 November 1969 (organized by the Georgia Museum of Art and The American Federation of Arts, New York).
Catalog published, essay by Samuel Adams Green.
TRAVELED TO:
Junior League of Amarillo, Texas, 30 November–28 December 1969.

Coe College, Cedar Rapids, Iowa, 28 January–15 February 1970.
State University College, Potsdam, New York, 8 March–15 April 1970.
The Mobile Art Gallery, Alabama, 2–30 August 1970.
Roberson Center for the Arts and Sciences, Binghamton, New York, 20 September–18 October 1970.

The Albert Pilavin Collection: Twentieth Century American Art
Museum of Art, Rhode Island School of Design, Providence, 7 October–23 November 1969.
Catalog published as issue of *Bulletin of Rhode Island School of Design Museum Notes*, May 1969.

Prints/Multiples
Henry Art Gallery, University of Washington, Seattle, 16 November–23 December 1969.
Catalog published, introduction by Bill H. Ritchie, essays by Ernst Scheyer, Andrew Stasik, Samuel J. Wagstaff, Jr., Virginia Wright, Luis Camnitzer, Glen Alps, Garo Z. Antreasian, and Kurt von Meier.

Kompas 4: West Coast U.S.A.
Stedelijk Van Abbemuseum, Eindhoven, The Netherlands, 21 November 1969–4 January 1970.
Catalog published, forewords by Jan Leering, Eugene Thiemann, and Zdenek Felix, introduction by Jan Leering.

West Coast 1945–1969
Pasadena Art Museum, California, 24 November 1969–18 January 1970.
Catalog published, introduction by John Coplans.
TRAVELED TO:
City Art Museum of Saint Louis (now Saint Louis Art Museum), 13 February–29 March 1970.
Art Gallery of Ontario, 17 April–17 May 1970.
Fort Worth Art Center, Texas, 8 June–19 July 1970.

The Now Scene
E.B. Crocker Art Gallery, Sacramento, November 1969.*

The H. Marc Moyens Collection
Corcoran Gallery of Art, Washington, D.C., 12 December 1969–18 January 1970.
Catalog published, introduction by James F. Pilgrim.

1969 Annual Exhibition: Contemporary American Painting
Whitney Museum of American Art, New York, 16 December 1969–1 February 1970.
Catalog published, foreword by John I.H. Baur.

Painting 1969
Church Fine Arts Gallery (now Sheppard Gallery), University of Nevada, Reno, 1969.
Catalog published, introduction by William V. Howard.

1970 *The Highway*
Institute of Contemporary Art, University of Pennsylvania, Philadelphia, 14 January–25 February 1970.

Catalog published, essays by Denise Scott Brown, Robert Venturi, and John W. McCoubrey.

TRAVELED TO:

Institute for the Arts, Rice University, Houston, 12 March–18 May 1970.

Akron Art Institute, 5 June–26 July 1970.

Drawings by Nine West Coast Painters
The University of Kansas Museum, Lawrence, 15 February–2 March 1970.
Catalog published, essay by Robert O. Wright.

The American Scene 1900–1970
Indiana University Art Museum, Bloomington, 6 April–17 May 1970.
Catalog published, essay by Henry R. Hope.

Museum Leaders Collect
New School Art Center, New York, 24 April–27 May 1970.
Catalog published, introduction by Paul Mocsanyi, statement by each collector.

American Painting 1970
Virginia Museum of Fine Arts, Richmond, 4 May–7 June 1970.
Catalog published, introduction by James M. Brown, essay by Peter Selz.

The Cool Realists Part II
Jack Glenn Gallery, Corona del Mar, California, May–June 1970.*

A Century of California Painting: 1870–1970
Crocker Citizens Plaza, Los Angeles, 1–30 June 1970.
Catalog published, introduction by Kent L. Seavey, essays by Joseph A. Baird, Paul Mills, Kent L. Seavey, Mary Fuller McChesney, and Alfred Frankenstein.

TRAVELED TO:

Fresno Art Center, California, 6–26 July 1970.

Santa Barbara Museum of Art, California, 3 August–3 September 1970.

California Palace of the Legion of Honor, San Francisco, 11 September–8 October 1970.

de Saisset Gallery, University of Santa Clara, California, 13 October–5 November 1970.

E.B. Crocker Art Gallery, Sacramento, 10 November–10 December 1970.

The Oakland Museum, 15 December 1970–10 January 1971.

POP(ular) ART
Charles H. MacNider Museum, Mason City, Iowa, 27 August–27 September 1970.
Catalog published, essay by Richard Leet.

Looking West 1970
Joslyn Art Museum, Omaha, 18 October–29 November 1970.
Catalog published, foreword by Richard N. Gregg, introduction by LeRoy Butler.

Beyond the Actual: Contemporary California Realist Painting
Pioneer Museum and Haggin Galleries, Stockton, California, 6 November–6 December 1970.
Catalog published, introduction by Donald Brewer.

Excellence: Art from the University Community
University Art Museum, University of California,

Berkeley, 6 November 1970–10 January 1971.
Catalog published, foreword by Peter Selz.

International Graphics Invitational
Lang Art Gallery, Scripps College, Claremont, California, 17 November–11 December 1970.
Catalog published.

1971 *Thirty-second Biennial Exhibition of Contemporary American Painting*
Corcoran Gallery of Art, Washington, D.C., 28 February–4 April 1971.
Catalog published, essay by Walter Hopps.

Two Directions in American Painting
Purdue University Creative Arts Department, Lafayette, Indiana, February 1971.
Catalog published, essay by Al Pounders.*

Contemporary Prints and Drawings from the Museum Collection
San Francisco Museum of Art, 6 April–16 May 1971.

Society of Contemporary Art of The Art Institute of Chicago 31st Annual Exhibition: Works on Paper
The Art Institute of Chicago, 27 April–30 May 1971.
Catalog published.

A Decade in the West: Painting, Sculpture, and Graphics in the Anderson Collection
Stanford University Museum of Art, California, 12 June–22 August 1971.
Catalog published, introduction by Albert Elsen.

TRAVELED TO:

Santa Barbara Museum of Art, California, 10 September–10 October 1971.

Collectors
E.B. Crocker Art Gallery, Sacramento, 19 September–17 October 1971.
Catalog published, introduction by John A. Mahey.

Alfred Leslie, Philip Pearlstein, Wayne Thiebaud: Contemporary Views of Man
Hayden Gallery, Massachusetts Institute of Technology, Cambridge, 28 September–31 October 1971.
Catalog published, essay by Sidra Stich.

Texas Collects Twentieth Century Art
Philbrook Art Center, Tulsa, 4–26 October 1971.
Catalog published, foreword by Donald G. Humphrey.

R.O.S.C. '71
Royal Dublin Society, 24 October–29 December 1971.
Catalog published, forewords by Werner Schmalenbach, K.G. Pontus Hulten, and James Johnson Sweeney.

U.C.D. Art Department Faculty
Memorial Union Art Gallery, University of California, Davis, 1–26 November 1971.
Brochure published.

Fresno Independent Regional Invitational
Fresno Arts Center, California, 14 November–2 December 1971.

Art on Paper Invitational 1971
Weatherspoon Art Gallery, University of North Carolina, Greensboro, 14 November–17 December 1971.

Catalog published, essay by James E. Tucker.

Silkscreen: History of a Medium
Philadelphia Museum of Art, 17 December 1971–27 February 1972.
Catalog published, essay by Richard S. Field.

1972 *The New American Landscape/1972*
Boston University Art Gallery, 21 January–19 February 1972.
Catalog published, essay by Mark Strand.

The Topography of Nature: The Microcosm and the Macrocosm
Institute of Contemporary Art, University of Pennsylvania, Philadelphia, 22 March–27 April 1972.
Catalog published, statement by Luther Standing Bear.

An Invitational Exhibition of Intimate Works
Church Fine Arts Gallery, University of Nevada, Reno, April 1972.
Catalog published, introduction by James E. Spitznagel.*

The State of California Painting
Govett-Brewster Art Gallery, New Plymouth, New Zealand, 23 May–15 June 1972.
Catalog published, essay by Michael Walls.
TRAVELED TO:
Waikato Museum, Hamilton, 7 August–3 September 1972.
City of Auckland Art Gallery, 26 October–6 December 1972.
National Gallery, Wellington, 14 January–8 February 1973.
Robert McDougall Art Gallery, Christchurch, 8 March–12 April 1973.
Dunedin Public Art Gallery, 28 April–19 May 1973.

Eats: An Exhibition of Food in Art
The Emily Lowe Gallery, Hofstra University, Hempstead, New York, 18 June–31 August 1972.
Catalog published, essays by Frances Field and Maxine McKendry.

Seventieth American Exhibition
The Art Institute of Chicago, 24 June–20 August 1972.
Catalog published, introduction by A. James Speyer.

Realismus: Documenta 5
Kassel, West Germany, 30 June–8 October 1972.
Catalog published, essay by Jean-Christophe Ammann.

Crown Point Press at the San Francisco Art Institute
Emanuel Walter Gallery, San Francisco Art Institute, 1 September–1 October 1972.
Catalog published, introduction by Kathan Brown.

American Painting of the Nineteen Sixties
The Currier Gallery of Art, Manchester, New Hampshire (organized by the Rose Art Museum, Brandeis University, Waltham, Massachusetts), 9 September–8 October 1972.

Ladder Show

Artists Contemporary Gallery, Sacramento, 6–31 October 1972.
Catalog published.

Works on Paper—Part II: New Acquisitions and Old Treasures
John Berggruen Gallery, San Francisco, 3 November–2 December 1972.

Fresno Independent Regional Invitational
Fresno Arts Center, California, 14 November–3 December 1972.

Recent American Painting and Sculpture in the Albright-Knox Art Gallery
Albright-Knox Art Gallery, Buffalo, 17 November–31 December 1972.
Brochure published, essay by Henry Geldzahler.

Prints and Drawings
John B. Davis Art Gallery, Fine Arts Center, Idaho State University, Pocatello, 21 November–14 December 1972.

Eighteenth National Print Exhibition
The Brooklyn Museum, 22 November 1972–4 February 1973.
Catalog published, introduction by Jo Miller.
TRAVELED TO:
California Palace of the Legion of Honor, San Francisco, 24 March–17 June 1973.

An Exhibition of American Representational Painting
Allen Priebe Art Gallery, University of Wisconsin, Oshkosh, 27 November–14 December 1972.
Catalog published.

F.O.O.D.
Walnut Creek Civic Arts Center, California, December 1972.*

Graphics: Important Prints
Jack Glenn Gallery, Corona del Mar, California, 1972.*

1973 *San Francisco Area Printmakers*
Cincinnati Art Museum, 12 January–18 March 1973.
Catalog published, introduction by Kristin L. Spangenberg.

Art Acquisitions
University Art Gallery, University of Massachusetts, Amherst, 17 January–11 February 1973.
Catalog published.

Sacramento Sampler, Number II
E.B. Crocker Art Gallery, Sacramento, 27 January–25 February 1973.
Catalog published, introduction by Roger Clisby.

148th Annual Exhibition
National Academy of Design, New York, 24 February–18 March 1973.
Catalog published, foreword by Alfred Easton Poor.

Twenty-five Years of American Painting, 1948–1973
Des Moines Art Center, 6 March–22 April 1973.
Catalog published, essay by Max Kozloff.

Small Works: Selections from the Richard Brown Baker Collection of Contemporary Art
Museum of Art, Rhode Island School of Design, Providence, 5 April–6 May 1973.
Catalog published.

Works on Paper: Drawings and Watercolors
John Berggruen Gallery, San Francisco, June
1973.*

American Art: Third Quarter Century
Seattle Art Museum, 22 August–14 October
1973.
Catalog published, introduction by Jan van der
Marck.

*A Selection of American and European Paintings from
the Richard Brown Baker Collection*
San Francisco Museum of Art, 14 September–11
November 1973.
Catalog published, introduction by Suzanne
Foley.
TRAVELED TO:
Institute of Contemporary Art, University of
Pennsylvania, Philadelphia, 7 December
1973–27 January 1974.

20th Century Drawings from Chicago Collections
Museum of Contemporary Art, Chicago, 15
September–11 November 1973.
Catalog published, introduction by Stephen
Prokopoff.

Separate Realities
Municipal Art Gallery, Barnsdall Park, Los An-
geles, 19 September–21 October 1973.
Catalog published, introduction by Laurence
Dreiband.

23rd National Exhibition of Prints
National Collection of Fine Arts (now National
Museum of American Art), Smithsonian Institu-
tion, Washington, D.C., 21 September–25
November 1973 (cosponsored by the Library of
Congress).
Catalog published, foreword by Joshua Taylor
and L. Quincy Mumford.

Drawings by Seven American Realists
Harcus-Krakow Gallery, Boston, 16 October–10
November 1973.
Catalog published, essay by John Arthur.

*Three Americans: Wayne Thiebaud, H.C.
Westermann, William T. Wiley*
Norman MacKenzie Art Gallery, Regina,
Saskatchewan, 29 October–25 November 1973.
Brochure published.
TRAVELED TO:
Mendel Art Gallery, Saskatoon, Saskatchewan,
28 November–12 December 1973.

Waves
Cranbrook Academy of Art, Bloomfield Hills,
Michigan, 6 November 1973–3 February 1974.
Catalog published, foreword by John Peterson,
introduction by Michael Hall.
TRAVELED TO:
Grand Rapids Art Museum, 11 January–3 Feb-
ruary 1974.

New Acquisitions
John Berggruen Gallery, San Francisco, Decem-
ber (n.d.) 1973–5 January 1974.

1974 *National Print Invitational Exhibition 1974*
Artists Contemporary Gallery, Sacramento (pre-
sented concurrently at Main Art Gallery, Califor-
nia State University, Sacramento), 9–27 January
1974.

Checklist published.

American Self-Portraits 1670–1973
National Portrait Gallery, Smithsonian Institu-
tion, Washington, D.C., 1 February–17 March
1974 (organized by the International Exhibitions
Foundation, Washington, D.C.).
Catalog published, introduction by Ann C. Van
Devanter and Alfred V. Frankenstein.
TRAVELED TO:
Indianapolis Museum of Art, 1 April–15 May
1974.

1961: American Painting in the Watershed Year
Allan Frumkin Gallery, New York, 9 March–2
April 1974.
Catalog published, introduction by Allan
Frumkin.

Aspects of the Figure
Cleveland Museum of Art, 10 July–1 September
1974.
Catalog published, introduction by Edward B.
Henning.

Twelve American Painters
Virginia Museum of Fine Arts, Richmond, 30
September–27 October 1974.
Catalog published, essay by William Gaines.

Contemporary Portraits by American Painters
Lowe Art Museum, Coral Gables, Florida, 3
October–10 November 1974.
Catalog published, introduction by John Gruen.

Living American Artists and the Figure
Museum of Art, Pennsylvania State University,
University Park, 2 November–22 December
1974.
Catalog published, introduction by William D.
Davis.

The Fine Art of Food
Lang Art Gallery, Scripps College, Pomona, Cali-
fornia, 5 November–3 December 1974.
Catalog published, foreword by David W.
Steadman.

*Twentieth Century American Painting and Sculpture
from the Collection of the Whitney Museum of Ameri-
can Art*
Phoenix Art Museum, 16 November 1974–2 Jan-
uary 1975.

Eight from California
National Collection of Fine Arts, Smithsonian
Institution, Washington, D.C., 29 November
1974–9 February 1975.
Catalog published, introduction by Janet A.
Flint.

Contemporary American Masterworks
Utah Museum of Fine Art, University of Utah,
Salt Lake City, 8 December 1974–5 January
1975.

1975 *Watercolors and Drawings—American Realists*
Louis K. Meisel Gallery, New York, 4 January–1
February 1975.
Catalog published, essay by Susan Pear Meisel.

Portrait Painting 1970–1975
Allan Frumkin Gallery, New York, 7–31 January
1975.
Catalog published, introduction by G.W.
Barrette and Allan Frumkin.

Realist Painting in California
John Berggruen Gallery, San Francisco, 29 January–8 March 1975.

Selections from the American Print Collection
Mills College Art Gallery, Oakland, 16 February–16 March 1975.
Catalog published.

Art Faculty Exhibition
Memorial Union Art Gallery, University of California, Davis, 2–29 April 1975.
Catalog published, introduction by Nancy S. Chambers.
TRAVELED TO:
Monterey Peninsula Museum of Art, California, 10 May–1 June 1975.

Fifty Years of Crocker-Kingsley: A Retrospective Exhibition
E.B. Crocker Art Gallery, Sacramento, 5 April–4 May 1975.
Catalog published, introduction by Ruth A. Holland and Susan J. Willoughby.

The Small Scale in Contemporary Art: Society of Contemporary Art of The Art Institute of Chicago: Thirty-fourth Exhibition
The Art Institute of Chicago, 8 May–15 June 1975.
Catalog published.

Drawings
Margo Leavin Gallery, Los Angeles, 12 May–14 June 1975.

Print Mediums
Artists Contemporary Gallery, Sacramento, 11 July–7 August 1975.

The Growing Spectrum of American Art
Joslyn Art Museum, Omaha, 20 September–9 November 1975.
Catalog published, essay by Vincent Price.

California Gold
J.P.L. Fine Arts, London, 15 October–21 November 1975.
Catalog published, essay by Sylvia Brown.

Figure as Form: American Painting 1930–1975
Museum of Fine Arts of Saint Petersburg, Florida, 25 November 1975–4 January 1976.
Catalog published, introduction by Bradley Nickels, essay by Margaret A. Miller.
TRAVELED TO:
Florida Center for the Arts, University of South Florida, Tampa, 12 January–6 February 1976.
Columbus Museum of Arts and Crafts, Georgia, 8 March–4 April 1976.

Portraits/1975
Boston University Art Gallery, 2–21 December 1975.

1976 *Tenth Anniversary Exhibition*
Charles H. MacNider Museum, Mason City, Iowa, 10 January–15 February 1976.
Catalog published, essay by Richard Leet.

The Richard L. Nelson Gallery Commemorative Exhibition
Richard L. Nelson Gallery, University of California, Davis, 6–27 February 1976.

Brochure published, introduction by Joseph A. Baird, Jr.

Unclassified
Art Gallery, California State University, Northridge, 9–29 February 1976.
Brochure published, introduction by Karen Carson.

Bicentennial Landscape Exhibition
Capricorn Asunder Gallery, San Francisco, 12 March–9 April 1976.
Catalog published.

Second Williams College Alumni Loan Exhibition
Hirschl and Adler Galleries, New York, 1–24 April 1976 (organized by Williams College Museum of Art, Williamstown, Massachusetts).
Catalog published, introduction by S. Lane Faison, Jr.
TRAVELED TO:
Williams College Museum of Art, 9 May–13 June 1976.

America 1976
Corcoran Gallery of Art, Washington, D.C., 27 April–6 June 1976.
Catalog published, foreword by Thomas S. Kleppe, essays by Robert R. Rosenblum and Neil Welliver.
TRAVELED
Wadsworth Atheneum, Hartford, 4 July–12 September 1976.
Fogg Art Museum, Harvard University, Cambridge, Massachusetts, 19 October–7 December 1976.
The Minneapolis Institute of Arts, 16 January–27 February 1977.
Milwaukee Art Center, Wisconsin, 19 March–15 May 1977.
Fort Worth Art Museum, Texas, 18 June–14 August 1977.
San Francisco Museum of Modern Art, 10 September–13 November 1977.
The High Museum of Art, Atlanta, 10 December 1977–5 February 1978.
The Brooklyn Museum, 11 March–21 May 1978.

Printmaking in America
Prints Division, The New York Public Library, 3 June–30 September 1976.

20 Bay Area Painters
Richmond Art Center, California, 2 September–3 October 1976.
Brochure published, essay by Katherine Church Holland.

American Master Drawings and Watercolors: Works of Art on Paper from Colonial Times to the Present
The Minneapolis Institute of Arts, 2 September–24 October 1976 (organized by The American Federation of Arts, New York).
Catalog published, essay by Theodore E. Stebbins, Jr.
TRAVELED TO:
Whitney Museum of American Art, New York, 23 November 1976–23 January 1977.
California Palace of the Legion of Honor, San Francisco, 19 February–17 April 1977.

Painting and Sculpture in California: The Modern Era
San Francisco Museum of Modern Art, 3 September–21 November 1976.
Catalog published, preface by Henry T. Hopkins, essays by Henry T. Hopkins, Jan Leering, Harvey L. Jones, George W. Neubert, Terry St. John, Priscilla C. Colt, Nancy Dustin Wall Moure, Frederick S. Wight, Joseph E. Young, Beatrice Judd Ryan, Katherine Church Holland, Wolfgang Paalen, Jules Langsner, James Monte, John Coplans, Donald Brewer, and Germano Celant.
TRAVELED TO:
National Collection of Fine Arts, Smithsonian Institution, Washington, D.C., 20 May–11 September 1977.

Six from California
Museum of Art, Washington State University, Pullman, 29 October–20 November 1976.
Catalog published, essay by P[atricia] G[rieve] W[atkinson].

30 Years of American Printmaking
The Brooklyn Museum, 20 November 1976–30 January 1977.
Catalog published, essay by Gene Baro.

1977 *Still Life: Recent Drawings and Watercolors*
Boston University Art Gallery, 28 January–27 February 1977.

30 Years of American Art, 1945–1975: Selections from the Permanent Collection
Whitney Museum of American Art, New York, 29 January–1 May 1977.

Archives of American Art: California Collecting
The Oakland Museum, 1 February–20 March 1977.
Catalog published, essay by Paul J. Karlstrom.

Drawings of the '70s
The Art Institute of Chicago, 9 March–1 May 1977.
Brochure published, introduction by Harold Joachim.

American Paintings and Drawings
John Berggruen Gallery, San Francisco, 30 March–7 May 1977.

The Chosen Object: European and American Still Life
Joslyn Art Museum, Omaha, 23 April–5 June 1977.
Catalog published, introduction by Ruth H. Cloudman.

Stanford Monotypes
Stanford University Museum of Art, California, 12 July–4 December 1977.

Contemporary Pastels and Watercolors
Indiana University Art Museum, Bloomington, July 1977.*

Group Show
Adler Gallery, Los Angeles, July–August 1977.*

Aspects of Realism: Sylvia Mangold, Don Nice, Dalia Ramanauskas, Paul Sarkisian, Wayne Thiebaud
Young Hoffman Gallery, Chicago, 10 September–11 October 1977.

Selected Prints 1969–1977
Brooke Alexander, New York, 13 September–8 November 1977.
Catalog published.

Invitational American Drawing Exhibition
Fine Arts Gallery of San Diego, California, 17 September–30 October 1977.
Catalog published, introduction by G.A. Santangelo.

New Plan
Artists Contemporary Gallery, Sacramento, 18 September–6 October 1977.

Miniature
Fine Arts Gallery, California State University, Los Angeles, 3 October–10 November 1977.
Catalog published, essay by Sandy Ballatore.

Artists' Postcards
The Cooper-Hewitt Museum, Smithsonian Institution, New York, 10 October–3 December 1977 (organized by the Smithsonian Institution Traveling Exhibition Service, Washington, D.C.)
TRAVELED TO:
Kenan Center, Lockport, New York, 11 February–12 March 1978.
Montclair Museum, New Jersey, 1–30 April 1978.
Kennedy-Douglass Center for the Arts, Florence, Alabama, 8 July–10 August 1978.
Toledo Museum of Art, 14 October–12 November 1978.
C.W. Woods Art Gallery, Hattiesburg, Mississippi, 2–31 December 1978.
Cranbrook Academy of Art, Bloomfield Hills, Michigan, 20 January–18 February 1979.
Millersville State College, Pennsylvania, 10 March–8 April 1979.
Portland Art Museum, Oregon, 4 August–2 September 1979.
Guild Hall, East Hampton, New York, 22 September–21 October 1979.
Concord College, Athens, West Virginia, 10 November–9 December 1979.
The Nelson-Atkins Museum of Art, Kansas City, Missouri, 29 December 1979–27 January 1980.

Representations of America
Alexander Pushkin Museum, Moscow, 15 December 1977–15 February 1978 (organized by The Metropolitan Museum of Art, New York).
TRAVELED TO:
Hermitage Museum, Leningrad, 15 March–15 May 1978.
Palace of Art, Minsk, 15 June–15 August 1978.*

1978 *California: 3 × 8 Twice*
Honolulu Academy of Arts, 3 February–5 March 1978.
Catalog published, foreword by James W. Foster.

The Human Figure in Painting in the U.S.A.
Art Gallery, Parsons School of Design, New York, February 1978.*

Forms in Sport 1842–1978
Terry Dintenfass Gallery, New York, May 1978.
Catalog published, introduction by Terry Dintenfass, essay by Alexander deWitt Walsh.*

New American Monotypes

Holzman Gallery, Towson State University, Maryland, 26 August–24 September 1978 (organized by the Smithsonian Institution Traveling Exhibition Service, Washington, D.C.)
Catalog published, preface by Quinton Hallett, essay by Jane M. Farmer.
TRAVELED TO:
John Mariani Gallery, University of North Colorado, Greeley, 20 January–18 February 1979.
Anchorage Historical and Fine Arts Museum, Alaska, 10 March–8 April 1979.
The Phillips Collection, Washington, D.C., 16 June–15 July 1979.
Mendel Art Gallery, Saskatoon, Saskatchewan, 4 August–2 September 1979.
(Although the exhibition traveled further, documentation for subsequent venues is unavailable.)

Things Seen
Sheldon Memorial Art Gallery, University of Nebraska, Lincoln, 5 September–1 October 1978.
Catalog published, introduction by Norman A. Geske.
TRAVELED TO:
Mulvane Art Center, Washburn University, Topeka, Kansas, 8 October–5 November 1978.
Arkansas Art Center, Little Rock, 15 November–16 December 1978.
Springfield Art Museum, Missouri, 2–28 January 1979.
Wichita Art Museum, Kansas, 4 February–11 March 1979.
Union National Bank, Manhattan, Kansas, 18 March–22 April 1979.
McIlroy Bank and Trust, Fayetteville, Arkansas, 29 April–3 June 1979.
Oklahoma Art Center, Oklahoma City, 10 June–15 July 1979.
Hutchinson Public Library, Kansas, 22 July–26 August 1979.

Invitational Drawing and Watercolor Exhibition
Art Gallery, Viterbo College, La Crosse, Wisconsin, 18 October–10 November 1978.

Fullerton College Art Collection
Muckenthaler Cultural Center, Fullerton, California, 28 October–19 November 1978.

Selected Prints II
Brooke Alexander, New York, 4 November 1978–6 January 1979.
Catalog published.

The Frederick Weisman Company Collection of California Art
The Art Museum and Galleries, California State University, Long Beach, 20 November–17 December 1978.
Catalog published, introduction by Cecille Caterson, Lucinda H. Gedeon, and Joan Hemphill.

1979 *Recent Acquisitions*
John Berggruen Gallery, San Francisco, 10 January–3 February 1979.

Degrees of Realism
Art Gallery, San Jose State University, California, 29 March–24 April 1979.

Sacramento Valley Landscapes
Richard L. Nelson Gallery, University of California, Davis (presented concurrently at Davis Art Center, California; Memorial Union Art Gallery, University of California, Davis; Pence Gallery, Davis, California; and Woodland Art Center, Davis, California), 23 April–1 June 1979.
Catalog published, preface by Price Amerson, essays by Mary Altenhofen and Joseph Baird, Jr.

The Pastel in America
Odyssia Gallery, New York, 8 May–16 June 1979.
Catalog published, essay by Irving Petlin.
TRAVELED TO:
Grand Rapids Art Museum, 6 August–16 September 1979.

Documents, Drawings, and Collages
Williams College Museum of Art, Williamstown, Massachusetts, 8 June–5 July 1979.
Catalog published, essays by Stephen D. Paine, Franklin W. Kelly, Stephen Eisenman, and Hiram Carruthers Butler.
TRAVELED TO:
The Toledo Museum of Art, 6 October–18 November 1979.
The John and Mable Ringling Museum of Art, Sarasota, Florida, 6 December 1979–1 March 1980.
Fogg Art Museum, Harvard University, Cambridge, Massachusetts, 10 April–15 May 1980.

Teachers and Their Pupils
Anna Gardner Gallery, Stinson Beach, California, 10 June–31 July 1979.

American Portraits of the Sixties & Seventies
The Aspen Center for the Visual Arts, Colorado, 17 June–5 August 1979.
Catalog published, introduction by Philip Yenawine, essay by Julie Augur.

S.I. 25: A Sports Illustrated Retrospective
Spectrum Fine Art Gallery, New York, 3 October–2 November 1979.
Catalog published, introduction by Bill Goff.

Recent Acquisitions
The Metropolitan Museum of Art, New York, 16 October–28 December 1979.

Reflections of Realism
Albuquerque Museum, New Mexico, 4 November 1979–27 January 1980.
Catalog published, introduction by Ellen Landis.

1980 *Contemporary Prints from Northern California*
University Gallery, University of Massachusetts, Amherst, 25 January–14 March 1980.

Realism
Walnut Creek Civic Arts Gallery, California, 31 January–22 March 1980.
Catalog published, introduction by Carl Worth.

Selections from the Collection of George M. Irwin
Krannert Art Museum, University of Illinois, Champaign, 2 March–13 April 1980.
Catalog published, foreword by Muriel B. Christison, essay by Margaret M. Sullivan.

Bay Area Art: Then and Now
Suzanne Brown Gallery, Scottsdale, Arizona, 20 March–9 April 1980.

Catalog published, foreword by Frank McKemy, essay by R.H. Turk.

Drawing: At the Henry
Henry Art Gallery, University of Washington, Seattle, 5 April–25 May 1980.
Catalog published, foreword by Harvey West, introduction by Norman Lundin.

American Watercolors from the Collection of George Hopper Fitch
Yale University Art Gallery, New Haven, Connecticut, 13 April–31 August 1980.
Catalog published as issue of *Yale University Art Gallery Bulletin*, Spring 1980, foreword by G.H. Fitch.

Still Life Today
Goddard-Riverside Community Center, New York, 1–20 May 1980 (organized by the Gallery Association of New York State).
Catalog published, essay by Janet C. Oresman.*
TRAVELED TO:
Michael C. Rockefeller Gallery, State University College at Fredonia, New York, 18 September–9 October 1981.
Tyler Art Gallery, State University College at Oswego, New York, 18 October–22 November 1981.
Root Art Center, Hamilton College, Clinton, New York, 5 December 1981–2 February 1982.
College of Saint Rose, Albany, New York, 26 February–30 March 1982.
Skidmore College, Saratoga Springs, New York, 26 April–16 May 1982.
Hudson River Museum, Yonkers, New York, 25 July–5 September 1982.
Federal Reserve Bank of New York, New York City, 14 September–2 October 1982.
The Hyde Collection, Glens Falls, New York, 5–27 February 1983.
Federal Reserve Board, Washington, D.C., March–May 1983.

American Portrait Drawings
National Portrait Gallery, Smithsonian Institution, Washington, D.C., 1 May–3 August 1980.
Catalog published, introduction by Marvin Sadik, essay by Harold Francis Pfister.

Contemporary Naturalism: Works of the 1970s
Nassau County Museum of Fine Art, Roslyn Harbor, New York, 8 June–24 August 1980.
Catalog published, preface by Phyllis Stigliano and Janice Parente, introduction by Lawrence Alloway.

A.A.D.H.H.J.M.N.P.S.S.T.T.
Richard L. Nelson Gallery, University of California, Davis, 30 September–31 October 1980.
Catalog published.

Realism/Photorealism
Philbrook Art Center, Tulsa, 5 October–23 November 1980.
Catalog published, essay by John Arthur.

Santa Barbara Museum of Art Contemporary Graphics Center, William Dole Fund Collection
Santa Barbara Museum of Art, California, 11 October–23 November 1980.

Catalog published, preface by Paul Chadbourne Mills, introduction by Betty Klausner, abecedarium by William Dole.

The Painterly Print: Monotypes from the Seventeenth to the Twentieth Century
The Metropolitan Museum of Art, New York, 16 October–7 December 1980.
Catalog published, essays by Sue Welsh Reed, Eugenie Parry Janis, Barbara Stern Shapiro, David W. Keihl, Colta Ives, and Michael Mazur.
TRAVELED TO:
Museum of Fine Arts, Boston, 24 January–22 March 1981.

American Figure Painting: 1950–1980
The Chrysler Museum, Norfolk, Virgina, 17 October–30 November 1980.
Catalog published, essay by Thomas W. Styron.

Art on Paper 1980
Weatherspoon Art Gallery, University of North Carolina, Greensboro, 16 November–14 December 1980.
Catalog published, introduction by Gilbert F. Carpenter.

American Drawing in Black and White: 1970–1980
The Brooklyn Museum, 22 November 1980–18 January 1981. Catalog published, essay by Gene Baro.

Drawings
Leo Castelli Gallery, New York, 29 November–20 December 1980.

1981 *A Salute to the San Francisco Art Institute on the Occasion of Its 110th Anniversary*
John Berggruen Gallery, San Francisco, 14 January–7 February 1981.

1981 Biennial Exhibition
Whitney Museum of American Art, New York, 20 January–19 April 1981.
Catalog published, foreword by Thomas N. Armstrong, preface by John G. Hanhardt, Barbara Haskell, Richard Marshall, and Patterson Sims.

Contemporary Prints from the Virginia Museum Collection
Virginia Museum of Fine Arts, Richmond, 24 February–5 April 1981.
Checklist published.

Real, Really Real, Super Real
San Antonio Museum of Art, Texas, 1 March–26 April 1981.
Catalog published, introduction by Sally Boothe-Meredith, essays by Alvin Martin, Linda Nochlin, and Philip Pearlstein, interviews with artists, statements by the artists.
TRAVELED TO:
Indianapolis Museum of Art, 19 May–28 June 1981.
Tucson Museum of Art, Arizona, 19 July–26 August 1981.
Museum of Art, Carnegie Institute, Pittsburgh, 24 October 1981–3 January 1982.

California: The State of Landscape 1872–1971
Newport Harbor Art Museum, Newport Beach, California, 13 March–3 May 1981.

Catalog published, introduction by Betty Turnbull.

TRAVELED TO:

Santa Barbara Museum of Art, California, 25 July–6 September 1981.

The Fine Art of Business
Federal Reserve Bank of Boston, 16 March–1 May 1981 (organized by De Cordova and Dana Museum and Park, Lincoln, Massachusetts).
Catalog published, essay by Mika Hornyak.

A Feast for the Eyes
Heckscher Museum, Huntington, New York, 28 March–26 April 1981.
Catalog published, foreword by Katherine Lochridge, essay by Anne Cohen DePrieto.

Illusions of Light
Worcester Art Museum, Massachusetts, 31 March–31 May 1981.
Brochure published, essay by Terry Priest.

Drawings from the Figure
University Galleries, California State University, Hayward, 8 April–8 May 1981.

The Smaller Image
Artists Contemporary Gallery, Sacramento, 8 May–4 June 1981.

Group Show
Charles Campbell Gallery, San Francisco, 29 July–29 August 1981.

The Image in American Painting and Sculpture 1950–1980
Akron Art Museum, 12 September–8 November 1981.
Catalog published, preface by I. Michael Danoff, introduction by Carolyn Kinder Carr.

Forty Famous Californians
Judith Christian Gallery, New York, 18 September–14 October 1981.

Contemporary American Realism
Pennsylvania Academy of the Fine Arts, Philadelphia, 18 September–13 December 1981.
Catalog published, introduction by Elizabeth Kolowat.

TRAVELED TO:

Virginia Museum of Fine Arts, Richmond, 1 February–28 March 1982.

The Oakland Museum, 6 May–25 July 1982.

Gulbenkian Foundation, Lisbon, 29 September–27 October 1982.

Salas de Exposiciónes, Madrid, 17 November 1982–8 January 1983.

Kunsthalle, Nuremberg, West Germany, 11 February–10 April 1983.

The American Landscape: Recent Developments
Whitney Museum of American Art, Fairfield County, Stamford, Connecticut, 23 October–9 December 1981.
Catalog published.

Amerikanische Malerei 1930–1980
Haus der Kunst, Munich, 14 November 1981–31 January 1982.
Catalog published, introduction and essay by Thomas N. Armstrong.

1982 *Drawings by Painters*

Long Beach Museum of Art, California, 17 January–7 March 1982.
Catalog published, introduction by Richard Armstrong.

TRAVELED TO:

Mandeville Art Gallery, University of California, San Diego, 25 September–31 October 1982.

The Oakland Museum, 8 January–13 March 1983.

A Private Vision: Contemporary Art from the Graham Gund Collection
Museum of Fine Arts, Boston, 9 February–4 April 1982.
Catalog published, foreword by Jan Fontein, preface by Graham Gund, essays by Carl Belz, Kathy Halbreich, Kenworth Moffett, Elizabeth Sussman, and Diane W. Upright.

Inaugural Exhibition of the New Space of John Berggruen Gallery
John Berggruen Gallery, San Francisco, 17 February–24 March 1982.

The West as Art: Changing Perceptions of Western Art in California Collections
Palm Springs Desert Museum, California, 24 February–30 May 1982.
Catalog published, essay by Patricia Jean Trenton.

Three California Painters
Sun Valley Center Gallery, Idaho, 5–24 August 1982.

Northern California Art of the Sixties
de Saisset Museum, University of Santa Clara, California, 1 September–12 December 1982.
Catalog published, introduction by Georgianna M. Lagoria, essay by Fred Martin.

Selected Prints III
Brooke Alexander, New York, 7 September–2 October 1982.
Catalog published.

Realists Revisited
Quincy Art Center, Illinois, 10 October–7 November 1982.
Catalog published, essay by James McGarrel.

Elegant Miniatures from San Francisco and Kyoto
Belca House, Kyoto, Japan, 25 October–20 November 1982 (organized by the Museum of Conceptual Art, San Francisco).

TRAVELED TO:

San Francisco Museum of Modern Art, 14 July–25 September 1983.

Classical Traditions
Henry Art Gallery, University of Washington, Seattle, 1 November 1982–30 January 1983.

Northern California Realist Painters
Redding Museum and Art Center, California, 3–29 November 1982.
Brochure published, introduction by Charles Johnson.

Perspectives on Contemporary American Realism: Works of Art on Paper from the Collection of Jalane and Richard Davidson
Pennsylvania Academy of the Fine Arts, Philadelphia, 17 December 1982–20 February 1983.
Catalog published, essay by Frank H. Goodyear.

TRAVELED TO:

The Art Institute of Chicago, 1 April–20 May 1983.

1983 *Figure Drawings: Five San Francisco Artists*
Charles Campbell Gallery, San Francisco, 5 January–12 February 1983.
Catalog published, introduction by Wayne Thiebaud.

A Heritage Renewed
University Art Museum, University of California, Santa Barbara, 2 March–17 April 1983.
Catalog published, essay by Eileen Guggenheim.

TRAVELED TO:

Oklahoma Art Center, Oklahoma City, 26 June–7 August 1983.

Elvehjem Museum of Art, University of Wisconsin, Madison, 21 August–9 October 1983.

Colorado Springs Fine Arts Center, 5 November–18 December 1983.

Twentieth Century Prints
Sheehan Art Gallery, Whitman College, Walla Walla, Washington, 1–30 April 1983.

Directions in Bay Area Painting: A Survey of Three Decades, 1940s–1960s
Memorial Union Art Gallery and Richard L. Nelson Gallery, University of California, Davis, 14 April–20 May 1983.

Catalog published, foreword by L. Price Amerson, Jr., introduction by Joseph Armstrong Baird, Jr., essays by Joan Roebuck, Ruth Hurd, Joan Bossart, Anna Novakov, Julia Armstrong, Dianne Sachko Macleod, Jenny Fink, Vinita Sundaram, and Jackson Dodge.

Modern Still Life
Whitney Museum of American Art, Fairfield County, Stamford, Connecticut, 22 April–29 June 1983.
Catalog published, essay by Pamela Gruninger.

West Coast Realism
Laguna Beach Museum of Art, California, 3 June–24 July 1983.
Catalog published, essay by Lynn Gamwell.

TRAVELED TO:

Museum of Art, Fort Lauderdale, Florida, 1 November–4 December 1983.

Center for Visual Arts, Illinois State University, Normal, 15 January–28 February 1984.

Fresno Art Center, California, 1 April–13 May 1984.

Louisiana Arts and Science Center, Baton Rouge, 3 June–15 July 1984.

Museum of Art, Bowdoin College, Brunswick, Maine, 7 September–4 November 1984.

Colorado Springs Fine Arts Center, 20 November–18 December 1984.

Spiva Art Center, Joplin, Missouri, 6 January–15 February 1985.

Beaumont Art Museum, Texas, 8 March–21 April 1985.

Sierra Nevada Museum of Art, Reno, 5 May–16 June 1985.

Edison Community College, Fort Myers, Florida, 7 July–18 August 1985.

American Accents Américains
The Gallery/Stratford, Stratford, Ontario, 6 June–7 August 1983 (organized by Rothman's of Pall Mall, Toronto).
Catalog published, essay by Henry Geldzahler.

TRAVELED TO:

Eaton's College Park, Toronto, 18 August–17 September 1983.

Musée du Quebec, 22 September–26 October 1983.

Art Gallery of Nova Scotia, Halifax, 5 January–6 February 1984.

Art Gallery of Windsor, Ontario, 23 February–25 March 1984.

The Edmonton Art Gallery, Alberta, 5 April–13 May 1984.

Vancouver Art Gallery, British Columbia, 5 July–26 August 1984.

Glenbow Museum, Calgary, Alberta, 13 September–30 October 1984.

Musée d'Art Contemporain, Montreal, 29 November 1984–30 January 1985.

Perspectives of Landscape
Fuller Goldeen Gallery, San Francisco, 7 July–27 August 1983.
Brochure published, essay by Susan Freudenheim.

Four from Potrero Hill
Joseph Chowning Gallery, San Francisco, 7 September–13 October 1983.

The Painted Object Painted
Herbert Palmer Gallery, Los Angeles, 19 September–5 November 1983.

American Still Life 1945–1983
Contemporary Arts Museum, Houston, 20 September–20 November 1983.
Catalog published, foreword and essay by Linda Cathcart.

TRAVELED TO:

Albright-Knox Art Gallery, Buffalo, 10 December 1983–15 January 1984.

Columbus Museum of Art, Ohio, 7 April–20 May 1984.

Neuberger Museum, State University of New York at Purchase, 7 June–15 September 1984.

Portland Art Museum, Oregon, 9 October–9 December 1984.

Bon à Tirer
de Saisset Museum, University of Santa Clara, California, 27 September–11 December 1983.

World Print Four
San Francisco Museum of Modern Art, 5 October–18 December 1983 (organized in conjunction with the World Print Council, San Francisco, California College of Arts and Crafts, Oakland, and Osaka University of Arts, Japan).
Catalog published, foreword by Karen Tsujimoto, introduction by Leslie Luebbers.

TRAVELED TO:

Tacoma Art Museum, Washington, 14 January–12 February 1984.

Anchorage Historical and Fine Arts Museum, Alaska, 3 March–1 April 1984.

Edison Community College, Fort Myers, Florida, 9 June–8 July 1984.

University Art Museum, California State University, Long Beach, 28 July–26 August 1984.

University of Southern Mississippi, Hattiesburg, 15 September–14 October 1984.

El Paso Museum of Art, Texas, 3 November–2 December 1984.

The Toledo Museum of Art, 12 October–19 December 1985.

The American Artist as Printmaker
The Brooklyn Museum, 27 October 1983–22 January 1984.
Catalog published, foreword by Robert T. Buck, essay by Barry Walker.

Twenty-five Years of the Artists Contemporary Gallery
Crocker Art Museum, Sacramento, 12 November 1983–1 January 1984.
Catalog published.

The First Show: Painting and Sculpture from Eight Collections, 1940–1980
The Museum of Contemporary Art, Los Angeles, 18 November 1983–19 February 1984.
Catalog published, foreword by Julia Brown, essays by Pontus Hulten and Susan C. Larsen.

California Drawings
Modernism, San Francisco, 16 December 1983–28 January 1984.

1984 *Works by Crown Point Press*
Pace Gallery, New York, 13 January–11 February 1984.

Realists at Work
Harcus Gallery, Boston, 21 January–15 February 1984.

Painters at U.C. Davis, Part I: 1950s–1960s
Richard L. Nelson Gallery, University of California, Davis, 22 January–21 February 1984.

Painters at U.C. Davis, Part II: 1970s–1980s
26 February–30 March 1984.
Catalog published, preface by L. Price Amerson, Jr., interviews with and statements by the artists.

Crime and Punishment: Reflections of Violence in Contemporary Art
Triton Museum, Santa Clara, California, 11 February–1 April 1984.
Catalog published, essay by Jo Farb Hernandez.

New Directions
Oberon Gallery, Napa, California, 25 February–31 March 1984.

Drawings 1974–1984
Hirshhorn Museum and Sculpture Garden, Smithsonian Institution, Washington, D.C., 15 March–13 May 1984.
Catalog published, foreword by Abram Lerner, essay by Frank Gettings, statements by the artists.

Autoscape: The Automobile in the American Landscape
Whitney Museum of American Art, Fairfield County, Stamford, Connecticut, 29 March–30 May 1984.
Catalog published, essay by Pamela Gruninger Perkins.

Prints: Diebenkorn, Johns, Motherwell, Thiebaud
Dana Reich Gallery, San Francisco, 1–28 April 1984.

Icons of the Sixties
Brooke Alexander, New York, 24 April–19 May 1984.

The Urban Landscape
One Market Plaza, San Francisco, 21 May–15 June 1984.
Catalog published, essay by Michele Bell.

Recent Bay Area Prints
Allport Associates Gallery, San Francisco, 20 June–7 July 1984.

Drawings, Drawings, Drawings
Forum Gallery, New York, 9 July–31 August 1984.

50 Artists/50 States
Fuller Goldeen Gallery, San Francisco, 11 July–25 August 1984.

Automobile and Culture
The Museum of Contemporary Art, Los Angeles, 21 July 1984–6 January 1985.
Book published (checklist not included), forewords by Pontus Hulten and Lord Montagu of Beaulieu, essays by Gerald Silk, Henry Flood Robert, Jr., Strother MacMinn, and Angel Tito Anselmi.

Juxtapositions: Recent Acquisitions
Richard L. Nelson Gallery, University of California, Davis, 17 September–26 October 1984.

Brand New Prints
Martina Hamilton Gallery, New York, 18 September–30 October 1984.

New Impressions: Recent Prints by Bay Area Artists
World Print Gallery, San Francisco, 3 October–2 November 1984.

Figurative Options: Jack Ogden, Mel Ramos, Wayne Thiebaud
Robert Else Gallery, California State University, Sacramento, 26 October–7 December 1984.
Catalog published, essay by David P. Conner, Margo L.K. Jameson, and Steven Kaltenbach.

Wayne Thiebaud and Others
Allan Stone Gallery, New York, 3 November–20 December 1984.

The 20th Century: The San Francisco Museum of Modern Art Collection
San Francisco Museum of Modern Art, 9 December 1984–17 February 1985.
†Book published.

BIBLIOGRAPHY
Compiled by Eugenie Candau

STATEMENTS BY THE ARTIST

"Art: A Personal View." *C.A.A. Newsletter*, April 1981, p. 5, ill.

"Artists Say: 'Nudes Now.'" *Art Voices*, Summer 1966, p. 45, ill.

In *Art of the Real: Nine American Figurative Painters*, edited by Mark Strand. New York: Clarkson N. Potter, 1983, pp. 180–199.

"As Far as I'm Concerned, There Is Only One Study and That Is the Way in Which Things Relate to One Another." *Untitled 7–8* (Friends of Photography, Carmel, Calif.), 1974, pp. 23–25.

In "Creativity Is Contagious: A Second Look at the Creative Experience Workshop," edited by Fred R. Parker. *Untitled 2–3* (Friends of Photography, Carmel, Calif.), 1972–1973, pp. 52–53, 65, ill.

In *Drawings 1974–1984*, by Frank Gettings. Washington, D.C.: Hirshhorn Museum and Sculpture Garden, 1984, pp. 230–232, ill. Ex. cat.

"A Fellow Painter's View of Giorgio Morandi." *The New York Times*, 15 November 1981, pp. D37–D38.

In *50 West Coast Artists*. San Francisco: Chronicle Books, 1981, p. 40.

In *Figure Drawings: Five San Francisco Artists*. San Francisco: Charles Campbell Gallery, 1983, n.p. Ex. cat.

"First Person: Wayne Thiebaud." *Sacramento Union*, 5 February 1983, pp. C1–C2, ill.

"Is a Lollipop Tree Worth Painting?" *San Francisco Sunday Chronicle*, 15 July 1962, *This World*, pp. 28–29, ill.

Quoted in *Mary Cassatt*, by Nancy Hale. Garden City, N.Y.: Doubleday, 1975, pp. 33–34.

"Matisse—A Personal View" in *Henri Matisse*. San Francisco: John Berggruen Gallery, 1982, pp. ix–x.

"A Painter's Personal View of Eroticism." *Polemic* (Case Western Reserve University, Cleveland), Winter 1966, pp. 33–36, ill.

"Personal Notes on Painting" in *Figures: Thiebaud*. Stanford, Calif.: Stanford Art Museum, Stanford University, 1965, n.p. Ex. cat.

In *Real, Really Real, Super Real: Directions in Contemporary American Realism*. San Antonio: San Antonio Museum Association, 1981, p. 100, ill. p. 101. Excerpts from Stowens, Susan. "Wayne Thiebaud: Beyond Pop Art." *American Artist*, September 1980. Ex. cat.

In *Theophilus Brown: Recent Paintings*. San Francisco: John Berggruen Gallery, 1983, p. 3. Ex. cat.

In *Wayne Thiebaud: Prints*. Osaka: Yoh Art Gallery, 1982. Ex. cat.

INTERVIEWS

Amerson, Price. *Interview with Allan Stone on Wayne Thiebaud*. Unpublished transcript, New York, February 1981. Richard L. Nelson Gallery and The Fine Arts Collection, University of California, Davis.

————. *Interview with Wayne Thiebaud*. Unpublished transcript, San Francisco, 1981. Richard L. Nelson Gallery and The Fine Arts Collection, University of California, Davis.

Arthur, John. *Realists at Work*. New York: Watson-Guptill, 1983, pp. 114–129.

Benson, A. LeGrace G., and David H.R. Shearer. "Documents: An Interview with Wayne Thiebaud." *Leonardo*, January 1969, pp. 65–72, ill.

Butterfield, Jan. "Wayne Thiebaud: 'A Feast for the Senses.'" *Arts Magazine*, October 1977, pp. 132–137, ill.

Coplans, John. "Wayne Thiebaud: An Interview." Pasadena, Calif.: Pasadena Art Museum, 1968, pp. 23–36, ill. Ex. cat.

Moser, Charlotte. "Artist Thiebaud Rejects Labels or 'Movements.'" *Houston Chronicle*, 25 January 1975, sect. II, p. 8.

Tooker, Dan. "Wayne Thiebaud." *Art International*, November 1974, pp. 22–25, 33, ill. Reprinted in *Wayne Thiebaud*. Santa Cruz, Calif.: Art Museum of Santa Cruz County, 1982.

"Wayne Thiebaud in Conversation with Gwen Stone." *Visual Dialog*, Winter 1977–1978, pp. 12–15, ill.

ONE-PERSON EXHIBITION CATALOGS

Wayne Thiebaud. Milan: Galleria Schwarz, 1963. Essay by Abraham Stein.

Thiebaud. New York: Allan Stone Gallery, 1964. Introduction by Allan B. Stone.

Figures: Thiebaud. Stanford, Calif.: Stanford Art Museum, Stanford University, 1965. Introduction by Gerald M. Ackerman, statement by the artist.

Wayne Thiebaud. New York: Allan Stone Gallery, 1967.

Coplans, John. *Wayne Thiebaud*. Pasadena, Calif.: Pasadena Art Museum, 1968. Acknowledgments by James T. Demetrion, introduction by John Coplans, interview with the artist.

Thiebaud. Milwaukee: Milwaukee Art Center, 1968. Introduction by John Lloyd Taylor.

Recent Works by Wayne Thiebaud. Sacramento: E.B. Crocker Art Gallery, 1970. Introduction by John A. Mahey.

Wayne Thiebaud Graphics: 1964–1971. New York: Parasol Press, 1971.

Wayne Thiebaud: Survey of Painting 1950–72. Long Beach: California State University, 1972. Essay by Gene Cooper.

Wayne Thiebaud: Prints, Drawings, Paintings. Fort Collins: Colorado State University, 1975. Essay by Marlene Chamber.

Wayne Thiebaud: Paintings and Works on Paper. Santa Cruz, Calif.: Mary Porter Sesnon Art Gallery, University of California, 1976. Essay by Douglas McClellan.

Wayne Thiebaud: Survey 1947–1976. Phoenix: Phoenix Art Museum, 1976. Foreword by Ronald D. Hickman, preface by Donald J. Brewer, essay by Gene Cooper.

Wayne Thiebaud: Creations on Paper. Saint Paul: Visual Arts Gallery, College of Saint Catherine, 1977. Essay by Philip Larson.

Wayne Thiebaud. San Marcos, Calif.: Boehm Gallery, Palomar College, 1978. Essay by Gene Cooper.

Beal, Graham W.J. *Wayne Thiebaud: Painting.* Minneapolis: Walker Art Center, 1981. Acknowledgments by Martin Friedman, essay by Graham W.J. Beal.

Wayne Thiebaud. Santa Cruz, Calif.: Art Museum of Santa Cruz County, 1982. Essay by Gene Cooper, interview with the artist (reprint of 1974 interview with Dan Tooker).

Wayne Thiebaud. Tokyo: Gallery Hiro, 1982.

Wayne Thiebaud: Recent Drawings. Santa Cruz, Calif.: Eloise Pickard Smith Gallery, University of California, 1982.

Wayne Thiebaud: Landscapes & City Views. Sacramento: Crocker Art Museum, 1983. Essay by Roger D. Clisby.

Wayne Thiebaud: Paintings, Drawings, Graphics 1961–1983. Carlisle, Pa.: The Trout Gallery, Emil R. Weiss Center for the Arts, Dickinson College, 1983. Acknowledgments, introduction, and biographical notes by David Alan Robertson.

BOOKS

Adams, Clinton. *American Lithographers, 1900–1960: The Artists and Their Printers.* Albuquerque: University of New Mexico Press, 1983, p. 173.

Alloway, Lawrence. *American Pop Art.* New York: Collier Books, 1974, pp. 20–21.

————. *Topics in American Art since 1945.* New York: Norton, 1975, pp. 165, 169, 177, ill. p. 173.

Amaya, Mario. *Pop Art...and After.* New York: Viking, 1966, pp. 63, 64.

Arthur, John. *Realist Drawings & Watercolors.* Boston: New York Graphic Society, 1980, pp. 19, 30, ill. pp. 6, 32, [36].

————. *Realists at Work.* New York: Watson–Guptill, 1983, pp. 61, 108, 114–129, ill.

Barr, Alfred H., Jr. *Painting and Sculpture in The Museum of Modern Art, 1929–1967.* New York: The Museum of Modern Art, 1977, p. 593.

Battcock, Gregory, ed. *Super Realism: A Critical Anthology.* New York: Dutton, 1975, pp. 59, 85, 88, 224.

Beall, Karen F. *American Prints in the Library of Congress.* Baltimore: Johns Hopkins Press, 1970, p. 474, ill.

Betti, Claudia, and Teel Sale. *Drawing: A Contemporary Approach.* New York: Holt, Rinehart and Winston, 1980, p. 69, ill. p. 68.

Bro, Lu. *Drawing: A Studio Guide.* New York: Norton, 1978, p. 219, ill. p. 220. Also published under the title *Wie lerne ich Zeichen.* Cologne: DuMont, 1983.

Broder, Patricia Janis. *The American West.* Boston: Little, Brown, 1984, pp. 266, 301, 302–303, ill.

Calvesi, Maurizio. *Le Due Avanguardie, dal futurismo alla Pop Art.* Rome: Laterza, 1981, p. 292.

Catalogue of the Collection of the Whitney Museum of American Art. New York: Whitney Museum of American Art, 1974, pp. 166, 225, ill. p. 137.

Chase, Linda. "Existential vs. Humanist Realism" in *Photo Realism.* New York: Eminent Publications, 1975. Reprinted in Gregory Battcock, ed. *Super Realism: A Critical Anthology.* New York: Dutton, 1975, pp. 85, 88.

Compton, Michael. *Pop Art.* London: Hamlyn, 1970, pp. 92, 137, ill. pp. 126–127, 140, 142.

Crispolti, Enrico. *La Pop Art.* Milan: Fratelli Fabbri, 1966, pp. 84, 103, 104, ill. p. 85.

Crocker Art Museum: Handbook of Paintings. Sacramento: Crocker Art Museum, 1979, pp. 75–76, ill. pp. 87, 129.

De Antonio, Emile, and Mitch Tuchman. *Painters Painting.* New York: Abbeville, 1983, p. 182.

duPont, Diana C., Katherine Church Holland, Garna Garren Muller, and Laura L. Sueoka. *San Francisco Museum of Modern Art: The Painting and Sculpture Collection.* New York: Hudson Hills Press in association with San Francisco Museum of Modern Art, 1985, p. 226, ill. p. 227. Collection catalog published on the occasion of the fiftieth anniversary of the San Francisco Museum of Modern Art.

Edmondson, Leonard. *Etching.* New York: Van Nostrand Reinhold, 1973, ill. p. 25.

50 West Coast Artists. San Francisco: Chronicle Books, 1981, pp. 40, 68–69, ill.

Gealt, Adelheid M. *Looking at Art: A Visitor's Guide to Museum Collections.* New York: Bowker, 1983, pp. 465, 466.

Gerdts, William H. *The Great American Nude.* New York: Praeger, 1974, pp. 196, 201.

Hale, Nancy. *Mary Cassatt.* Garden City, N.Y.: Doubleday, 1975, pp. 33–34. Artist's statement.

Handbuch Museum Ludwig: Kunst des 20. Jahrhunderts. Cologne: Museum der Stadt Köln, 1979, pp. 776, 858, ill.

Herbert, John. *Christies' Review of the Season 1981.* London: Weidenfeld and Nicolson, 1981, ill. p. 178.

Howard, Seymour. "Wayne Thiebaud, Salad, Sandwiches, and Dessert, 1962: The Persistence of Academic Norms and Bittersweet Visions of Popular Nostalgia" in *The Counterpart to Likeness,* edited by Seymour Howard. Davis: University of California, 1977, n.p.

Hunter, Sam, and John Jacobus. *American Art of the 20th Century.* New York: Abrams, 1973, p. 334, ill. pp. 336, 360.

Johnson, Ellen H. *Modern Art and the Object.* New York: Harper & Row, 1976, p. 146.

Kultermann, Udo. *The New Painting.* New York: Praeger, 1969, pp. 30, 31–32, pls. 178, 191.

Lippard, Lucy, ed. *Pop Art.* New York: Praeger, 1966, pp. 140, 153–154, 158, ill. pp. 150, 152.

Lucie-Smith, Edward. *Art Now: From Abstract Expressionism to Superrealism.* New York: William Morrow, 1977, p. 234, 499, ill. p. 235.

Matusow, Marshall. *The Art Collector's Almanac No. 1.* Huntington Station, L.I.: Art Collector's Almanac, 1965, pp. 460, 568, 605, 630, ill. p. 461.

McArdle, Lois. *Portrait Drawing: A Practical Guide to Today's Artists.* Englewood Cliffs, N.J.: Prentice-Hall, 1984, pp. 43, 114, ill. p. 117.

Mendelowitz, Daniel M. *Drawing.* New York: Holt, Rinehart and Winston, 1967, pp. 281, 284, ill. p. 279.

_____ . *A History of American Art.* 2d ed. New York: Holt, Rinehart and Winston, 1970, pp. 424–425, ill.

New Art Around the World: Painting and Sculpture. New York: Abrams, 1966, p. 34, pl. 18.

Orr-Cahall, Christina, ed. *The Art of California: Selected Works from the Collection of The Oakland Museum.* Oakland, Calif.: The Oakland Museum, 1984, pp. 34, 35, 185, 194, ill.

Pellegrini, Aldo. *New Tendencies in Art.* New York: Crown, 1966, p. 236, ill. p. 241.

Plagens, Peter. *Sunshine Muse: Contemporary Art on the West Coast.* New York: Praeger, 1974, pp. 60, 71, 73, 140, ill. p. 67.

Rose, Barbara. *American Art since 1900: A Critical History.* New York: Praeger, 1967, p. 237.

Rosenberg, Harold. *The Anxious Object.* New York: Horizon Press, 1964, p. 74.

Rublowsky, John. *Pop Art.* New York: Basic Books, 1965, p. 28.

Russell, John, and Suzi Gablik. *Pop Art Redefined.* London: Thames and Hudson, 1969, pp. 54, 239, pls. 6, 36, 110.

Sager, Peter. *Neue Formen des Realismus.* Cologne: M. DuMont Schauberg, 1973, pp. 42, 269, ill. p. 47.

Sandback, Amy Baker. *Looking Critically: 21 Years of Artforum Magazine.* Ann Arbor: UMI Research Press, 1984, pp. 83, 84, 85, 87, ill. p. 86.

A Selection of Works from the Art Collections at the University of Nebraska. Lincoln: University of Nebraska, 1963, no. 99, ill. Collection catalog published on the occasion of the inauguration of the Sheldon Memorial Art Gallery.

Selz, Peter. *Art in Our Times.* New York: Abrams, 1981, pp. 467, 532, ill.

Society for Contemporary Art, The Art Institute of Chicago: 1940–1980. Chicago: The Art Institute of Chicago, 1980, pp. 29, 34, 54, ill.

Stebbins, Theodore E., Jr. *American Master Drawings and Watercolors.* New York: Harper & Row, 1976, pp. 382–383, ill. p. 384.

Stoltenberg, Donald. *The Artist and the Built Environment.* Worcester, Mass.: Davis, 1980, p. 17, ill.

Strand, Mark, ed. *Art of the Real: Nine American Figurative Painters.* New York: Clarkson N. Potter, 1983, pp. 180–199, 237, 238, ill. Artist's statement.

Taylor, Joshua C. *The Fine Arts in America.* Chicago: University of Chicago Press, 1979, p. 218.

Thomas, Karin. *Bis Heute: Stilgeschichte der bildenden Kunst im 20. Jahrhundert.* Cologne: DuMont, 1981, pp. 298, 303, 376.

Watson, Dori. *The Techniques of Painting.* New York: Galahad Books, 1970, p. 130, ill.

Weiss, Evelyn. *Katalog der Gemälde des 20. Jahrhunderts, die jüngeren Generationen ab 1915 im Museum Ludwig.* Cologne: Wallraf-Richartz Museum, 1976, pp. 100–101, pl. 42.

Weller, Allen S. *The Joys and Sorrows of Recent American Art.* Urbana: University of Illinois Press, 1968, p. 75, pl. 77.

Wilmerding, John. *American Art.* Harmondsworth, England: Penguin Books, 1976, p. 218.

Wilson, Simon. *Pop.* Woodbury, N.Y.: Barron's, 1978, pp. 29–30, pl. 30.

Wilson, William. *The Los Angeles Times Book of California Museums.* New York: Abrams, 1984, p. 28, ill. p. 27.

ARTICLES AND REVIEWS

An R following an entry indicates a review.
An * indicates that the article was not available for review.

1951 Osenbaugh, Merril. "We Enjoyed Thiebaud Show Because It's Easy to Grasp." *Sacramento Union,* 11 February 1951, p. 17. R.

1952 "Water Play: A Fountain by Wayne Thiebaud and Jerry McLaughlin." *Arts and Architecture,* November 1952, pp. 16–17, ill.

1953 "Eaglet Play Will Feature Thiebaud Sets." *Sacramento Bee,* 21 November 1953, p. 6, ill.

"Fountain by Charles Frazier, Jerry McLaughlin, Wayne Thiebaud." *Arts and Architecture,* August 1953, pp. 12–13, ill.

Langsner, Jules. "Art News from Los Angeles: Thiebaud and Texas." *Art News,* December 1953, p. 66.

1956 Glackin, William C. "Sights for Seeing Eyes." *Sacramento Bee,* 30 August 1956, p. C-14.

1957 Glackin, William C. "Two Ways of Going." *Sacramento Bee,* 26 October 1957, p. L-6, ill. R.

1958 Oglesby, John C. "Crocker Gallery Will Present Remodeled Rooms, New Show." *Sacramento Bee,* 6 September 1958, p. L-21, ill.

_____ . "Paintings Reveal Talent Galore." *Sacramento Bee,* 2 August 1958, p. L-21, ill. R.

_____ . "Thiebaud Takes Off in New (Old) Direction." *Sacramento Bee,* 23 August 1958, p. L-23. R.

1959 "Newsy Notes on New Office." *High Lines* (Sacramento Municipal Utility District), October 1959, pp. 3–4, ill.

1960 Oglesby, John C. "Thiebaud Provides Outstanding New Show for Opening ACG Exhibition." *Sacramento Bee,* 13 March 1960, p. L-27. R.

_____ . "Valley Artists Are Doing Just Fine." *Sacramento Bee,* 31 January 1960, p. L-25, ill.

1961 "Building of Four Faces: Headquarters for a California Utility Is a Successful Experiment in Sun Control." *Architectural Forum,* May 1961, p. 84, ill.

Frankenstein, Alfred. "Impressive Shows at Legion of Honor." *San Francisco Chronicle,* 29 December 1961, p. 23. R.

Oglesby, John C. "Coffee Cups and Pies Become Artist's Models." *Sacramento Bee,* 28 May 1961, p. L-4. R.

1962 "Art: It Figures." *Newsweek,* 4 June 1962, p. 95. R.

Coplans, John. "The New Paintings of Common Objects." *Artforum,* November 1962, pp. 26, 27.

"Everything Clear Now?" *Newsweek,* 26 February 1962, p. 87. R.

Frankenstein, Alfred. "Commonplaces of Culture on a Tour of the Galleries." *San Francisco Sunday Chronicle,* 15 July 1962, *This World,* p. 25. R.

Fried, Alexander. "Thiebaud's Oils Are as Homey as a Piece of Pie." *San Francisco Examiner,* 22 July 1962, *Highlight,* p. 7, ill. R.

H[ess], T[homas] B. "Wayne Thiebaud" in "Reviews and Previews." *Art News*, May 1962, p. 17, ill. R.

H[opps], W[alter]. "Wayne Thiebaud." *Artforum*, September 1962, pp. 43–45, ill. R.

J[udd], D[onald]. "Wayne Thiebaud" in "In the Galleries." *Arts Magazine*, September 1962, pp. 48–49, ill. R.

Kozloff, Max. "Art." *The Nation*, 5 May 1962, pp. 406–407. R.

————— . "Art." *The Nation*, 14 July 1962, p.19. R.

————— . "New York Letter." *Art International*, September 1962, pp. 37–38, ill. R.

Langsner, Jules. "Los Angeles Letter, September 1962." *Art International*, November 1962, p. 49, ill. R.

O'Doherty, Brian. "Art: America Seen through Stomach." *The New York Times*, 28 April 1962, p. 22. R.

————— . "Art: Avant-Garde Revolt." *The New York Times*, 31 October 1962, p. L-41. R.

————— . "A Vivid Art Season." *The New York Times*, western ed., 27 December 1962, p. 5. R.

P[olley], E[lizabeth] M. "Crocker Art Gallery." *Artforum*, August 1962, p. 38, ill. p. 39.

Rosenberg, Harold. "The Art Galleries." *New Yorker*, 24 November 1962, pp. 165–167. R.

Sandler, Irving. "In the Art Galleries." *New York Post*, 13 May 1962, p. 11. R.

Seckler, Dorothy Gees. "Folklore of the Banal." *Art in America*, Winter 1962, pp. 57, 60, ill. p. 59.

"The Slice-of-Cake School." *Time*, 11 May 1962, p. 52, ill. R.

"Something New Is Cooking." *Life*, 15 June 1962, p. 115, ill.

Sorrento, Gilbert. "Kitsch into 'Art': The New Realism." *Kulchur 8*, Winter 1962, pp. 15–16.

Thiebaud, Wayne. "Is a Lollipop Tree Worth Painting?" *San Francisco Sunday Chronicle*, 15 July 1962, *This World*, pp. 28–29, ill.

1963 "Art Raises Questions, Not Answers." *Sacramento Union*, 20 November 1963, p. B-3.

Coplans, John. "Pop Art—U.S.A." *Art in America*, October 1963, p. 26, ill. p. 27.

Davies, Lawrence E. "Oakland to Show 2 Coasts' Pop Art." *The New York Times*, 7 September 1963, p. L-16.

————— . "Pop Art, U.S.A." *Artforum*, October 1963, ill. p. 28. Catalog essay for exhibition *Pop Art, U.S.A.*, The Oakland Museum.

*Dickman, Joseph. "Art of Gastronomy." *Gourmet*, November 1963, p. 27.

F[actor], D[on]. "Six Painters and the Object and Six More." *Artforum*, September 1963, pp. 13, 14, ill. p. 15. R.

Fried, Michael. "New York Letter." *Art International*, May 1963, pp. 71–72, ill. p. 73. R.

Langsner, Jules. "Painting and Sculpture: The Los Angeles Season." *Craft Horizons*, May 1963, p. 41, ill. R.

Loran, Erle. "Pop Artists or Copy Cats?" *Art News*, September 1963, p. 49.

Oglesby, John C. "Thiebaud Takes New York." *Sacramento Bee*, 21 April 1963, p. L-10.

"Painting and Sculpture Acquisitions." *The Museum of Modern Art Bulletin* 30:2–3 (1963), p. 29, ill.

P[etersen], V[alerie]. "Wayne Thiebaud" in "Reviews and Previews." *Art News*, May 1963, p. 15. R.

"Pop Pop." *Time*, 30 August 1963, p. 40. R.

Preston, Stuart. "Art: Variety Marks New Exhibitions." *The New York Times*, 13 April 1963, p. 16. R.

Restany, Pierre. "Le Nouveau Réalisme à la conquête de New York." *Art International*, January 1963, p. 33. R.

Roberts, Colette. "Les Expositions à l'étranger." *Aujourd'hui*, May 1963, p. 15.

Rose, Barbara. "Dada Then and Now." *Art International*, January 1963, p. 23. R.

Seldis, Henry J. "Dog Days? Hot in the Public Galleries of L.A." *Los Angeles Times*, 14 July 1963, *Calendar*, p. 2.

————— . "The 'Pop' Art Trend: This, Too, Will Pass." *Los Angeles Times*, 4 August 1963, *Calendar*, p. 3, ill. R.

Selz, Peter. In "A Symposium on Pop Art." *Arts Magazine*, April 1963, p. 36.

"Sold Out Art." *Life*, 20 September 1963, p. 128, ill.

Tono, Yoshiaki. "Is Action Painting Over?" *Mizue*, May 1963, p. 51, ill.

1964 C[ampbell], L[awrence]. "Wayne Thiebaud" in "Reviews and Previews." *Art News*, May 1964, p. 10, ill. R.

Coplans, John. "Circle of Styles on the West Coast." *Art in America*, June 1964, pp. 26–28, ill.

Doty, Robert. "Trend and Traditions: Recent Acquisitions." Albright-Knox Art Gallery, *Gallery Notes*, Spring 1964, p. 7, ill. p. 8.

Fried, Michael. "New York Letter." *Art International*, May 1964, p. 43. R.

"Goodies, Girls, and Games." *Horizon*, Autumn 1964, p. 27, ill.

Kelly, Edward T. "Neo-Dada: A Critique of Pop Art." *Art Journal*, Spring 1964, p. 192, ill. p. 193.

Lord, J. Barry. "Pop Art in Canada." *Artforum*, March 1964, p. 28.

Oglesby, John C. "Small, Short Pop Show." *Sacramento Bee*, 12 July 1964, p. L-8, ill. R.

————— . "Star Will Pose for Thiebaud." *Sacramento Bee*, 1 March 1964, p. L-9, ill.

————— . "Thiebaud Scores Again." *Sacramento Bee*, 5 April 1964, p. L-9, ill. R.

"Pop-Art Diskussion." *Das Kunstwerk*, April 1964, ill. p. 23.

"They Paint: You Recognize." *Time*, 3 April 1964, p. 74, ill. p. 75. R.

Thiebaud, Wayne. "Four Drawings: Wayne Thiebaud." *Artforum*, December 1964, ill. pp. 34–35.

T[illim], S[idney]. "Wayne Thiebaud" in "In the Galleries." *Arts Magazine*, May 1964, p. 37, ill. R.

Tomkins, Calvin. "Art or Not, It's Food for Thought." *Life*, 20 November 1964, p. 144.

1965 Benedikt, Michael. "New York Letter." *Art International*, June 1965, p. 56. R.

Bloomfield, Arthur. "Thiebaud Discovers People." *San Francisco Examiner*, 1 October 1965, p. 29, ill. R.

C[astile], R[and]. "Wayne Thiebaud" in "Reviews and Previews." *Art News*, May 1965, p. 15, ill. R.

Cross, Miriam Dungan. "New Thiebaud Art Debuts." *Oakland Tribune*, 20 October 1965, p. 41, ill. R.

————. "Pop Artist Turns to Figures." *Oakland Tribune*, 24 September 1965, p. 30.

Emery, Tony. "The Nude in Art." *Canadian Art*, January–February 1965, p. 39, ill. p. 47. R.

Frankenstein, Alfred. "People Were More Solid than Pie." *San Francisco Sunday Examiner and Chronicle*, 10 October 1965, *This World*, p. 24, ill. R.

Glackin, William C. "Thiebaud Takes Another Kind of Approach to Food." *Sacramento Bee*, 5 December 1965, pp. L-24, L-27, ill. R.

————. "Wayne Thiebaud." *Sacramento Bee*, 3 October 1965, pp. L-8–L-9, ill. R.

Gray, Cleve. "New Ventures in Luxury Books." *Art in America*, September 1965, p. 98, ill. R.

M[onte], J[ames]. "Manuel Neri and Wayne Thiebaud." *Artforum*, March 1965, p. 44. R.

"O Say Can You See." *Newsweek*, 11 January 1965, p. 78.

Oglesby, John. "San Francisco Shows." *Sacramento Bee*, 17 January 1965, p. L-9, ill. p. L-8. R.

P[olley], E[lizabeth] M. "Crocker Art Gallery Association Invitational." *Artforum*, March 1965, p. 44. R.

————. "San Francisco." *Artforum*, December 1965, pp. 47–48, ill. R.

Preston, Stuart. "Art: Assemblage, to Be More Precise." *The New York Times*, 17 April 1965, p. 16. R.

R[aynor], V[ivien]. "Wayne Thiebaud" in "In the Galleries." *Arts Magazine*, May–June 1965, p. 60. R.

Thiebaud, Wayne. "Wayne Thiebaud: Photographs of His Work." *Motley* (Associated Students, University of California, Davis), Winter 1965-1966, ill. pp. 6-9.

Wallace, Dean. "Thiebaud's Spotless 'Pop' Food." *San Francisco Chronicle*, 13 January 1965, p. 34, ill. R.

"Wayne Thiebaud." *New York Herald-Tribune*, 17 April 1965, p. 11. R.

Willard, Charlotte. "Collector's Cooperative in Houston." *Art in America*, December 1965, p. 126, ill.

1966 Adrian, Dennis. "Wayne Thiebaud" in "New York." *Artforum*, December 1966, p. 58, ill. p. 59. R.

"Artists Say: 'Nudes Now.'" *Art Voices*, Summer 1966, p. 45, ill.

Benedict, Michael. "New York Letter." *Art International*, September 1966, pp. 49–50. R.

Donohoe, Victoria. "Contemporary Show Pinpoints New Art." *Philadelphia Inquirer*, 2 October 1966, p. 6, ill. R.

Hoffman, Donald L. "Cites Influence on His Art." *Kansas City Times*, 9 May 1966, p. 6A. R.

*James, Ted. "Art Review." *Women's Wear Daily*, 8 April 1966.

Meier, Kurt von. "Los Angeles–San Francisco Letter." *Art International*, September 1966, pp. 39, 40.

Thiebaud, Wayne. "A Painter's Personal View of Eroticism." *Polemic* (Case Western Reserve University, Cleveland), Winter 1966, pp. 33–36, ill.

Waldman, Diane. "Thiebaud: Eros in Cafeteria." *Art News*, April 1966, pp. 39–41, 55–56, ill.

1967 Alloway, Lawrence. "Art as Likeness, with a Note on Post Pop Art." *Arts Magazine*, May 1967, pp. 34, 35, 36, 37, ill.

————. "Hi-Way Culture: Man at the Wheel." *Arts Magazine*, February 1967, p. 30, ill. p. 33.

C[ampbell], L[awrence]. "Wayne Thiebaud" in "Reviews and Previews." *Art News*, May 1967, p. 56, ill. p. 12. R.

Canaday, John. "Art: Window for Curators." *The New York Times*, 25 March 1967, p. 18. R.

D[ienst], R[olf]-G[unter]. "Wayne Thiebaud." *Das Kunstwerk*, June–July 1967, p. 64, ill. pp. 49–51. R.

Glueck, Grace. "For São Paulo — Some Pop, Lots of Hop[per]." *The New York Times*, 19 March 1967, p. D-29. R.

Kaprow, Allan. "Pop Art: Past Present and Future." *Malahat Review*, July 1967, pp. 54–76. Reprint of "The Future of Pop Art" in *Happenings*, by Jurgen Becker and Wolf Vostell. Hamburg: Rowohlts, 1965.

M[ussman], T[oby]. "Wayne Thiebaud" in "In the Galleries." *Arts Magazine*, April 1967, p. 59, ill. R.

Townsend, Benjamin. "Albright-Knox-Buffalo: Work in Progress." *Art News*, January 1967, ill. p. 37.

Wherry, Joe. "Davis Speaker Describes Loneliness Found in Art." *The Daily Democrat*, 26 January 1967, p. 6.

1968 Alloway, Lawrence. "Art." *The Nation*, 25 November 1968, p. 572. R.

Andreae, Christopher. "Art for the Banks and Factories." *Christian Science Monitor*, 26 September 1968, p. 13, ill.

Constable, Rosalind. "Style of the Year: The Inhumanists." *New York*, 16 December 1968, p. 50, ill. p. 44.

Geske, Norman A. "America at Venice." *Art International*, Summer 1968, p. 79.

Good, Jeanne. "Art and Artists: Stare Concept." *Pasadena Citizen-News*, 23 February 1968, p. 11. R.

Hovick, Suzanne. "Hamburger's Shape Approved." *Minneapolis Star*, 5 April 1968, p. 8B, ill.

Johnson, Charles. "Hot, Cool in L.A." *Sacramento Bee*, 17 March 1968, pp. L-15, L-22, ill. R.

————. "Thiebaud Changes...Fantastic Hills Follow Cream Pies." *Sacramento Bee*, 9 June 1968, pp. L-14–L-15, ill. R.

Jones, C.M., and Wayne Thiebaud. "A Ball at Wimbledon." *Sports Illustrated*, 24 June 1968, pp. 40–45, ill.

Key, Donald. "Thiebaud's Still Lifes Exceed Pop Imagery." *Milwaukee Journal*, 17 November 1968, part 5, p. 6, ill. R.

Perreault, John. "Art: More than Real." *Village Voice*, 21 November 1968, p. 18. R.

R[osenstein], H[arris]. "Wayne Thiebaud" in "Reviews and Previews." *Art News*, November 1968, p. 78, ill. p. 15. R.

Simon, Richard. "Wayne Thiebaud: Pop Artist in Mid-Career." *Sacramento Union*, 9 June 1968, pp. F2, E11–E12, ill.

Smith, William L. "Fine Arts Museum Shows Thiebaud." *Daily Utah Chronicle* (Salt Lake City), 4 October 1968, p. 8, ill. R.

Wilson, William. "Art: A Hamburger Heritage, Rare and Well Done." *Los Angeles Times*, 25 February 1968, *Calendar*, pp. 50, 58, ill. R.

1969 "Albert Pilavin Collection: Twentieth-Century American Art." *Bulletin of Rhode Island School of Design Museum Notes*, May 1969, pp. 39–42, ill.

Alloway, Lawrence. "Popular Culture and Pop Art." *Studio International*, July–August 1969, ill. p. 20.

Andreae, Christopher. "Is the Pudding Done?" *Christian Science Monitor*, 26 November 1969, p. 12, ill.

Benson, A. LeGrace G., and David H.R. Shearer. "Documents: An Interview with Wayne Thiebaud." *Leonardo*, January 1969, pp. 65–72, ill.

Borsick, Helen. "A New Image: Three Versions." *Plain Dealer* (Cleveland), 3 August 1969, p. 2-F. R.

"California Survey in Holland." *Los Angeles Times*, 23 November 1969, *Calendar*, p. 71.

Freed, Eleanor. "High Visibility: The Epic of the Real." *Houston Post*, 21 September 1969, *Spotlight*, p. 12. R.

Johnson, Charles. "A.C.G. Opens Splashy Invitational; Foodstuffs Become Art Forms." *Sacramento Bee*, 27 July 1969, p. L-22, ill. R.

———. "The New Symbolism." *Sacramento Bee*, 13 April 1969, p. 124, ill. R.

———. "Thiebaud Cites Gain of New Realism in Painting." *Sacramento Bee*, 16 November 1969, p. L-10.

Lebrun, Caron. "Collectors' Exhibits Launch the New Year." *Sunday Herald Traveler* (Boston), 5 January 1969, p. 14, ill. R.

Russell, John. "Pop Reappraised." *Art in America*, July 1969, ill. p. 82.

Tillim, Sidney. "A Variety of Realisms." *Artforum*, Summer 1969, pp. 42, 43, 44, 46, ill. p. 45. R. Reprinted in *Looking Critically: 21 Years of Artforum Magazine*, edited by Amy Baker Sandback. Ann Arbor: UMI Research Press, 1984.

Turner, Bob. "Thiebaud House Is Their Gallery." *Sacramento Union*, 19 July 1969, p. C-2, ill.

Wolfram, Eddie. "Pop Art Undefined." *Art and Artists*, September 1969, p. 19. R.

1970 Albright, Thomas. "Thiebaud's Change of Style." *San Francisco Chronicle*, 22 January 1970, p. 40, ill. R.

Amaya, Mario. "Collectors: Mr. and Mrs. Jack W.

Glenn." *Art in America*, March–April 1970, p. 93, ill. p. 89.

Atkinson, Tracy, and John Lloyd Taylor. "Likenesses." *Art and Artists*, February 1970, p. 20, ill. p. 19. R.

Frankenstein, Alfred. "'Beyond the Actual' Exhibition." *San Francisco Chronicle*, 30 November 1970, p. 43. R.

Hale, David. "For Wayne Thiebaud, Popularity Was Surprise—and a Bit Suspect." *Fresno Bee*, 28 June 1970, p. 5-D, ill.

Johnson, Charles. "Art Views." *Sacramento Bee*, 15 November 1970, p. L-14, ill. R.

———. "Thiebaud 'Contradictions' Enliven Crocker Exhibition." *Sacramento Bee*, 11 January 1970, pp. L-14–L-15, ill. R.

———. "Thiebaud Talks about Freedom and Sensitivity." *Sacramento Bee*, 4 January 1970, pp. L-1, L-11, ill.

Perreault, John. "Art." *Village Voice*, 16 April 1970, p. 14. R.

Ratcliff, Carter. "New York." *Art International*, Summer 1970, p. 141. R.

Richardson, Brenda. "Bay Area Survey: The Myth of Neo-Dada." *Arts Magazine*, Summer 1970, pp. 47, 48.

R[osenstein], H[arris]. "Wayne Thiebaud" in "Reviews and Previews." *Art News*, April 1970, p. 75. R.

Simon, Richard. "51 Works of Wayne Thiebaud Show Wide Scope of Talent." *Sacramento Union*, 11 January 1970, *Sacramento Magazine*, pp. B-6–B-7, cover, ill. R.

"Thiebaud Completes Sojourn to France, Makes Lino-Cuts." *Sacramento Bee*, 22 November 1970, p. L-7.

Tuchman, Phyllis. "American Art in Germany: The History of a Phenomenon." *Artforum*, November 1970, ill. p. 66.

1971 Baker, Kenneth. "Dubious Realism at M.I.T." *Boston after Dark*, 19 October 1971, pp. 39–40. R.

Connor, Harriet J. "Chroniscope." *Spokane Daily Chronicle*, 8 December 1971, p. 23, ill.

Fitz Gibbon, John. "Sacramento!" *Art in America*, November 1971, p. 79, ill. p. 82.

Gale, Andrew. "Thiebaud Prints Are at A.C.G." *Sacramento Bee*, 4 July 1971, p. L-3, ill. R.

Grillo, Jean Bergantini. "Art: The Figure Returns." *Phoenix* (Boston), 19 October 1971, p. 44, ill. R.

Guilbert, Gladys E. "Guest Lecturer at F.W.C." *Spokesman-Review* (Spokane), 5 December 1971, p. 16-f, ill.

Hoffmann, Donald. "Those Good Little Things." *Kansas City Star*, 12 September 1971, pp. 2-G, 6-G, ill.

Shirey, David L. "Wayne Thiebaud's Graphics at Whitney." *The New York Times*, 12 June 1971, p. 25. R.

Simon, Richard. "The Value of Green Gumballs." *Sacramento Union*, 17 July 1971, p. 9, ill. R.

1972 Albright, Thomas. "A Pair of Printmakers." *San Francisco Chronicle*, 15 June 1972, p. 48. R.

Baker, Kenneth. [Parasol Press suite.] *Christian Science Monitor*, 4 January 1972, p. 8, ill. R.

B[enedikt], M[ichael]. "Wayne Thiebaud" in "Reviews and Previews." *Art News*, May 1972, p. 56. R.

Canaday, John. "Wayne Thiebaud" in "Art." *The New York Times*, 18 March 1972, p. 27. R.

Case, William D. "Wayne Thiebaud" in "Reviews." *Arts Magazine*, March 1972, pp. 62–63. R.

Frankenstein, Alfred. "Graphic Arts Showing: Exceptional Charm and Interest." *San Francisco Chronicle*, 7 September 1972, p. 52. R.

Goheen, Ellen. "From Romanticism to Pop." *Apollo*, December 1972, p. 548, ill.

Henry, Gerrit. "New York." *Art International*, May 1972, p. 55. R.

Johnson, Charles. "Los Angeles Still Leads in Art." *Sacramento Bee*, 31 December 1972, *Leisure*, p. 8, ill. R.

Juris, Prudence [Lynn Hershman]. "Wayne Thiebold's [sic] 'Delicious' Works." *San Francisco Progress*, 21 June 1972, p. 3, ill. R.

Kramer, Hilton. "Art: Comeback for Landscapes." *The New York Times*, 31 January 1972, p. 19. R.

Kurtz, Bruce. "Interview with Harry N. Abrams." *Arts Magazine*, September–October 1972, ill. p. 50.

Nemser, Cindy. "The Closeup Vision — Representational Art — Part II." *Arts Magazine*, May 1972, p. 48. Reprinted in Gregory Battcock, *Super Realism: A Critical Anthology*. New York: Dutton, 1975, p. 59.

Parker, Fred. R., ed. "Creativity Is Contagious: A Second Look at the Creative Experience Workshop." *Untitled 2–3* (Friends of Photography, Carmel, Calif.), 1972–1973, pp. 52–53, 65, ill.

Perreault, John. "Art." *Village Voice*, 23 March 1972, p. 32. R.

Schjeldahl, Peter. "There's No Touchdown, but Chalk Up Plenty of Yardage." *The New York Times*, 2 April 1972, p. D-19. R.

Seldis, Henry J. "Painterliness of Thiebaud." *Los Angeles Times*, 11 December 1972, sect. IV, p. 9, ill. R.

"Wayne Thiebaud, Painter of Things." *Artweek*, 9 December 1972, p. 7, ill. R.

1973 Albright, Thomas. "Real and Surface Art." *San Francisco Chronicle*, 27 February 1973, p. 36, ill. R.

Canaday, John. "Art: Good Shows for Gallery-Goers." *The New York Times*, 10 November 1973, p. 27. R.

Hull, Roger. "Artist's Luscious, Banal Objects Magical." *Sunday Oregonian* (Portland), 6 May 1973, ill. R.

Johnson, Charles. "Thiebaud's Art of the Overlooked." *Sacramento Bee*, 18 February 1973, *Valley Leisure*, pp. 4–5, ill.

———. "U.C.D. Faculty Hears Paradox of Painter." *Sacramento Bee*, 3 April 1973, *Scene*, pp. C-1–C-2, ill.

Lascault, Gilbert. "L'Alimentaire dans l'art américain récent." *XXe Siècle*, December 1973,

pp. 117, 120, ill.

Latter, Ruth. "British Born Pop Art: The Big Put-On." *Daily Progress* (Charlottesville, Va.), 6 May 1973, p. E-8, ill.

McColm, Del. "Realism Is Alive." *Davis Enterprise* (Calif.), 8 March 1973, p. 6, ill.

Peterson, Susan. "Painter Thiebaud Charms 400 at U.C.D." *Davis Enterprise*, 3 April 1973, pp. 1, 10, ill.

Reed, Ann. "Wayne Thiebaud Gives Kingsley Members a Survey." *Sacramento Bee*, 22 February 1973, p. C-7, ill.

Seldis, Henry J. "Neo-Realism: Crisp Focus on the American Scene." *Los Angeles Times*, 21 January 1973, *Calendar*, p. 54. R.

Simon, Richard. "The Real Meaning of Thiebaud's Trifles." *Sacramento Union*, 17 February 1973, p. 16, ill. R.

Wilson, William. "The Camera Is the Hero Again." *Art News*, April 1973, p. 58. R.

1974 Cortright, Barbara. "American Art from the Whitney." *Artweek*, 14 December 1974, p. 6. R.

Drukker, Leendert. "The Artist as Model." *Popular Photography*, April 1974, p. 124, ill. p. 115.

Frank, Peter. "Wayne Thiebaud" in "Reviews and Previews." *Art News*, January 1974, p. 100. R.

Karlstrom, Paul. "San Francisco." *Archives of American Art Journal* 14:4 (1974), p. 16.

Seldis, Henry J. "'The Fine Art of Food,' a Feast for the Eyes." *Los Angeles Times*, 24 November 1974, *Calendar*, p. 90. R.

Slater, Pamela. "Thiebaud — Master of Oil Imageries." *Spectator* (University of California, Davis), June 1974, p. 6, ill.

Thiebaud, Wayne. "As Far As I'm Concerned, There Is Only One Study and That Is the Way in Which Things Relate to One Another," *Untitled 7–8* (Friends of Photography, Carmel, Calif.), 1974, pp. 23–25.

Tooker, Dan. "Wayne Thiebaud." *Art International*, November 1974, pp. 22–25, 33, ill.

Van Baron, Judith. "Wayne Thiebaud." *Arts Magazine*, January 1974, p. 65. R.

1975 Albright, Tom. "Myth Makers." *Art Gallery*, February 1975, pp. 15, 17.

———. "The New Realists." *San Francisco Chronicle*, 6 February 1975, pp. 37–38. R.

Alvarez, Janice P. "California Visual Artists' Conference—A First." *Artweek*, 10 May 1975, p. 2.

Ballatore, Sandy. "The Sixties and Seventies Reviewed." *Artweek*, 1 March 1975, p. 5. R.

Flanagan, Ann. "California Realist Painting." *Artweek*, 22 February 1975, p. 16. R.

Ianco-Starrels, Josine. "Documentary Features Collector Scull." *Los Angeles Times*, 9 March 1975, *Calendar*, pp. 71–72.

Marioni, Tom. "Out Front." *Vision*, September 1975, pp. 8–9, ill. pp. 12–13.

Moser, Charlotte. "Artist Thiebaud Rejects Labels or 'Movements.'" *Houston Chronicle*, 25 January 1975, sect. 2, p. 8, ill.

Perrone, Jeff. "California Realists." *Artforum*, May 1975, p. 83. R.

Pitman, Lyman. "Deliciousness Displayed at Art

Gallery." *Collegian* (Colorado State University, Fort Collins), 6 February 1975, p. 13. R.

Ronte, Dieter. "Die Kunst der Sussen Sachen." *Museen in Köln Bulletin*, August 1975, pp. 1353–1355, ill.

1976 Bloomfield, Arthur. "Food for Artistic Thought." *San Francisco Examiner*, 23 November 1976, p. 20, ill. R.

Boesch, Barry. "His Art's Not Commercial but It Sells." *Corpus Christi Caller*, 2 April 1976, pp. 1-B–2-B, ill.

Burkhart, Dorothy. "Wayne Thiebaud." *Artweek*, 3 April 1976, p. 15, ill. R.

Cortright, Barbara. "Wayne Thiebaud Retrospective." *Artweek*, 2 October 1976, pp. 1, 24, ill. R.

Curtis, Cathy. "Another Painting of Pie, Please." *Daily Californian* (Berkeley), 10 December 1976, p. 23, ill. R.

Frankenstein, Alfred. "Thiebaud Served the Soup and It Was Good." *San Francisco Chronicle*, 5 December 1976, *This World*, p. 51, cover, ill. R.

Johnson, Charles. "Ultimate Accolade." *Sacramento Bee*, 28 November 1976, *Scene*, p. 3, ill. R.

Kramer, Hilton. "Back to the Land, with a Paintbrush." *The New York Times*, 30 May 1976, p. D-23. R.

Larson, Kay. "Painting the Public Lands." *Art News*, January 1976, p. 33. R.

Rosenblum, Robert. "Painting America First." *Art in America*, January–February 1976, p. 83. R.

Shere, Charles. "Eastbay Becomes a Center for Quality Prints, Etchings." *Oakland Tribune*, 20 June 1976, *Entertainment*, p. 18-E.

————. "Wayne Thiebaud: Getting Beneath the Luscious Lollipops." *Oakland Tribune*, 5 December 1976, *Entertainment*, p. 15, cover, ill. R.

Wilson, William. "'Unclassified' Reaction to Labels." *Los Angeles Times*, 16 February 1976, sect. IV, p. 5. R.

1977 Albright, Thomas. "The 'Hot' Art of Friedel Dzubas." *San Francisco Chronicle*, 26 February 1977, p. 34, ill. R.

————. "Wayne Thiebaud: Outdistancing Pop." *Art News*, February 1977, pp. 87–88, ill. R.

Beals, Kathie. "The Californians: Here They Come." *Westchester Weekend* (New York), 29 July 1977, p. D-7, ill. R.

Brown, Christopher. "New Drawings by Wayne Thiebaud." *Artweek*, 7 May 1977, p. 20, ill. R.

Butterfield, Jan. "Made in California." *American Art Review*, July 1977, p. 139, ill. p. 134.

————. "Wayne Thiebaud: 'A Feast for the Senses.'" *Arts Magazine*, October 1977, pp. 132–137, ill.

Frankenstein, Alfred. "Monotypes and Brilliant Colors." *San Francisco Chronicle*, 4 August 1977, p. 39. R.

Glueck, Grace. "Painting Is His Language." *The New York Times*, 22 July 1977, p. C-15, ill. R.

Hess, Thomas B. "Wayne Thiebaud: Eternal Mayonnaise." *New York*, 8 August 1977, pp. 56–57, ill. R.

*Howell, Betje. "Thiebaud Brings Stage, Photog-raphy to Art." *Los Angeles Herald-Examiner*, [February–30 March 1977].

Johnson, Charles. "City Streets Awry." *Sacramento Bee*, 24 April 1977, *Scene*, p. 3, ill. R.

Loercher, Diana. "Art of California: Diversity Prevails." *Christian Science Monitor*, 14 July 1977, p. 27, ill. R.

Paltridge, Blair. "Poet Laureate of the Coffee Break." *San Francisco Bay Guardian*, 7 January 1977, p. 16, ill. R.

Perrone, Jeff. "Wayne Thiebaud from Phoenix to Des Moines." *Artforum*, March 1977, pp. 42–45, ill. R.

Russell, John. "Art: Thiebaud's Food for Thought." *The New York Times*, 29 July 1977, p. C-18, ill. R. Reprinted in *Sacramento Bee*, 19 August 1977, p. A-24.

Seldis, Henry J. "Thiebaud Revealed in Spotlight of a Retrospective." *Los Angeles Times*, 6 February 1977, *Calendar*, p. 74, ill. R.

Shere, Charles. "A Show of Thiebaud's Works and What's Hot off the (Small) Presses." *Oakland Tribune*, 29 May 1977, p. 15-E, ill. R.

Shirey, David L. "Even Dieters Can Partake of This Fare." *The New York Times*, 21 August 1977, sect. 22, p. 18, ill. R.

Tarshis, Jerome. "Far West's 20th-Century Art in East Coast Review." *Smithsonian*, May 1977, p. 58. R.

Taylor, Robert. "Thiebaud's Work — It's Masterful." *Boston Sunday Globe*, 25 September 1977, p. A-9, ill. R.

"Wayne Thiebaud in Conversation with Gwen Stone." *Visual Dialog*, Winter 1977–1978, pp. 12–15, ill.

1978 Albright, Thomas. "Wayne Thiebaud: Scrambling Around with Ordinary Problems." *Art News*, February 1978, pp. 82–86, cover, ill.

Atkins, Robert. "Wayne Thiebaud." *Arts Magazine*, September 1978, p. 13, ill. R.

Bloomfield, Arthur. "Thiebaud Is Still Tilting at S.F." *San Francisco Examiner*, 7 June 1978, p. 34, ill. R.

Bossick, Karen. "Governor's Conference on the Arts." *Idaho Statesman* (Boise), 8 October 1978, *Tempo*, p. 1, ill.

Bourdon, David. "Art: Cityscapes." *Architectural Digest*, September 1978, p. 174, ill. p. 137.

Frankenstein, Alfred. "Unusual Show of Chinese Modernism." *San Francisco Chronicle*, 23 May 1978, p. 44. R.

Jennings, Jan. "Works Cast Uncommon Eye on Life." *San Diego Evening Tribune*, 21 February 1978, ill. R.

Kay, Alfred. "Thiebaud...Had His Cake, Now Something New." *Sacramento Bee*, 9 June 1978, p. E-5, ill. R.

McColm, Del. "Thiebaud's Work Moves to San Francisco's Streets." *Davis Enterprise*, 26 May 1978, *Weekend*, p. 7. R.

Ratcliff, Carter. "Wayne Thiebaud at Neuberger Museum." *Art in America*, January 1978, pp. 118–119. R.

Rohrer, Judith. "The Shape and Color of the

City." *Artweek*, 17 June 1978, p. 3, ill. R.

Thiebaud, Wayne. "A Metropolis Askew." *San Francisco Sunday Examiner and Chronicle*, 10 October 1978, *California Living*, ill. pp. 16–17.

Workman, Andrée. "Wayne Thiebaud's New Approach to Painting." *Westart*, 9 June 1978, pp. 1, 3, ill. R.

1979 Boettger, Suzaan. "Spirit of the Valley." *Artweek*, 19 May 1979, p. 6. R.

Burnside, Madeleine. "Wayne Thiebaud." *Arts Magazine*, September 1979, p. 37. R.

Glackin, William C. "Thiebaud Paintings on View in the Big Apple." *Sacramento Bee*, 28 April 1979, pp. A-12–A-13, ill.

Kahn, Wolf. "The Subject Matter in New Realism." *American Artist*, November 1979, pp. 50, 53, ill. p. 51.

Kennedy, John. "Wayne Thiebaud: The Drive-In Artist." *Sacramento*, August 1979, pp. 40–43, 47, ill.

Kramer, Hilton. "Art." *The New York Times*, 27 April 1979, p. C-21. R.

1980 Albright, Thomas. "A Schizophrenic Picture of Wayne Thiebaud." *San Francisco Chronicle*, 17 January 1980, p. 48. R.

————— . "'Realism'—A Wide Range of Styles and Approaches." *San Francisco Sunday Examiner and Chronicle*, 17 February 1980, *This World*, p. 47. R.

————— . "Bay Area Art." *Horizon*, July 1980, pp. 24, 27, ill. p. 25.

Bourdon, David. "Made in U.S.A." *Portfolio*, November–December 1980, p. 46, ill. pp. 43, 44.

Brown, Christopher. "Confectionary Painting." *Artweek*, 2 February 1980, pp. 1, 20, ill. R.

Donnell-Kotrozo, Carol. "Bay Area Art." *Arts*, March 1980, p. 4. R.

————— . "Bay Area Synopsis." *Artweek*, 5 April 1980, p. 16. R.

Glueck, Grace. "Art: The Cityscapes of Wayne Thiebaud." *The New York Times*, 11 April 1980, p. C-18, ill. R.

Junker, Howard. "The Objects of Desire." *Quest/80*, December 1980, pp. 78–80, ill.

Kay, Alfred. "Artist with Sure Command." *Sacramento Bee*, 3 February 1980, p. H-5, ill. R.

Michaels, Leonard. "Thiebaud's City." *Antaeus 39*, Autumn 1980, pp. 98–101, ill. Printed in slightly different form in *Nob Hill Gazette* (San Francisco), November 1980, pp. 6–7, ill.

Moss, Stacey. "Everyday Objects Get a Second Look from the Talents of Wayne Thiebaud." *Peninsula Times Tribune* (Palo Alto, Calif.), 13 February 1980, p. C-6, ill. R.

Shere, Charles. "Thiebaud Returns to Bay Area with Two Exhibits." *Oakland Tribune*, 27 January 1980, p. G-40, ill. R.

Stowens, Susan. "Wayne Thiebaud: Beyond Pop Art." *American Artist*, September 1980, pp. 46–51, 102–104, ill.

"Wayne Thiebaud" in "New York Reviews." *Art News*, September 1980, p. 241, ill. R.

Wilson, William. "Thiebaud's Exhibition — A Vaudevillian Spirit." *Los Angeles Times*, 6 July

1980, *Calendar*, p. 83, ill. R.

Workman, Andrée M. "Teaching by Doing." *Artweek*, 25 October 1980, p. 3. R.

Zimmer, William. "Art Pick." *Soho News*, 23 April 1980, p. 50, ill. R.

1981 [Andrews, Coleman.] "California: Art of the State." *New West*, January 1981, p. 85, ill.

Berryhill, Michael. "Art Fantasies that Comment on Life." *Fort Worth Star-Telegram*, 3 May 1981, pp. E1–E2, ill. R.

Bourdon, David. "Wayne Thiebaud Painting." *Vogue*, March 1981, pp. 38, 41, ill. R.

Chadwick, A.M. "Recent Work by California Artist Wayne Thiebaud." *Connoisseur*, March 1981, p. 180, ill. R.

Donohoe, Victoria. "Separating a Painter from His Pop." *Philadelphia Inquirer*, 11 October 1981, p. 13–H, ill. R.

Hegeman, William R. "Painter, Sculptor Share Walker Billing." *Minneapolis Tribune*, 9 February 1981, p. 7B, ill. R.

Hellekson, Diane. "Touring the Landscape with Thiebaud." *Minnesota Daily* (University of Minnesota, Minneapolis), 26 February 1981, *d'Art*, p. 7, ill.

Henry, Gerrit. "Realism/Photorealism" in "Books in Review." *Print Collector's Newsletter*, July–August 1981, p. 88.

Kramer, Hilton. "Art: A Strategy for Viewing the Whitney Biennial." *The New York Times*, 6 February 1981, p. C-18. R.

Kutner, Janet. "Menu Changes." *Dallas Morning News*, 16 May 1981, pp. 1C, 9C, ill. R.

Marèchal-Workman, Andrée. "Individualism and the Avant-Garde: Wayne Thiebaud." *Vanguard*, Summer 1981, pp. 25-29, ill.

————— . "Wayne Thiebaud's Cityscapes." *Images & Issues*, Winter 1981–1982, pp. 67–70, ill.

Marvel, Bill. "There's Rhythm in Thiebaud's Gooey Goodies." *Dallas Times Herald*, 6 May 1981, pp. 1, 8, ill. R.

Menzies, Neal. "Twenty Years of Wayne Thiebaud." *Artweek*, 7 November 1981, p. 1, ill. R.

"New York Art Market Now." *Art & Collector* (Japan), 13 (1981), pp. 36–37, ill. p. 35.

Simon, Richard. "Sacramento's $ix-Figure Painter." *Sacramento Union*, 17 July 1981, p. D-1, ill.

Thiebaud, Wayne. "A Fellow Painter's View of Giorgio Morandi." *The New York Times*, 15 November 1981, pp. 37–38.

————— . "Art: A Personal View." *C.A.A. Newsletter*, April 1981, p. 5, ill.

1982 Albright, Thomas. "Looking Back at a Unique Decade in Art." *San Francisco Chronicle*, 1 November 1982, p. 44. R.

Delehanty, Hugh J. "Wayne Thiebaud Doesn't Want to Be a Superstar — He Wants to Be a Better Painter." *San Francisco*, December 1982, pp. 76–79, 128–130, ill.

Geeting, Corinne. "E.R.A.! For the Arts." *Westart*, 8 July 1982, p. 2. Includes brief statement by Thiebaud.

Glenn, Constance W. "A Conversation with Wayne Thiebaud." *Architectural Digest*, September 1982, pp. 62, 68, ill.

Klein, Michael. "Wayne Thiebaud: Allan Stone." *Art News*, September 1982, p. 155, ill. R.

LeSuer, Claude. "Thiebaud's Dizzying Vistas." *Artspeak*, May 1982, p. 4, ill. R.

Oresman, Janice C. "Still Life Today." *Arts Magazine*, December 1982, p. 113, ill. p. 112.

Thiebaud, Wayne. "Matisse — A Personal View" in *Henri Matisse*. San Francisco: John Berggruen Gallery, 1982, pp. ix–x.

1983 C[loud], S[hawn]. "Thiebaud's Show: Sweet Realism." *University of Richmond Magazine* (Virginia), Winter 1983, p. 21, ill. R.

"First Person: Wayne Thiebaud." *Sacramento Union*, 5 February 1983, pp. C1–C2, ill.

Gable, Mona. "Pop & Pies to Urban Landscape: The Art of Wayne Thiebaud." *San Francisco Focus*, July 1983, pp. 8, 10–11, ill.

Gordon, Gail. "Thiebaud Puts a Visual Feast on Canvas." *California Aggie* (University of California, Davis), 9 February 1983, *Profile*, pp. 2, 7, cover, ill. R.

Kennedy, Idella. "Thiebaud's City Views." *Suttertown News* (California), 4–11 March 1983, p. 8, ill.

Kidd, Virginia. "At Home with Art." *Sacramento*, April 1983, pp. 38–40, ill.

Marlowe, John. "San Francisco." *Westart*, 25 January 1983, p. 2. R.

McColm, Del. "Thiebaud Dazzling." *Davis Enterprise Weekend*, 10 February 1983, p. 5, ill. R.

Morch, Al. "5 Artists Drawn Together." *San Francisco Examiner*, 10 January 1983, p. B-14, ill. R.

O'Flaherty, Terrence. "Eat Your Way through Art." *San Francisco Chronicle*, 18 July 1983, p. 34.

Platt, Susan. "Artists Who Draw." *Artweek*, 29 January 1983, p. 5, ill. R.

"Sacramento: Locals Combine for World Renowned Exhibit." *AirCal*, February 1983, pp. 42–44, ill.

Schlesinger, Ellen. "An Artist Who Shuns Eccentricity." *Sacramento Bee*, 13 February 1983, *Scene*, pp. F-1–F-3, ill.

Shere, Charles. "Artists' Selves Shine through Their Drawings." *Oakland Tribune*, 20 January 1983, p. C-3. R.

Simon, Richard. "Landscapes with Great Energy." *Sacramento Union*, 8 February 1983, p. 33, ill. R.

"Wayne Thiebaud" in "Prints and Photographs Published." *Print Collector's Newsletter*, July–August 1983, p. 106. R.

Weisberg, Ruth. "Representational Drawing: The Power of Subjectivity." *Artweek*, 2 April 1983, p. 16. R.

Weiss, Jeffrey. "Wayne Thiebaud's Old Snack Magic." *Arts Magazine*, November 1983, pp. 80–81, ill. R.

1984 "Acquisitions." *The Tate Gallery Illustrated Biennial Report*, 1982–1984, p. 135.

Martini, Chris. "Crime and Punishment in Silicon Valley." *Studio International* 197:1005 (1984), p. 62. R.

Regan, Kate. "A Graphic Display of Talent." *San Francisco Chronicle*, 15 August 1984, p. 60. R.

"Wayne Thiebaud." *Print Collector's Newsletter*, May–June 1984, p. 66.

1985 Schlesinger, Ellen. "Even Thiebaud Can Disappoint." *Sacramento Bee*, 12 May 1985, *Encore*, p. 8, ill. R.

FILMS

Works of Wayne Thiebaud. San Francisco: KQED, 1965–1966. 25 min., color, sound.

Wayne Thiebaud and Peter Voulkos. New York: National Educational Television, 1968. 30 min., b&w, sound. From the *Creative Person* series, distributed by Indiana University Audio-Visual Center, Bloomington.

Wayne Thiebaud. Sacramento: Carr Films, 1971. 22 min., color, sound. Film monograph covering 1961–1970.

Tooker, Dan. *Contemporary Artists at Work*. Orlando: Harcourt Brace Jovanovich, School Division, 1975. Two-part film strip.

A Piece of Cake . . . and Other Paintings by Wayne Thiebaud. San Francisco: KQED, 1983. 30 min., color, sound.

PHOTOGRAPHY CREDITS

Photographs of the works of art have been supplied, in many cases, by the owners or custodians of the works as cited in the captions. The following list applies to photographs for which additional acknowledgment is due.

Huntley Barad: Pl. 27
Ben Blackwell: Figs. 13, 33
Geoffrey Clements: Fig. 31
Diana Crane: Fig. 29, frontis
Patrick Dullanty: Fig. 23
M. Lee Fatherree: Figs. 9, 11, 16, 17, 18; Pls. 1, 4, 6, 11, 22, 24, 31, 37, 49, 50, 54, 57, 58, 61, 67, 70, 80, 81, 83, 88
C. Federowicz: Fig. 35
Janice Felgar: Pl. 25
Roger Gass: Pls. 5, 20, 68
Brian Gaumer: Pl. 55
Greg Heins: Pl. 9
Hollmarc Productions: Pl. 64
Bob Kolbrener: Pl. 52
Gregory Kondos: Fig. 32
A.F. Madeiras: Pl. 3
Bernard Marque: Pl. 14
Thomas Moore: Pl. 79
Muldoon Studio: Fig. 26
Don Myer: Figs. 3, 5, 10, 20
Eric Pollitzer: Pls. 8, 13, 19, 26, 48, 53, 84
Joe Samberg: Fig. 14
E.G. Schempf: Pls. 2, 18
John Schiff: Pl. 62
Steven Sloman: Pls. 23, 34, 63
Joseph Szaszfai: Fig. 19
John Tennant: Pl. 75
Betty Jean Thiebaud: Fig. 28

Cover: Detail, *Urban Downgrade, 20th and Noe,* 1981 (Pl. 70)
Back Cover: Detail, *Strawberry Cone,* 1969 (Pl. 17)
Pp. 2–3: Detail *Neapolitan Pie,* 1963/1964–65 (Pl. 10)
Pp. 4–5: Detail, Untitled, 1971 (Pl. 27)
Pp. 6–7: Detail, *Woman in Tub,* 1965 (Pl. 52)

WAYNE THIEBAUD
was produced for the
San Francisco Museum of Modern Art
and the University of Washington Press
by Perpetua Press, Los Angeles.
Edited by Letitia Burns O'Connor
Designed by Dana Levy
Typeset in Baskerville by Continental Typographics
Printed in Japan by Toppan Printing Company
in an edition of 15,000 copies